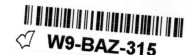

NORTH GERMAN FOLK POTTERY

OF THE 17TH TO THE 20TH CENTURIES

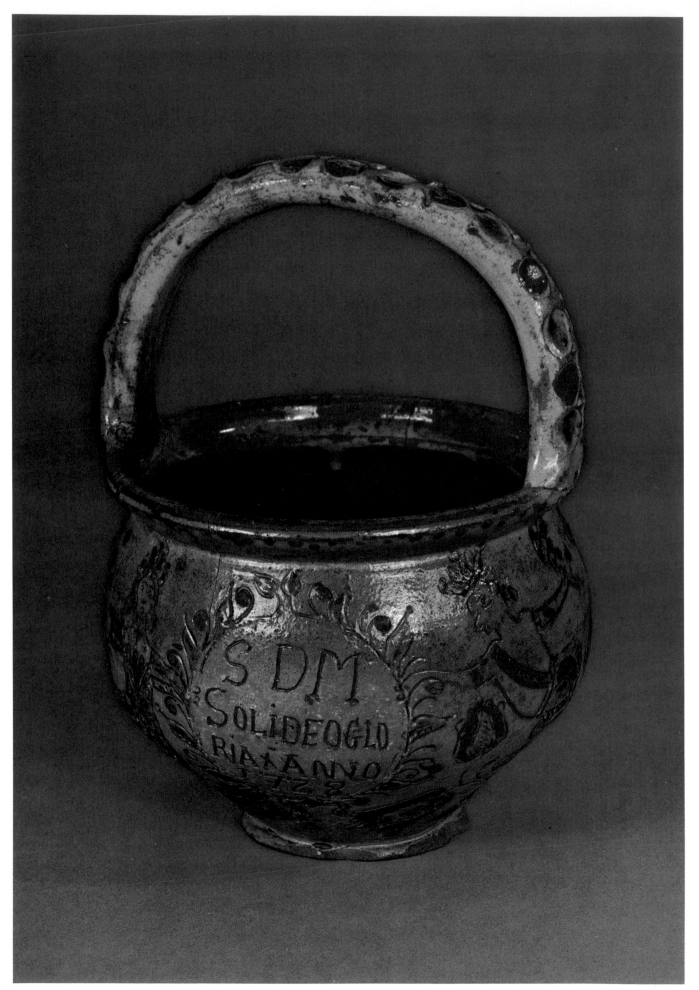

North German Folk Pottery

OF THE 17TH TO THE 20TH CENTURIES

Catalogue by Gerhard Kaufmann

Organized and Circulated by the International Exhibitions Foundation

1979-1980

Copyright © 1979 by the International Exhibitions Foundation
Library of Congress Catalogue Card No. 79-88-221
ISBN: 0-88397-006-6

Produced for the International Exhibitions Foundation
by W.M. Brown & Son, Richmond, Virginia

Designed by Raymond Geary

Cover illustration; Cat. No. 99, Dish from North Germany, ca. 1800

PARTICIPATING MUSEUMS

Abby Aldrich Rockefeller Folk Art Center
Williamsburg, Virginia

Baltimore Museum of Art
Baltimore, Maryland

Indianapolis Museum of Art
Indianapolis, Indiana

Mansion Museum, Oglebay Institute
Wheeling, West Virginia

Leigh Yawkey Woodson Art Museum
Wausau, Wisconsin

LENDERS TO THE EXHIBITION

Altonaer Museum in Hamburg, Norddeutsches Landesmuseum, Hamburg

Dithmarscher Landesmuseum, Meldorf

Kulturgeschichtliches Museum Osnabrück

Museum für Kunst und Gewerbe, Hamburg

Niederrheinisches Museum der Stadt Duisburg

Schleswig-Holsteinisches Landesmuseum, Schleswig

Städtisches Museum Flensburg

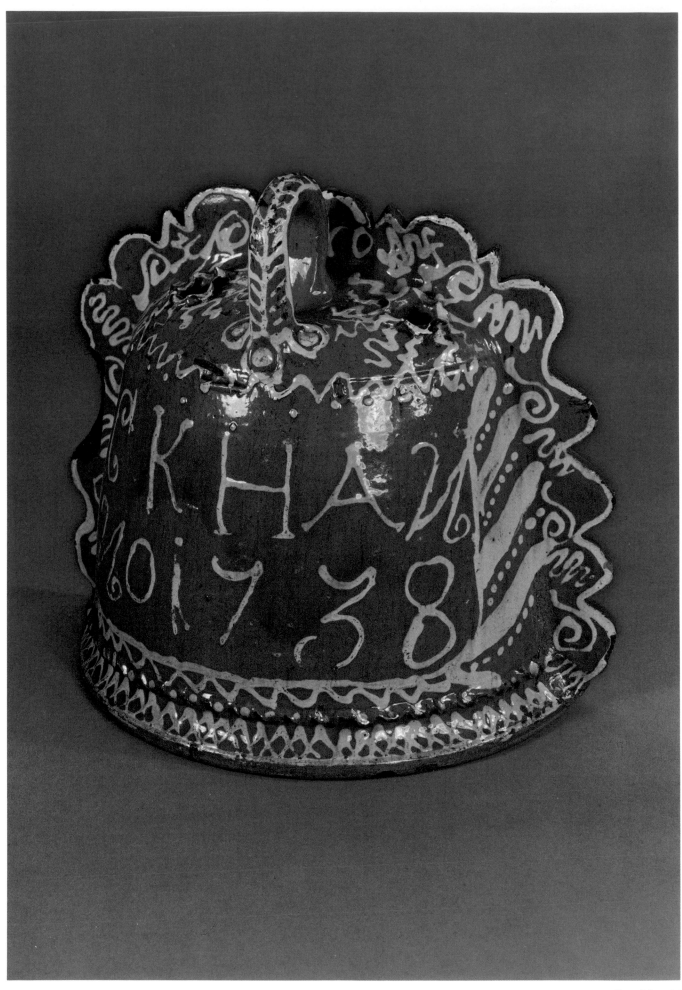

Acknowledgments

It is with great pleasure that the International Exhibitions Foundation presents this exhibition of folk pottery from North Germany for a tour of American museums. Plans for such a tour date from 1976, when the Museum für Kunst und Gewerbe in Hamburg, under the direction of Dr. Axel von Saldern, mounted a special exhibition from their own collection, accompanied by a superb catalogue by Dr. Hermann Jedding. All agreed that it would be highly desirable to make such an exhibition available to American audiences, and thus the idea for the present exhibition was born.

The tour would not have been possible without the able assistance of Professor Dr. Gerhard Kaufmann, Director of the Altonaer Museum in Hamburg, who has devoted untold hours to the selection of the works and arrangement of the loans, as well as the writing of the scholarly catalogue. To accomplish these several endeavors while at the same time attending to his many responsibilities as a museum director is an achievement for which he deserves our warmest thanks.

It is always difficult to adequately thank those who lend to an exhibition, and we owe a special debt of gratitude to the seven German museums who have agreed to part with treasures from their collections for the duration of the tour. Their willingness to share their potteries with American audiences is generous indeed, and we are most appreciative.

The Foundation wishes to thank His Excellency Berndt von Staden, Ambassador of the Federal Republic of Germany, under whose patronage the exhibition is circulated. Special thanks are also due Dr. Haide Russell and Dr. Rudolf Schmidt of the Cultural Department of the Embassy for their interest and assistance throughout.

Once again we wish to express our gratitude to The Andrew W. Mellon Foundation for their generous grant toward the exhibition catalogue.

Our warmest appreciation goes to James Witt of W. M. Brown and Sons and graphic designer Raymond Geary for collaborating to produce another fine catalogue. We are also indebted to Dennis Clarke for translating the catalogue material, and to Taffy Swandby and Ludy Biddle for their editorial assistance. Finally, I wish to thank the Foundation staff for attending to the numerous details involved in preparing the exhibition for tour.

ANNEMARIE H. POPE
President
International Exhibitions Foundation

Foreword

The incentive for this touring exhibition, suggested by Mrs. John A. Pope, originally came from a special exhibition at the Museum für Kunst und Gewerbe, Hamburg, in 1976, which presented a selection of the Museum's vast collection of folk art of the German-speaking world. Ceramic folk art was a much admired element of this exhibition and was explained in exemplary fashion in an illustrated booklet by Dr. Hermann Jedding, with a scholarly introduction and relevant descriptions and commentaries.

But as no museum is willing to loan a whole collection, always a risky undertaking despite the utmost care, there was no possibility of taking over in toto the original selection for the touring exhibition. Dr. Jedding, however, was not able to undertake the arrangement of a new exhibition owing to his other commitments, and so I accepted the offer to do this. This decision was made all the easier for me when Professer Dr. Axel von Saldern, Director of the Museum für Kunst und Gewerbe in Hamburg, as well as Dr. Jedding, keeper of the department in question, promised me every help and showed every readiness to fulfill my wishes in respect of loans and I, in my own institution, the Altonaer Museum in Hamburg, could fall back on an equally respectable collection of ceramic folk art, although of a very different type.

The choice of the pieces for this exhibition was determined on the one hand by a regional and technological limitation and, on the other, by the addition of normal standard ware to highly-decorated ornamental wares. The decision to limit the selection to earthenware alone was made for the sake of insuring uniformity in the craftsmen's products to be shown—a uniformity of decors, forms and usage confined to the region of North Germany. The concentration of material thus achieved encourages not only an understanding of folk art but also of folklore and hence of the cultural history of this whole region. For the same reason, simple standard wares also had to be selected in addition to the magnificent showpieces, highly prized and bought at great expense by collectors. Apart from the fact that this simple standard ware can boast of the same accuracy of form as the decorative ceramic ware, the latter could only develop on the basis of simple ware, which at one time accounted for ninety-five percent of pottery production, and in many places even more. Today, however, simple standard wares, insofar as they are well-recorded old pieces of work, are often almost rarer than the magnificently decorated pieces which were always carefully looked after and very early sought after by collectors.

By North Germany we mean essentially the area covered by the North German plain. Those parts of this plain east of the Elbe, which have always formed a cultural and a historical unity with the western parts, must, however, remain outside the scope of this exhibition. Our knowledge of ceramic folk art there is scanty: only a few pieces have found their way into West German museums and collections, and those in museums of the German Democratic Republic and Poland are not available for loans. However, several pieces imported from neighboring countries into North Germany have been included here to give an idea of the competition to which native production was subjected.

To simplify the question of loans and transport, we set great store on having as few lenders as possible; hence the list of lenders does not necessarily represent all the most important collections of ceramic folk art from North Germany in German museums, although the museums participating do belong to those with collections of the highest significance for this theme. There would have been little purpose—to quote just one example—in requesting loans from the Germanisches National Museum in Nuremberg, when comparable pieces were available for loan in Hamburg, Schleswig or Duisburg.

The mounting of this exhibition would have been impossible without the generous help of numerous colleagues, who were not only prepared to dispense with important pieces from their own collections for almost two years, but who also spared no pains in providing excerpts from inventories and material for illustrations. Thus special thanks are due to Dr. Gernot Tromnau and Dr. Günther Krause from the Niederrheinisches Museum Duisburg, Dr. Rudolf Zöllner and Dr. Ulrich Schulte-Wülwer of the Städtisches Museum Flensburg, Prof.

Dr. Axel von Saldern and Dr. Hermann Jedding of the Museum für Kunst und Gewerbe in Hamburg, Dr. Nis Rudolf Nissen of the Dithmarscher Landesmuseum in Meldorf, Dr. Manfred Meinz and Dr. Ernst Helmut Segschneider of the Kulturgeschichtliches Museum Osnabrück, Prof. Dr. Gerhard Wietek and Dr. Arnold Lühning of the Schleswig-Holsteinisches Landesmuseum in Schleswig and all their respective technical staff as well as the staff of my own institution, the Altonaer Museum in Hamburg, Norddeutsches Landesmuseum. Thanks are likewise due to the public authorities responsible for the above museums, who agreed to make exceptions in the rule limiting loans to the duration of one year at the most. Finally we would like to thank the staff of the International Exhibitions Foundation for the organization of the exhibition and the publication of this superbly produced and illustrated catalogue.

I hope that this exhibition will not only stimulate in America a pleasure in the artistic skill of North German potters and an understanding of the life and customs of the rural and small town inhabitants of this area, particularly in the 18th and 19th centuries, but will also serve as a reminder of one period of our common history. For it was immigrants from Germany, especially from rural districts, who brought with them to their new homeland many of the habits, customs and practices with which we are concerned in this exhibition. Even if the most conspicuous reflection of the German ceramic folk art tradition in the USA, namely the pottery ware of the "Pennsylvania Dutch," is mainly based on South German earthenware of the 18th century, nevertheless any connoisseur of such pieces will notice that they also certainly have affinities with the ceramics exhibited here, for they have their origin in common pottery traditions, spread by wandering craftsmen and the passing on of patterns all over Germany.

GERHARD KAUFMANN

Cat. No. 29

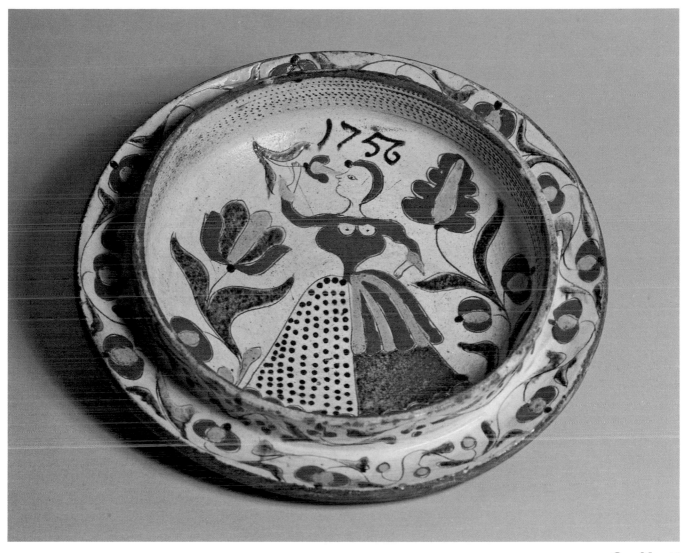

Cat. No. 48

Introduction

Ceramics is man's oldest and most widespread cultural art which demands a technique, i.e. a knowledge of a systematic series of actions and methods of procedure. Pottery, as far as is known, first appears during the transitional phase from the Paleolithic to the Neolithic age. Depending on the culture in question, in Europe this could mean between 8000-4000 B.C.

Ceramic material, once fired, is almost as durable as stone, but vessels, once broken, cannot be used again, unlike metal which can always be recast. In the earth, however, it can survive for thousands of years. Also, undamaged pots were less often subjected to deliberate destruction than were vessels of metal, since broken ceramic material is worthless.

In spite of this, our knowledge of ceramics is far less than is generally thought. We often know very little about even comparatively recent ceramics dating from the end of the Middle Ages, and, astonishingly enough, our knowledge of the succeeding centuries—in Central Europe, at any rate—is not better but even more scanty. Somewhat more exact information is available only for a modest proportion of ceramic production, namely, decorative crockery (particularly that which is dated). Except for a few examples, we cannot keep a tally of the mass of standard everyday crockery that exists.

There are considerable problems of identification even with pieces of decorative crockery, however, since pieces began to be collected early in history and were thus removed from their place of use. In earlier days no importance was attached to recording their provenance or the details regarding their use. Thus it is very difficult to establish a connecting link running from, say, mediaeval ceramics via Renaissance and Baroque to the final decay of folk art earthenware around 1900. Explanations on the change of form and the influences on techniques and decors are often based on pure supposition.

Finally, it is also inexplicable how quite suddenly, about the middle of the 16th century, pottery ware with colored decoration appeared in Germany and there began to be a distinction between wares produced for urban and for rural markets. For hundreds of years ceramics for town and country appear to have differed in the quality of their craftsmanship but not in their form, type and decor. They were to be found in every household, mainly as cooking utensils and storage pots, and as they were not decorated, or were decorated only in the simplest fashion, there was no cause for social differentiation. Only when ceramics with ornamental relief or painted decorations began to appear did potters produce, alongside normal standard ware, expensive showpieces which only the well-to-do could afford.

There are various speculations about the influences which led to the coloring of ceramics; these need only be mentioned here in passing. There may have been influences from the Near East which reached Central Europe via Byzantium, or from Egypt which penetrated to Central Europe over the trade routes or as a result of wars. Probably the prototype was the tin-glazed Italian or Spanish faience. During the 16th century Italian faiences in particular penetrated to the north and stimulated the local potters who, benefiting from their experience in the production of stove tiles, went on to also produce colored decorative ware to compete with the stoneware which, with its decorations in relief, had been dominating the market for better-class ceramics since the 14th century. Stove tiles, however, were made of earthenware (known in South Germany as *Hafnerware,* or "potter ware") which was decorated by the application of green, yellow, brown or black lead glazes—a practice which had been in use since the late 14th century. Thus the potters were left with the choice of going over to painted tin glazes, like the Italian faience prototype, or achieving similar effects by using lead-glazed earthenware, a material to which they were accustomed and which was easier to work with. Both methods were used, but the second proved to be the decisive one in ceramic folk art.

The Technique of Earthenware

The basic material for earthenware is normal clay, such as that used for the production of bricks. After it has been more or less well moistened, kneaded, put to one side to settle and kneaded again, the clay is shaped—without any aids or with a foot driven wheel—into plates, dishes, jugs and the like, dried carefully in the air, and then fired (Fig. 1). Normal clay at firing

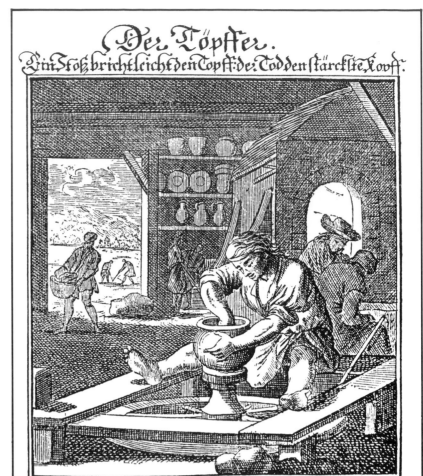

Der Töpffer.

Ein Stoß bricht leicht den Topff: der Todd den stärckste Kopff.

❧ Was die Arbeit der Haffner anbelanget, machen sie
Gefäße, so wol zu Ehren als Unehren
zu gebrauchen . . .

Fig. 1. A Potter at his Wheel
Engraving from the *Ständebuch* (Book of Classes) by Christoff Weigel (1654-1725), published in Nuremberg, 1698
The inscription reads: (above) "The Potter / A blow easily breaks the pot; Death the hardest head," (below) "As belongs to the work of potters they make vessels for honorable as well as dishonorable use . . ."

temperatures of 800°-900° C. becomes earthenware, which has a whitish to grey, yellowish, brownish or red body, depending on the proportion of lime, the amount of impurities due to mixture with other minerals, and the exact firing temperature. (The iron which is present in almost every clay produces the usual red coloring. A higher proportion of lime leads to a yellow color.) The clay body is somewhat pervious to water; in a moist state it can freeze and crack.

To make earthenware impervious to water one can glaze it. The simplest and cheapest glaze is lead glaze, a very fine layer of melted lead glass. Although basically colorless, it can be colored either by the presence of natural impurities or by the deliberate addition of metallic oxides, such as copper oxide (verdigris) to produce green, or iron oxide (rust) to produce yellowish to reddish-brown. However, the disadvantage of this glaze is that upon contact with acid, poisonous lead compounds are formed, thereby rendering lead-glazed vessels unsuitable for storing vinegar or curdled milk. Nonetheless, for many years lead-glazed crockery was in everyday use, although other types of vessels were preferred for long-term storage. The use of acid-soluble, lead oxide glazes for domestic crockery was eventually forbidden in Germany by the Reichs Law of June 25, 1885.

Although the lead glaze, in the form of a liquid paste and poured with a ladle, can be applied directly to the air-dried pieces before firing, in most instances the surface is first treated with an especially fine, "pretty firing" liquid clay paste known as slip or engobe. This can be made of the same clay as the body of the piece, in which case it gives the pot only a more even coloring; or it can be of a different color or even be made of another type of clay altogether. The slip at any rate gives the piece its basic color. It is, of course, important that the slip have the same shrinkage and expansion coefficient as the clay used in the body of the piece. This also applies to the paint and the glaze, as they must not crack when the piece is fired or when it is cooled after being fired.

After the slip has dried, and prior to glazing or firing, a drawing can be scratched in the slip. In this process the slip may be cut through or partly scraped off to expose the color of the clay beneath. This sgraffito technique can also be employed when two layers of different-colored slips are used. Another method for decorating the piece before glazing is to stick on with liquid clay little clay panels, ribbons or bits of clay shaped by hand or with press molds and stamps.

The simplest method of applying color is to spray or drip colored glaze or slip onto the piece. Depending on how liquid the substance is, it will flow or drip until the clay—unfired—has absorbed the water. Marbling effects can be achieved by turning the wheel faster or slower, by painting with a brush or a feather, or also by combing.

Whereas these simple methods of decoration were used only in certain regions, painting with the quill was generally widespread. Originally a cowhorn "paint pot" was used, into the point of which was fitted a goosefeather quill. Later, little earthenware pots, varying in appearance according to their region, were used, with a quill pen fitted into the drainage hole. The diameter of the quill opening determined the thickness of the strokes. The "paint" was the so-called *Schlicker* (from the Low German *Schlick,* or "ooze"), a mixture of liquid clay colored with metallic-oxide like slip—a substance sufficiently liquid to flow out of the quill at an even speed and not too quickly, so that one could write with it or spread it over a surface. For each color a different quill was used and thus one could "paint" with various colors. Occasionally a brush was used for painting; this was rare in the case of earthenware, but the general rule with faience.

A limited number of metal oxides were used to produce these colors, as only a few could withstand the required firing temperature. Pyrolusite (manganese dioxide) was used for liver-brown to dark-brown; rust (iron oxide) for reddish-brown; verdigris (copper acetate), converted to copper oxide, for green; stibnite (antimonious sulphide), converted to antimony oxide, for bright yellow; and either tin ashes or a white clay ("pipe clay") for white. Although cobalt oxide would produce blue, it was rarely used in Europe because it was expensive and in short supply. During firing, it was always important to provide an adequate supply of oxygen so that the oxides would not be transformed back into metals and thereby blacken the surface they were intended to color.

The potter himself was responsible for the preparation of the oxides, which he would grind, mix with clay, and then grind once more in the glaze mill. Oxides could be added to the slip either singly or in combination with other oxides, and the color intensity could be adjusted by varying the proportion of oxide in the slip.

As glazes were expensive, they were used sparingly. Thus, in contrast to the more expensive faience produced for well-to-do customers, the areas of earthenware pieces which were not directly visible customarily were left unglazed. In many cases the edges of dishes also were left unglazed; they could then be stacked in the kiln in pairs, edge to edge or base to base, without sticking to each other.

Another method of sealing earthenware, other than by glazing, is by smoking. Towards the end of firing, damp twigs are added. These produce tarry substances which settle on the fired piece, seal it, and color it black. Further blackening occurs when the smoking process, by partly shutting off the air supply, causes a reduction in the firing. Before the introduction of glazing, this procedure was commonplace. In North Germany the Jüte pots were fired in this way; these pots were hand formed in the old manner, without a potter's wheel, and were exported in large quantities from West Jutland, on the Danish west coast bordering on Schleswig-Holstein. The smoking method remained popular for the production of vinegar jars because of the sensitivity of lead glaze to acid.

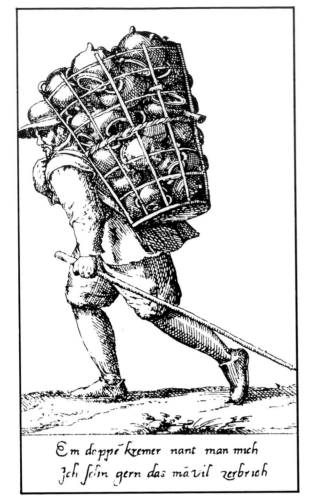

Fig. 2. Pottery Seller on the Streets of Cologne, with Rhenish Pottery in a Pannier
Etching from *Street cries in Cologne* by Franz Hogenberg (ca. 1540-1590), published in Cologne, 1584 Translation of the text: "They call me a pottery seller; I like to see lots of pots being broken."

Fig. 3. Seller of Crockery on the Streets of Hamburg, with Dresden Pottery in a Pannier
Etching from the *Hamburg street cries* of the brothers Christoffer and Cornelius Suhr (1771-1842 and 1781-1857), published in Hamburg 1806-1808

Faience and Stoneware

The same basic material is used to make faience as is used for earthenware, but it is covered with a tin rather than a lead glaze, which is not applied until after the first firing. Colors similar in composition to the glaze itself can then be painted onto the glaze with a brush; when the piece is fired a second time, these sink into the glaze and are firmly fused with it. The firing temperatures are the same as for earthenware.

For stoneware, on the other hand, much rarer clays are required, as they must withstand temperatures of up to 1400° C and over without softening or collapsing during firing. At these high temperatures the clay "sinters," or vitrifies, becoming dense like glass and hence impervious to water. To improve the appearance of stoneware one can apply a salt glaze by shovelling salt into the kiln; the salt evaporates and produces a chemical reaction with the white-hot surface of the piece, causing the formation of a thin layer of natrium glass. Clay glazes can also be produced in this way. In its clay body, stoneware resembles porcelain, which can be regarded as stoneware made from a particularly pure white firing material, namely, kaolin.

Producers and Purchasers

One frequently refers to earthenware as "peasant pottery," but this term is completely misleading and should be avoided. Only in rare instances, such as the case of the Jüte pots, were the producers peasants; the majority, since the Middle Ages at any rate, were trained

craftsmen with a seven-year apprenticeship behind them who had, in accordance with the regulation, completed their years of travel. They lived in larger, centrally situated villages and towns and supplied urban dwellers and peasants alike with their everyday domestic pottery. Of course, they frequently did a little farming on the side to assure their livelihood, for potterymaking was often poorly paid.

In order to increase sales, many pottery wares were not only traded on the nearby markets but were also peddled over long distances—sometimes by the potter himself, but more often by special traders (Figs. 2,3). They were transported on foot in a pannier; or, carefully packed in straw, on a dog- or horse-drawn cart or by ship. Earthenware traded over such a wide area included the decorated Wanfried ceramics from eastern Hesse, which at the end of the 16th and beginning of the 17th century were exported to the Netherlands, England and Denmark; the decorated wares from Marburg from the northwest of Hesse, which were exported as far as Denmark in the first half of the 19th century; and also the quite simple everyday Jüte pots, which until after the middle of the 19th century were sold from West Jutland as far as the Lüneburg Heath and the region of Lauenburg.

Altogether, there was a tremendous demand for ceramics—particularly for standard crockery, which, to the delight of the potter, was continually being broken. For instance, in the little Dithmarschen town of Wesselburen, which towards the end of the 18th century had barely 1500 inhabitants, about six cartloads of crockery were used per year. Even if this crockery was distributed over the whole parish, with its roughly 5000 inhabitants, this is still an enormous quantity (see Schlee, 1939).

Normal standard crockery was used by the urban upper classes as well as by the country laborers; the only differences were in the quantity and variety of the crockery, depending upon the type of household. But this was not the case with decorative crockery. This was purchased mainly by rich farmers and the well-to-do petit bourgeoisie of the little country towns; whereas the urban upper classes preferred metal utensils, faience, and sometimes also glass as status symbols. In contrast to standard everyday crockery, decorative ware was always carefully treated, seldom or never used, and handed down from generation to generation.

It is remarkable that in North Germany the craft of pottery had its great upswing only in the 18th century, and in many areas not until the second half. In the course of a booming and expanding agricultural economy, it was only in this latter period that the rural population began to change over in any appreciable measure from wooden to ceramic crockery and utensils. With the increasing demand for milk, more and more vessels were required—in particular, colanders and dishes for separating cream—and here earthenware began to take the place of wooden utensils. Pottery-making was dealt a severe blow when, in the last third of the 19th century, milk processing was largely taken over by dairies, which often operated on a cooperative basis. This meant that milk dishes in the individual farms became superfluous.

Regions of Origin

As was mentioned earlier, our knowledge of the exact provenance of earthenware is still very scanty. In the case of standard everyday ware, the only thing that helps us is a record of the last place of use, as these pieces show a great similarity regardless of where they were found. This similarity is due to the fact that the traditions of the various craftsmen were spread by their apprentices and by wandering journeymen. Shard refuse pits are always a lucky find. It was into these that the potters used to throw faultily fired and broken pieces, if they did not use them for paving the local paths. Provided such deposits are undisturbed, one can occasionally find there pieces that are almost complete, although distorted by overfiring. Had they been used, most would long since have been broken and would never have survived in their present whole state. Thus it can happen that one suddenly finds pottery wares from a district hitherto unknown as a potential pottery center (Fig. 4).

Geologically speaking, the production of earthenware was possible almost everywhere in North Germany, except for purely moorland areas. Almost more important was the availability of adequate supplies of fuel, either wood or peat. Good trade routes were also essential.

In those regions where customers were prosperous, the rise in the production of earthenware crockery was accompanied by a rise in the production of decorative ware. In

poorer regions, however, one could hardly expect to find decorative ware on any worthwhile scale: this applies, firstly, to the extensive sandy areas *(geest)* often studded with heathland, to the great stretches of moorland, and particularly to remote districts; and, secondly, to areas with large-scale farming on the estates of nobles. Here the peasants would not have been able to afford large sums for decorative crockery, and the nobility seem to have preferred to use utensils of metal (silver and pewter), faience and, later, porcelain instead of decorative crockery (although they did use large quantities of standard ware for their milk vessels).

In contrast, certain districts were particularly well known for the production of decorative ware. Although we cannot fully explain why production was especially intensive at some places and in some districts, in each case there appears to be a number of explanations, and obviously one single factor does not suffice. A deposit of clay, of as pure a quality as possible and in sufficient quantity to insure production for decades or centuries, is as important for highly developed pottery production as good trade routes are for sales over a wide area. Also useful is a wealthy clientele, one which not only requires a large quantity of standard ware but has also developed a feeling for work of quality and a certain sense of social

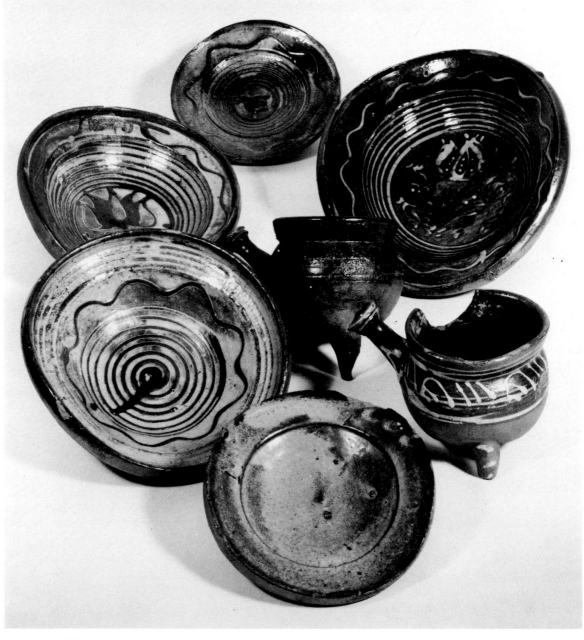

Fig. 4. Faultily Fired Pots from a Shard Pit of an Unknown Pottery in the Town of Uetersen/Schleswig-Holstein: dishes, plates and handled pots in lead-glazed earthenware ca. 1850/60 (Altonaer Museum in Hamburg, Inventory No. 1969/439)

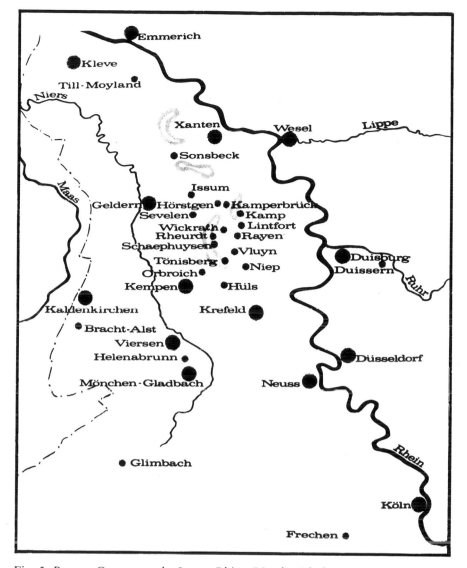

Fig. 5. Pottery Centers on the Lower Rhine (Map by Scholten-Neess/Jüttner, p. 8)

status. A growing awareness and appreciation of the tastes of a more affluent social class often leads to imitation, as occurred on the Lower Elbe or in Dithmarschen or the Probstei near Kiel, where the farmers attempted to copy some of the customs and habits of the neighboring nobility. Lastly, the pressure of competition from foreign wares would probably not be as great in some areas as it apparently was in East Frisia and—to a lesser extent—some parts of North Frisia, which imported Netherlandish faience.

Hence certain regions can be singled out as important centers for decorative crockery and tableware: the area on the Lower Rhine, northwest of Cologne (see map, Fig. 5), where the pottery centers and many workshops are relatively well known in comparison with other districts; the Altes Land, northwest of Hamburg, about whose pottery centers and workshops virtually nothing is known; the Probstei, northeast of Kiel, where it is not known which was the most important pottery center—the village of Schönberg, the little town of Preetz, or the town of Lütjenburg to the east, for here, too, nothing is known of any workshops (and, with one exception, no connection can be established between surviving ceramic ware and the records of potters in archives); the districts of Norderdithmarschen and Suderdithmarschen, in which the better class pottery appears to be concentrated in the village of Tellingstedt or the villages of Windbergen and Burg; and finally, an area around Flensburg, on both sides of the present-day German-Danish frontier, in existence since 1920, where it is possible that the towns of Flensburg and Hadersleben (now in Denmark) are the centers for the pottery craft. The descriptions of the pieces shown in this exhibition are an attempt to elaborate the characteristic features of the wares produced in the individual regions or districts.

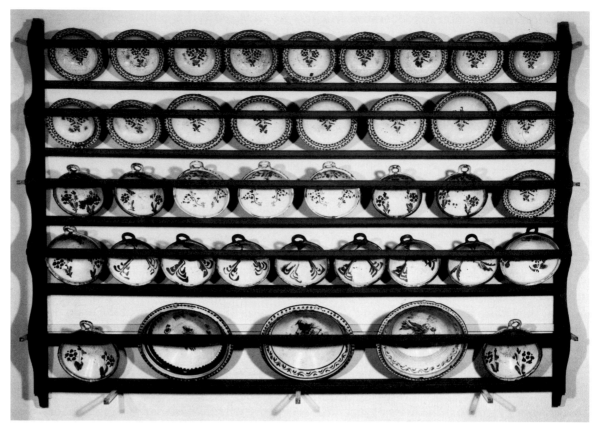

Fig. 7. Shelf with dishes and plates of lead-glazed earthenware, probably from a pottery in Lütjenburg/ East Holstein, middle of the 19th century. Trousseau from a farm in Dannau near Lütjenburg (Schleswig-Holsteinisches Landesmuseum, Schleswig, Inventory No. 1967/1—39)

Hence by the second half of the 18th century services or sets of crockery were being made and bought as part of a bride's dowry (Fig. 7).

One cannot overemphasize how closely the most important events in life, such as marriages or christenings, were linked with decorative crockery. The designs and inscriptions on the individual pieces point to this close connection. For example, many pieces reflect the obvious expectation that a wedding will be followed by a lot of children, who were necessary to maintain the succession and the work force both on the farm and in the craftsman's workshop. The importance of this idea is indicated in many inscriptions, pictures and decorations.

Inscriptions and Pictorial Representations

Inscriptions, whether of a secular or religious nature, nearly always appear in the scholarly High German rather than the Low German which was spoken everywhere. They were usually taken from the Bible, hymnbooks and prayer books, folk songs, or well-known expressions and rhymes. They were frequently passed from region to region, so that local idioms seldom give a clue to a piece's provenance. As potters and potters' journeymen in the 18th century were often unable to read or were little practiced in reading, inscriptions are easily misunderstood, either through being wrongly copied or because mistakes have gone undetected.

The pictorial representations are almost exclusively taken from designs transmitted by itinerant potters and based upon drawings and other graphic art, whose origins were no doubt largely the same for North and South Germany. Curiously enough, the designs frequently depict people of the 18th century in a secular context, very often fashionably dressed persons of rank. Peasants and craftsmen are portrayed to a far lesser extent—more on the Lower Rhine than elsewhere, and there not until the 19th century, at which time graphic art began to depict peasants and craftsmen, in costumes, on prints and on posters. But the primary inspiration was

those much admired pictures of fashionably dressed persons of rank which could be obtained cheaply as prints on picture-sheets, on the pages of calendars, and even on local maps and atlases. That there were considerable differences in rank between the people depicted on the decorated tableware and the farmers using it did not disturb the latter, for this was tableware used for festive occasions, at a time when no popular revolutionary mood existed.

The End of Traditional Earthenware

With a few exceptions, the end of the 19th century saw the death in North Germany of the traditional craft of pottery. Changes in the household, the availability of cheap industrial wares in enamel, stoneware and porcelain, and the taking over of milk processing by creameries had all robbed the potter of his means of existence. The few pottery workshops which survived adapted their wares to meet changing production and marketing conditions of artistic ceramics. Traditional earthenware survived only in a few southern regions of Germany, where it is now flourishing once more due to the tourist trade. But everywhere in North Germany traditional earthenware has been replaced by artistic ceramics, largely of the stoneware type, that are produced for a completely different clientele.

GERHARD KAUFMANN

Catalogue

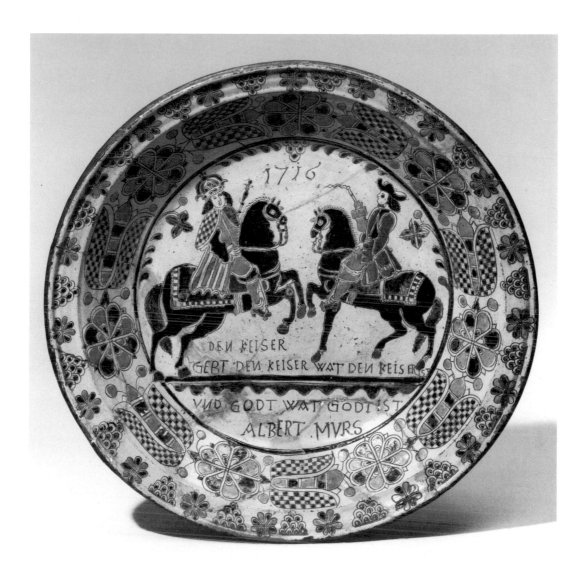

1.
Dish
Rayen (northwest of Duisburg), dated 1716
Lead-glazed earthenware; red clay, light-yellow slip, painted in dark brown, reddish-brown, green, light-yellow, sgraffito, slip in parts roughened and refined to the base
Diameter 59.5 cm., Height 10 cm.
Niederrheinisches Museum Duisburg, Inventory No. A 297

The dish, a decorative piece and not for everyday use, is made with a broad wall and small flat border, ending with a flange at the rim. Portrayed on the base are two riders in contemporary costume galloping towards each other: on the left, the Emperor with crown and scepter, on the right, a subject with a whip. The wall is decorated with rosettes and tulips, the border with rosettes and grapes. Over the picture is the date *1716*, and below, the inscription: *DEN KEISER | GEBT DEN KEISER WAT DEN KEISER IST | VND GODT WAT GODT IST | ALBERT MVRS.* (Render to Caesar the things that are Caesar's, and to God the things that are God's). Included is the potter's signature. The Murs are the oldest known Rayen potter family, with records dating from 1667. Their descendants remained active until the late 19th century. Several dishes of the eldest Albert Murs are still in existence, three of which date from the year 1716.

Typical of his work is the chess-board pattern of the tulip leaves and the clothing. Other potters in Rayen then adopted these patterns. The same applied to the galloping riders, a particular preference of the Murs family.

The picture refers to the parable of the penny, in St. Mark's Gospel (chap. 12, verse 17). The Christians' recognition of ecclesiastical as well as secular power is often expressed on Lower Rhenish dishes in the form of two riders galloping towards each other, with slightly varying inscriptions. By the Emperor (Kaiser) is always meant the sovereign ruler, in this case the King of Prussia, to which Rayen, in the former Duchy of Geldern, had belonged since 1713.

Literature: Scholten-Neess/Jüttner, p. 334, no. 382 (which provides further bibliographical references)

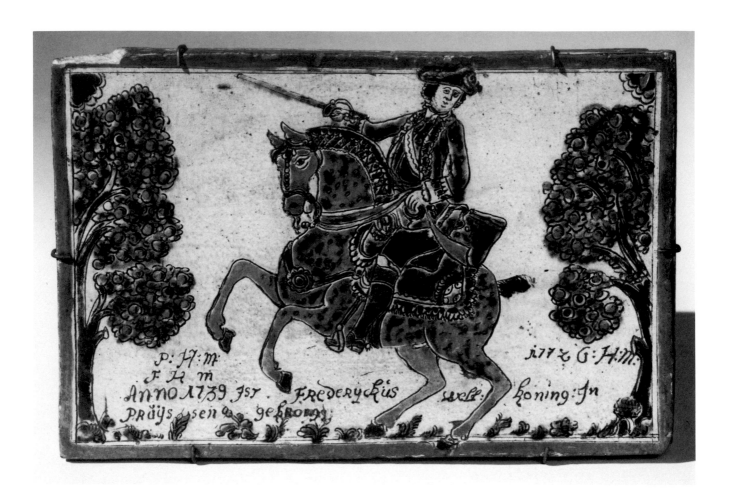

2.

Wall Tile

Rayen (west of Duisburg), dated 1772

Lead-glazed earthenware; red clay, light-yellow slip, painted in light-yellow and different browns and greens, sgraffito

Height 21 cm., Width 31 cm., Thickness 1.7 cm.

Niederrheinisches Museum Duisburg, Inventory No. A 2490

Here, portrayed between two trees, a galloping rider with raised saber—according to the inscription it is apparently the Prussian King, Frederick the Great (1740-1786)—with the inscription: *P:H:M:* / *FHM* / *Anno 1739 IST FRedeRyckus—well:- koning: IN* / *PRVYSSEN gek-Rongg.* / *1772 G:H:M:* (In the year 1739 Frederick was crowned King of Prussia). The quarter rosettes in the corners are patterned on Netherlandish tiles.

A counterpart with the name Petrus Half (see here the initials *PHM*), with the same initials *FHM* and *GHM* of other family members, including the wife, and the same year 1772, shows a galloping hussar with a drawn sword. The letter *M* might thus be connected with a farm or a village. The reference to the Prussian King, Frederick the Great, is not surprising, for on the Lower Rhine the Duchies of Cleves and Geldern as well as the immediate surroundings of Krefeld belonged to Prussia. The population in general was deeply interested in the great figures who in the 17th and 18th centuries almost turned Lower Rhenish territory into a permanent theatre of war, particularly between Prussia, Austria and France. This interest was characterized by admiration, reverence and by alternate sympathy or horror. The mistake of one year in the date of the Prussian King's coronation can be explained by the fact that written records of historical events were often not available to potters or those who commissioned them. For use see no. 9.

Literature: Scholten-Neess/Jüttner, p. 330, no. 359, fig. 287.

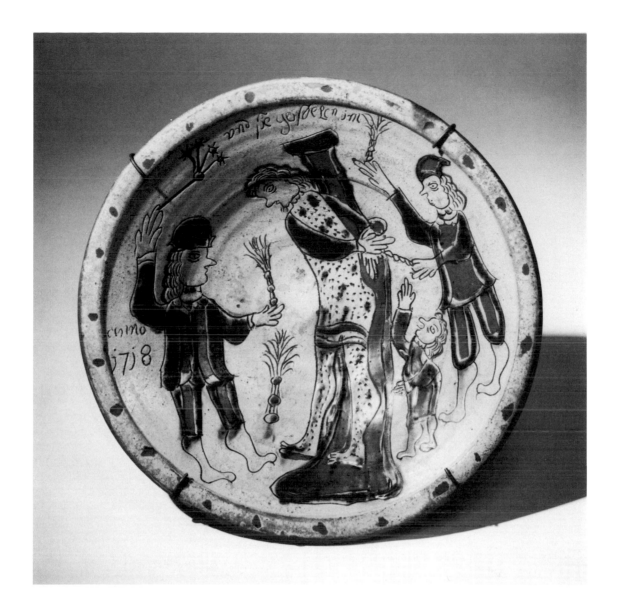

3.
Dish
Tönisberg (west of Duisburg, north of Krefeld), dated
 1718
Lead-glazed earthenware; red clay, sulphur-yellow slip,
 painted in ochre-brown and green, sgrafitto, slip in
 parts roughened and refined to the base
Diameter 34.5 cm., Height 7 cm.
Niederrheinisches Museum Duisburg, Inventory No. A
 364

The edge is shaped as a flat flange with notched dots. The scourging of Christ is portrayed. All figures are shown in profile or half-profile: Christ in the center at the stake; three henchmen, a large one, left, and a large and a small one, right. Above, the inscription: *vnd se geisselen im* (and they scourged him); also left: *anno 1718*.

In addition to the less lavishly decorated standard tableware to be found everywhere in Tönisberg, large numbers of richly ornamented pieces were produced; these can be distinguished from the usual Lower Rhenish showpiece dishes by their more primitive or rather more naive representations, smaller size and unusual profile. This dish, which cannot be attributed to any particular workshop, is one of them. The form is bowl-shaped, without the usual division into three parts—center, slanting wall

and border. Base and wall merge into one another and end up in the above mentioned flange with deep incisions, painted mostly ochre-brown to brick-red.

Pictures of Christ's Passion belonged to the usual canon of religious themes on dishes, tiles and wall tiles, beginning with Christ's entry into Jerusalem, and including the Last Supper, Jesus in the Garden of Gethsemane, the scourging, the crowning with thorns, the various Stations of the Cross and finally the Crucifixion itself. Customers were, above all, Catholics in an area of mixed confessions. Here the Catholic Church's love of pictures and display found an echo in contrast to the Reformed Church's iconclastic attitude.

Literature: Scholten-Neess/Jüttner, p. 414, no. 834, fig. 219.

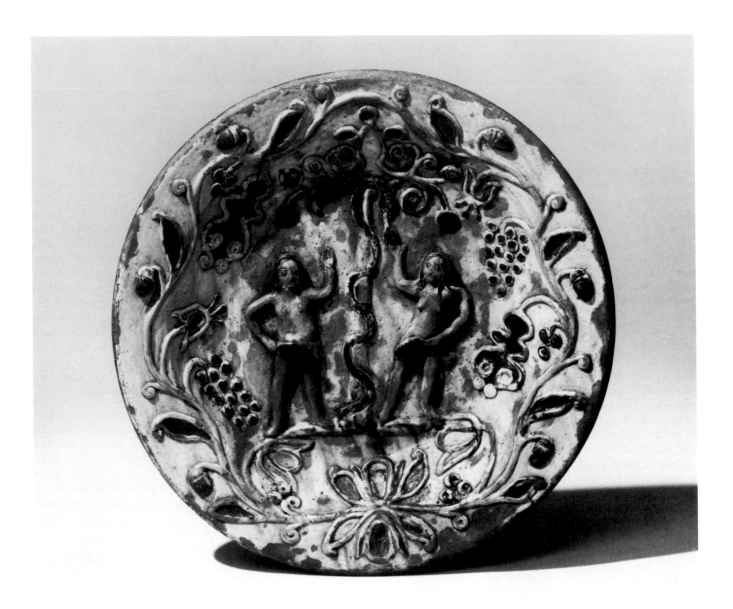

6.

Dish

Issum (northwest of Duisburg), 2nd half of the 18th
 century

Lead-glazed earthenware; red clay, decoration in strong
 relief, light-yellow slip, painted in dark-brown,
 reddish-brown, dark and light-green

Diameter 48 cm., Height 6.5 cm.

Niederrheinisches Museum Duisburg, Inventory No. A
 380

Portrayed is the Fall, with Adam and Eve under the Tree
of Knowledge, the top of which is purely ornamental. On
the wall is a tendril with flowers, leaves, acorns and large,
fantastic fruits rising left and right out of a leaf scroll.

Dishes with relief decor were a speciality of the Issum
potters, apparently originating from the works of the
potter, Jan Hendrick Andrae, records of whom exist in
the archives between 1756 and 1770. From Andrae
himself only relief dishes survive; on these religious
themes predominate, and the type of figurative repre-
sentation extends from low relief to almost complete
sculpture.

Both a Catholic and a Reformed population lived in the
area of Issum. Jan Hendrick Andrae was himself of the
Catholic faith but naturally worked also for clients of the
Reformed denomination. The pieces depicting religious
subjects, even if not expressly connected with a particular
confession, were designed more for the Catholic popula-
tion because of the iconoclastic attitude of the Reformed
Church.

All the known Issum relief dishes, regardless of the
workshop they came from, display a strong formal
relationship. Obviously, they were not meant for daily
use but were purely decorative pieces.

Literature: Scholten-Neess/Jüttner, p. 322, no. 318.

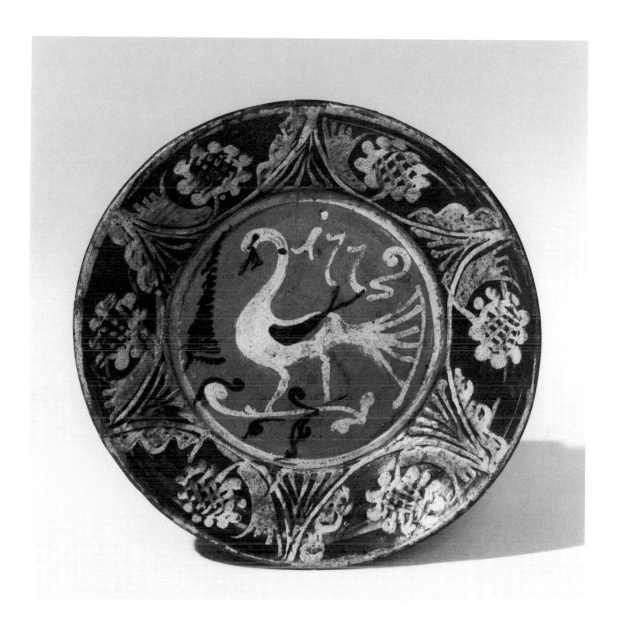

7.
Dish

Lower Rhine (no fixed location), dated 1773
Lead-glazed earthenware; red clay, ochre-brown and
 dark-brown slip, painted in light-yellow, light-green
 and dark-brown
Diameter 38.5 cm., Height 6.2 cm.
Niederrheinisches Museum Duisburg, Inventory No. A
 2762

In the circle under the date, a large bird is depicted in the slightly curved, ochre-brown center. It is light-yellow with a touch of dark-brown for accentuation. From its spreading tail it would appear to be a peacock, although its neck is more like that of a swan. The slanting wall with the slightly thickened rim is vivaciously decorated on a dark-brown background in light yellow and green with six circular arcs opening outwards. The arcs are heavily hatched so that all six together appear like the points of a star, while on their outsides, both right and left, are attached diversely stylized leaves, the left in each case flat

and linked with a rosette which fills out the circular arc. This type of decoration is strongly reminiscent of Netherlandish, and in particular Frisian faience prototypes, even if at first glance the completely different coloration differentiates the dish from the latter.

The dish is a piece of better crockery for everyday use. It is indeed richly painted but is far from being treated with that care normally accorded to the showpiece dishes. On the other hand, the decoration owes its charm to the lively and lighthearted application of slip from the quill.

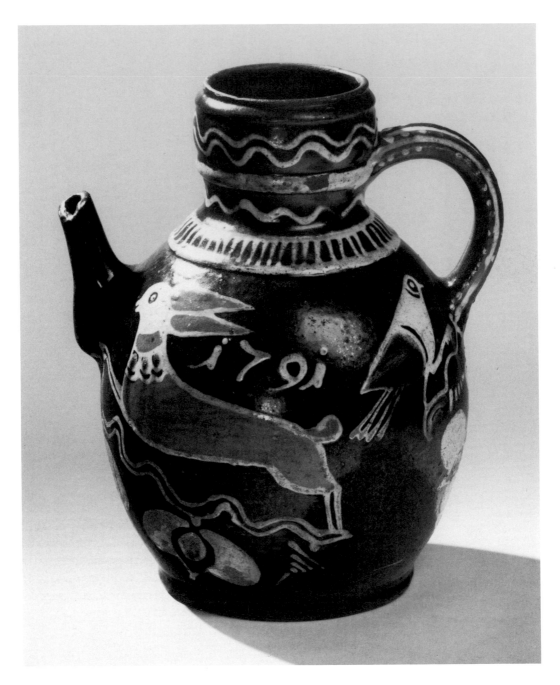

8.
Pot
Schaephuysen area (west of Duisburg), dated 1791
Lead-glazed earthenware; red clay, dark-brown slip,
 painted in yellow, brown, green
Height 30 cm., Diameter 20 cm., at base 14 cm.
Niederrheinisches Museum Duisburg, Inventory No. A
 331

The pot, with spout and handle, not very extensive foot and a rather pinched in neck, is decorated on the neck with wavy lines and a lattice pattern, and on both sides of the belly fairly symmetrically with hares, birds and flowers. The outline of the figures is yellow throughout. The interior surface of the hares is brown and a little green, with dark-brown collar and eyes; the birds are green and dark-brown. The date is divided over the two sides and reads: *Anno / 1791.*

A reddish-brown to dark-brown slip is characteristic of Schaephuysen work. This shade of color is achieved by

adding pulverized manganese dioxide to the slip. Schaephuysen work is also distinguished by the particularly bright sheen of the lead glazing, acquired by applying it more thickly.

The pot is an example of simple standard ware for the decoration of which, however, Schaephuysen potters used scarcely less imagination and care than for decorative pots.

Literature: Scholten-Neess/Jüttner, p. 376, no. 627, fig. 431.

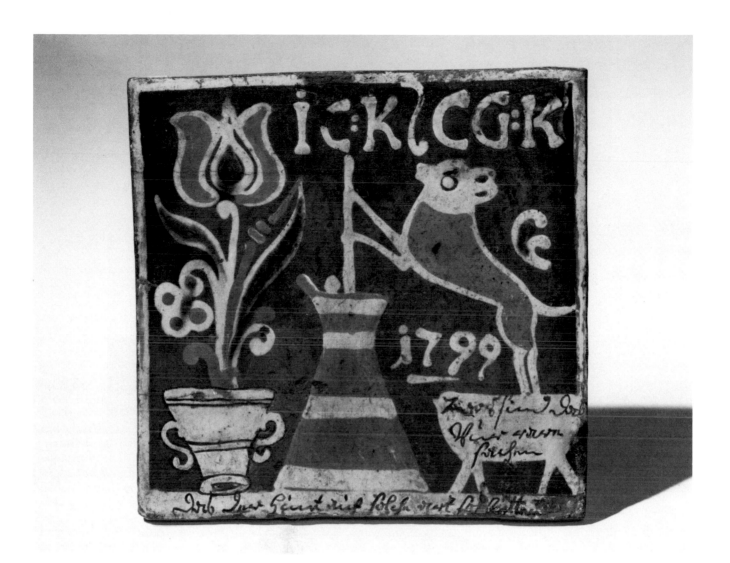

9.
Wall Tile
Schaephuysen (west of Duisburg), the workshop of
 Gerrit Evers, dated 1799
Lead-glazed earthenware; reddish clay, reddish-brown
 slip, painted in light-yellow, ochre, green, light and
 dark-brown, sgraffito partially applied
Height 19.5 cm., Width 20 cm., Thickness 1.3 cm.
Niederrheinisches Museum Duisburg, Inventory No. A
 337

The tile shows a tulip in a flowerpot and, next to it, a dog
standing on a table or a kneading trough and making
butter in a churn. Also appearing are the initials *IC:
K | CG:K*, the date *1799*, and the text written in German
(Gothic) lettering: *Was sind das | Vür rare | sachen | das
der Hunt auf solche art sol butten* (What an odd thing for
the dog to make butter in this way).

There is an exact counterpart to this tile, with the same
initials and the same date; the text: *das ich armer Hunt
mus hier arbeiten | Vür die anderen ihren mund* (That I,
poor dog must work here to feed the others), appears
below a dog which is acting as cook and stirring a pot over
an open fire. On both tiles, as with the jug (no. 8), the
outlines of the figures are heavily accentuated so that the
inner surfaces can have a similar color to the background.

Such tiles were used on the Netherlandish pattern for
lining an open fireplace or for decorating its surround-

ings. The Lower Rhenish house belongs, in type, to the
Lower German "hall house," which has a large open
chimney-shaped hearth at the end of the hall up against
the row of chambers. This was the place for both cooking
and keeping warm; the space in front of it served not only
as a kitchen but also a living and communal center. The
picture of a dog cooking or making butter is thus very
suitable at such a spot. It also continues the tradition of
the pictures of the "topsy-turvy world" so popular in the
Middle Ages. (The "topsy-turvy world" was also in-
tended to show the confusion that would arise without
the directing and creative power of God.) The representa-
tion also draws attention to the often thankless role of the
housewife who worked there.

Literature: Scholten-Neess/Jüttner, p. 356, no. 500, fig.
305; Kaufmann pp. 82-83, 204-209.

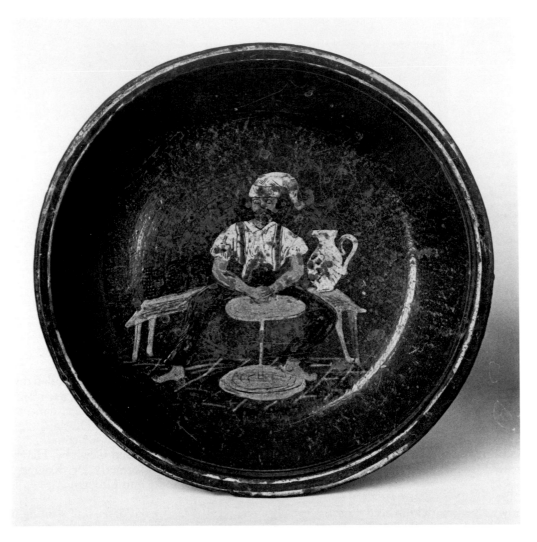

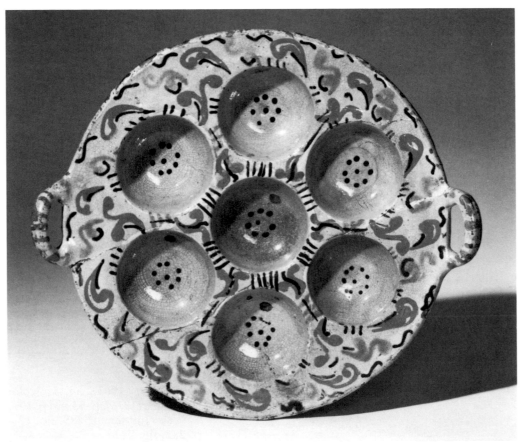

12.
Dish

Frechen (southwest of Cologne) (?), 1st half of 19th
 century
Lead-glazed earthenware; reddish-brown clay, reddish-
 brown slip, painted in yellow, green, dark and light-
 brown, white
Diameter 36.7 cm., Height 6.5 cm.
Museum für Kunst und Gewerbe, Hamburg, Inventory
 No. 1964.247 (formerly Dr. Konrad Strauss Collec-
 tion, Munich)

From a large, flat, clearly defined base rises a relatively
steep wall, without any special border; the rim is rather
angular and flanged. The form is fairly typical for
Frechen, and the dark coloring, compared with the
cream-colored slip of other pieces, is less common but
does occur. Typical for Frechen is the genre-like form of
representation, without sgraffito. Here a potter is shown,
in shirt sleeves and stocking cap, sitting at his wheel,
which he keeps in motion with his left foot. He is shaping
pots, three of which he has finished and put on his left,
while a water jug stands on his right. The paint has been
applied in a perfectly naturalist manner; bench and wheel
appear yellow, arms and face light-brown, the trousers
green, shirt and cap white and the pots dark-brown. In
contrast to older representations of potters on Lower
Rhenish ceramics, this one is wearing the long trousers
that had become customary during the French Revolu-
tion instead of the hitherto usual knee-breeches. As the
weather is apparently warm, he is wearing a linen shirt
with rolled up sleeves, without the button-through coat
generally depicted; he has retained his stocking cap.

Frechen, as the southernmost pottery center, has the
oldest tradition in the Lower Rhenish area. Because of its
enormous clay deposits, the largest in Germany, clay was
already being worked here in Roman times. From the
16th to the 18th century the place achieved its prime with
the production of the famous Frechen stoneware (includ-
ing Bartmann jugs). But alongside stoneware, there also
existed an earthenware production which experienced its
peak from the middle of the 18th to the middle of the 19th
century.

Literature: Jedding (1963), no. 33, fig. 18; Jedding
(1976), p. 13.

13.
Baking Mold for Pancakes *(Bollebäuskes)*

Frechen (southwest of Cologne), end of 18th/beginning
 of 19th century
Lead-glazed earthenware, red clay, cream-colored slip,
 painted in ochre, light-green, dark-brown
Diameter 32.5 cm., Height 4 cm.
Niederrheinisches Museum Duisburg, Inventory No. A
 368

Six calotte-shaped hollows are grouped around a seventh
in the middle. The mold has two handles at the side,
opposite one another.

Such molds, depending on the district, were also known
as *Ochsenaugenpfannen* (ox-eye pans) or *Förtchen*
molds, and in the 19th century were mostly replaced by
molds of cast-iron lined with enamel. They were used for
baking a special sort of pancake of slightly-beaten yeast
dough, prepared differently in various districts and eaten
at Christmas and New Year. These pancakes were known
on the Lower Rhine as *Bollebäusken* and in northern
Lower Saxony and Schleswig-Holstein as *Förtchen* or
Pförtchen. Today this festive dish has been largely
replaced by the Berlin pancakes with a jam filling made by
the bakeries from a similar but more solid dough; they are
known for short as *Berliner* (see also nos. 80-82).

Literature: Scholten-Neess/Jüttner, p. 299, no. 187, fig.
418.

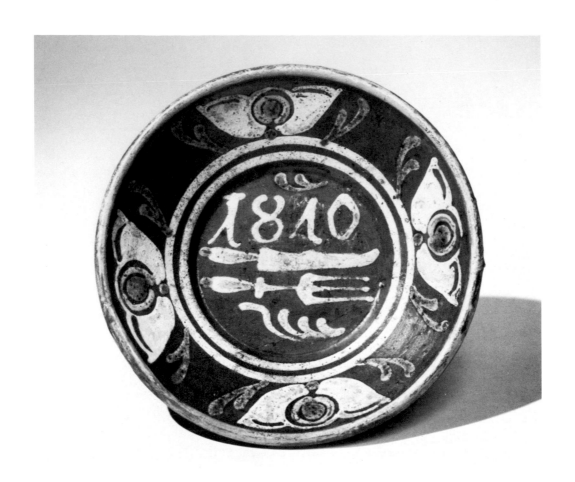

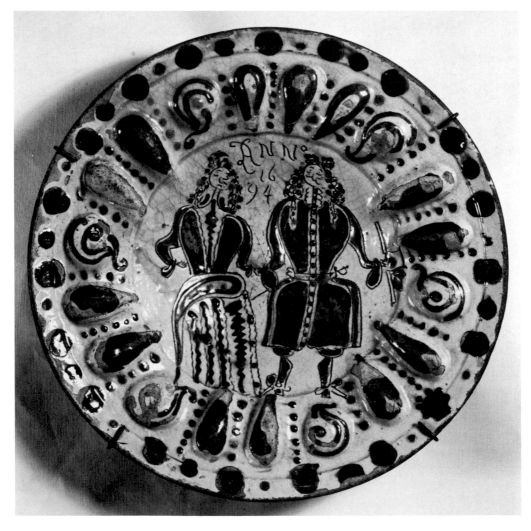

14.
Dish

Lower Rhine (no fixed location), dated 1810
Lead-glazed earthenware; red clay, brown slip, painted in light-yellow, dark-yellow and light-green
Diameter 20 cm., Height 4.2 cm.
Niederrheinisches Museum Duisburg, Inventory No. 2501

From a slightly curved base, a relatively wide wall slants up and ends in a thickened, flanged rim. Over the horizontal representation of knife and fork, the center bears the date *1810*. Above this a smaller, and below it a larger, stylized leafy branch. The wall is separated from the center by two painted lines which appear from above to be circles. Out of the upper line grow four broad flowers resembling butterflies, with leaves at the side. Such flowers developed by stylization and unconscious refinement out of what were originally tulips.

Little dishes of this sort were also known as *Kummen* (bowls). Although attractively decorated, they were not ornamental pieces but better crockery for everyday use.

At the time this piece was made, knives and forks were still objects of special value in the country, rather different from spoons. They could be very valuable when made of silver, and in this form usually came into the owner's possession as christening or wedding presents. For daily use they were replaced by wooden spoons. Every adult had his own knife and fork, which he had to take with him when eating out—for instance at weddings, christenings or funerals. He could not, as we now do, expect his hosts to provide a table laid with cutlery. Whole sets of cutlery of twelve or more matching knives, forks, spoons and teaspoons for a festive meal were usual only amongst the well-to-do bourgeoisie and the nobility.

15.
Embossed Dish (*Buckelschüssel*)

Altes Land (on the left bank of the Elbe southwest of Hamburg), dated 1694
Lead-glazed earthenware; reddish-brown clay, yellowish-white slip, in parts green due to the glaze; painted in light and dark brown, green, sgraffito
Diameter 31.8 cm., Height 9 cm.
Museum für Kunst und Gewerbe, Hamburg, Inventory No. 1888.416

The dish is deep and has a sloping border which is heightened by two pointed oval bosses and one round boss. The edge is thickened below and above, pinched into a wavy line.

In the center, under the date *ANNO | 16 | 94,* there is a frontal view of a couple standing hand in hand, dressed in the latest fashion: the man in a tailored, close-fitting jerkin with full-bottomed wig, buckled shoes, wearing a sword and carrying a stick; the woman apparently in a manteau over a richly decorated garment which, from the front, can be recognized as a vertically striped skirt. The picture is not quite correct in detail, indicating that the potter himself was relatively unacquainted with such fashionable clothing.

According to the previous owner, the dish was acquired in the Altes Land. Although to date it has not been possible to ascribe it to a particular place, let alone to a particular workshop, there is no doubt that such dishes were also made in the Altes Land. The examples of this type that have survived and been guaranteed date between 1691 and 1742. The form, with its embossed edge, follows the style of works in metal—christening bowls, dishes and plates for display of chased copper or brass. These were, under strong Dutch influence, the fashion in North Germany in the 17th century. Prototypes can be found in Dutch majolica of the early 17th century with actual or painted bosses. These, however, were also made from chased metal molds. There exist known examples of embossed dishes in earthenware from the Westphalian pottery center of Ochtrup and also individual dishes from the former Grand Duchy of Oldenburg.

In Altes Land these dishes were known as wedding dishes. It is quite certain that they were decorative pieces, made to be given as wedding presents or used on festive occasions. The distinguished appearance of the couple portrayed is not in any way a contradiction in such a rural milieu. In the Altes Land, a fertile marshy district with a rich, independent peasantry and a relatively free constitution, the elected counts and captains were the equal of the knightly class in both power and affluence. They dressed themselves in this manner, and rich peasants could quite easily afford dishes of this sort.

Literature: *Mit Drehscheibe und Malhorn,* no. 109; *Folklig Konst,* no. 43; Jedding (1976), p. 21, fig. 1; p. 87, no. 1; Schlee (1978), p. 158, fig. 254; pp. 174, 283-284.

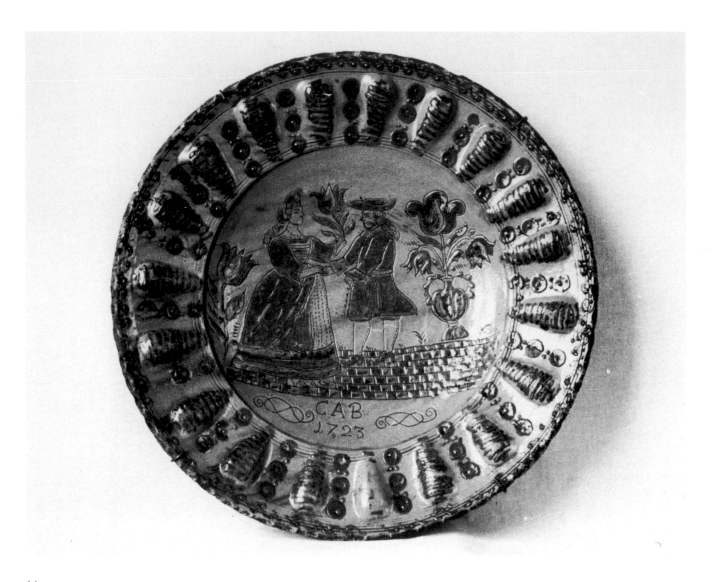

16.

Embossed Dish *(Buckelschüssel)*

Altes Land (on the left bank of the Elbe southwest of
 Hamburg), dated 1723

Lead-glazed earthenware; reddish-brown clay, yellow
 slip, in parts green due to the glazing, painted in
 light-brown and green, sgraffito

Diameter 49.5 cm., Height 5 cm.

Museum für Kunst und Gewerbe, Hamburg, Inventory
 No. 1896.37

The large dish is shallow, with a wide, sloping border,
heightened with pointed oval bosses. The edge is thick-
ened below and is grooved on top. The bosses, shaded in
green, are heavily marked by brown lines; between them
are circular discs in groups of three, painted brown, with
little dots attached.

The center shows a couple facing each other in profile, on
a tiled floor; the woman is giving the man a tulip. On
either side of the couple there are more tulips: a single one
on the left; on the right a so called triple tulip in a vase
with handles. The clothes are the same as on the 1694
dish, only a little more in the Regency style. The hooped
skirt under the mantle is wider, shorter—the shoes can be
seen—and has a hem with three rows of frills. The woman
is wearing a lace bonnet and the man a tricorn. That the
couple are wealthy but not persons of rank can be seen
from the fact that, although the clothing is elegant, the

lady's dress is without the (longer or shorter) train that
signifies rank, and the man is without a sword. Under the
picture are the initials *CAB* with the date *1723*.

The dish was acquired in Lamstedt near Bremervörde.
The district around Lamstedt, west of the Altes Land, has
better soil than the moor and heathland of the surround-
ings. This meant more well-to-do peasants lived there and
they could afford to buy silver ornaments for their
costumes in the suburbs of the Altes Land such as Stade
and Horneburg. So, this dish may have been bought there
or have come from the Altes Land to Lamstedt as part of a
dowry.

Literature: *Mit Drehscheibe und Malhorn*, no. 110, fig.
11; Meyer-Heisig, fig. 22; *Folklig Konst*, no. 44; Jedding
(1976), p. 22, fig. 2; p. 87, no. 2.

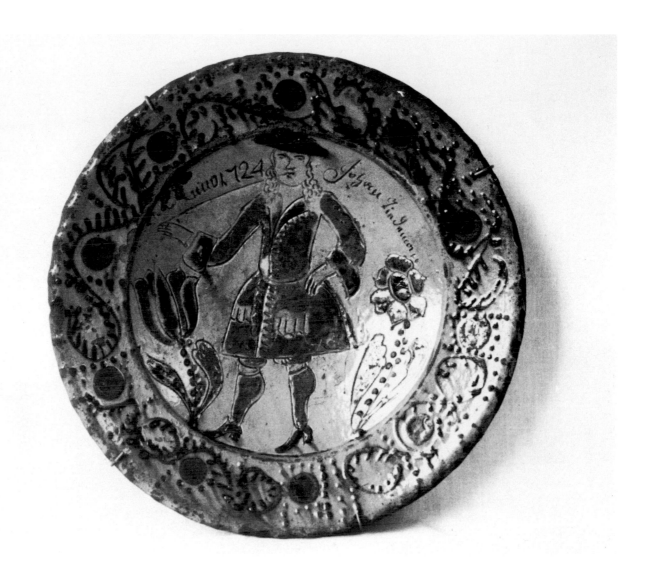

17.
Dish
Altes Land (on the left bank of the Elbe southwest of
 Hamburg), dated 1724
Lead-glazed earthenware; reddish-brown clay, ochre-
 yellow slip, painted in brown and green, sgraffito
Diameter 33.8 cm., Height 5.2 cm.
Museum für Kunst und Gewerbe, Hamburg, Inventory
 No. 1901.554

The shallow dish has a wide, almost horizontal border.
On it, painted very thick and almost like relief, are brown
leaf tendrils rolled into spirals, disk-like flowers and
brown dots. The edge is thickened below, and above,
pinched in to make little waves.

The center shows a fashionably dressed man in a tailored,
close-fitting jerkin, with narrow sleeves and wide,
buttoned-up cuffs, vertical pockets and the stiff, project-
ing coat-tails of the 18th century, under which the
knee breeches can scarcely be seen. On his full-bottomed
wig he wears a tricorn. He is holding a long clay pipe in
his right hand. On his left there is a tulip, and on his right,
a six-leafed flower (narcissus?), above which stands left,
the date: *Anno 1724*, and right, the owner's name: *Johan
Tiedeman*. Like no. 16, the dish, according to the
inventory, was acquired near Bremervörde, but could
hardly have originated in that more elevated sandy and
boggy district west of the Altes Land. Formal criteria

would ascribe the dish, rather, to potters of the Altes
Land. The name Tiedeman(n) occurs frequently here,
particularly around Stade, but also to the northwest, in
the adjacent Elbe marsh district of Kehdingen.

Literature: *Mit Drehscheibe und Malhorn*, no. 111;
Folklig Konst, no. 45; Jedding (1976), p. 23, fig. 3; p. 88,
no. 3.

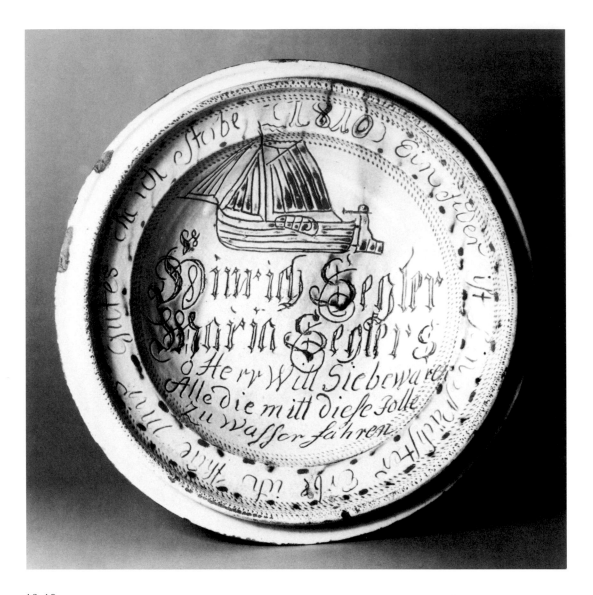

18-19.
Two Dishes
Altes Land (on the left bank of the Elbe, southwest of
 Hamburg), dated 1810
Lead-glazed earthenware; red clay, light-yellow slip,
 painted in reddish-brown and a little, partly blended
 green; drawings and legend have been scratched in and
 appear dark-brown
Diameter 33.3 cm. and 32.5 cm., Height 8 cm. (both)
Museum für Kunst und Gewerbe, Hamburg, Inventory
 Nos. 1902.151 and 1902.152

The dishes have a flat, slightly convex base, from which a
wide wall, fluted at the bottom, slants upwards. In the
middle of a slightly sloping border of about the same
width is a vertical rim, about 1.5 cm. high. This served for
scraping the spoon when eating groats. The outer part of
the border looks like a horizontal ring around the dish.
Dishes of this shape were expressly referred to as groats
dishes.

Center and wall of both dishes show, in the upper part, a
ship, which proves to be an Elbe sailing barge although
the text speaks of a yawl. The flat-bottomed sailing barges
used to be typical vessels of the Lower Elbe in earlier
days. They were clinker-built; had a round stem post,
which is here shown as rather too steep; lee-boards,
which were let down into the water to reduce drift; and a

relatively large rudder, also suitable for slow sailing.
Behind the mast they used a gaff sail as main sail, and
before the mast, a jib sail as well as a foresail. They were
excellent, seaworthy ships and were used for transporting
building material, fuel, grain, vegetables and fruit be-
tween the many little harbors on the Lower Elbe and
Hamburg or Altona.

Under the barge on the dish with the inventory no.
1902.151 is the inscription: *Hinrich Segler / Maria Seglers
/ o Herr Will Sie bewaren / Alle die mitt diese Jolle / zu
Wasser fahren* (Hinrich Segler/Maria Seglers/Lord pro-
tect all who sail on the water with this yawl). Around the
border, below the rim, is written: *Ein jeder ist sein
Nächster Erbe ich thue mir gutes ehe ich sterbe / 1810*
(Each man is his own best neighbor; I do myself good

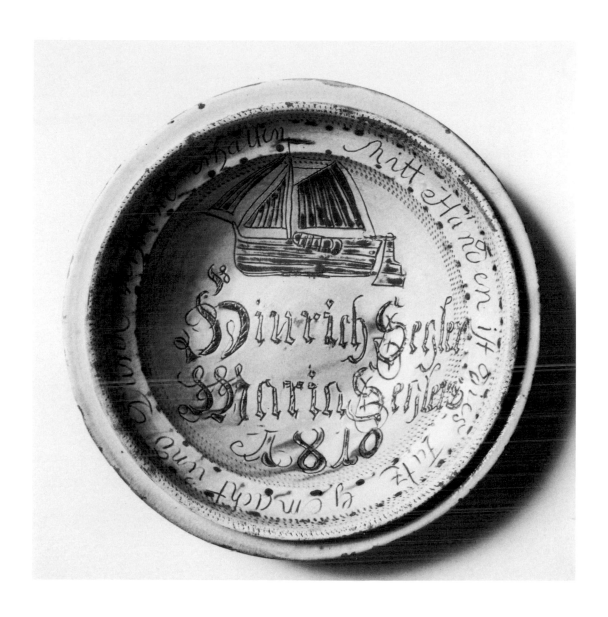

before I die/1810). The text lines are separated towards the wall or the rim by thick rows of short strokes.

Only the name of the married couple is to be found under the barge on the other plate: *Hinrich Segler / Maria Seglers / 1810* (here the genitive "s" added to the surname of the woman is usual in North Germany and indicates "wife of . . ."). On the border below the rim is the circular legend: *Mitt Händen ist dies Fatz gemacht und Durch Verstand erhalten* (This dish was made by hands and preserved by good sense). The German word *Fatz* here means not *Fass* (barrel), as in High German, but the Low German *Fatt* (dish).

The two dishes were acquired together in the small town of Horneburg. Presumably the full set originally consisted of far more dishes, which were made especially for the wedding and were primarily for decoration rather than for daily use. They were displayed on a shelf in the kitchen. The name Segler (sailer), originally denoting an occupation, still occurs today, in the form of Segeler, in the villages along the little river Lühe, particularly in Steinkirchen and Horneburg. There is still a captain among them today. Even at that time the family were not peasants but bargemen who transported the farm produce of the fertile marsh—in particular the Altes Land cherries, apples, pears and plums—to Hamburg and Altona. Occasionally they also took their ships over the North Sea to Holland and England.

Literature: Jedding (1976), p. 28, fig. 19; p. 94, no. 19.

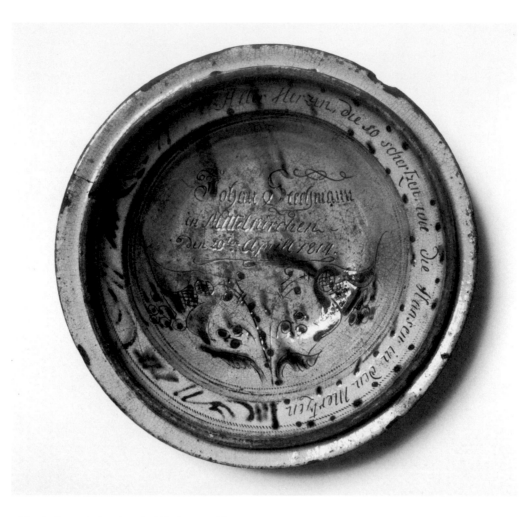

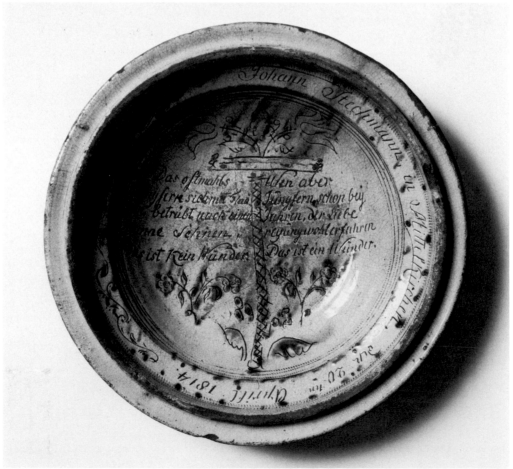

20a & b.
Two Dishes
Altes Land (on the left bank of the Elbe, southwest of
 Hamburg), dated 1814
Lead-glazed earthenware; red clay, light-yellow slip,
 painted in reddish-brown and green, drawing and
 legend lightly scratched in and appearing reddish-
 brown
Diameter 31.5 cm., Height 8 cm. (both)
Museum für Kunst und Gewerbe, Hamburg, Inventory
 Nos. 1887.261 and 1887.262

The dishes have the same groats-dish shape as those of nos.
18 and 19. They have a flat, slightly convex base, from
which the wide, fluted wall slopes upwards. On the outer
third of a slightly sloping border of the same width is a
vertical rim, about 1.5 cm. high, for scraping the spoon.
The outer part of the border is like a horizontal ring fitted
around the dish.

Center and wall of the dish, inventory no. 1887.261, bear
above a pair of flowers the inscription: *Johan Stechmann /
in Mittelkirchen—/ den 20 ten Aprill 1814*, and the border
below the rim, leaves and the text which covers two thirds
of the circumference of the dish: *Aller Herzin, die so
schertzen, wie die Haasen in den Mertzen* (All hearts
which frolic like the hares in March).

The other dish, inventory no. 1887.262, shows the same
owner on the border: *Johann Stechmann, in Mittelkir-
chen, den 20 ten Aprill 1814* followed by leaf tendril.
Painted on the wall and the center is a flowering tree with
pairs of flowers on either side. Above one pair of flowers is
a crown. The inscription—possibly an allusion to the
owner's personal circumstances—reads: *Das oftmahls /
Jungfern sich mit Thra / nen betrübt nach einem / Manne
sehnen / das ist kein Wunder. // Wen aber / Jungfern, schon
bey / Jahren, der Liebe / regung wohl erfahren / Das ist ein
Wunder* (That maidens often languish with tears for a
man is no wonder. But when maidens, getting on in years,
experience love's thrill, that is a wonder.)

There are two more dishes from Farmer Johann
Stechmann's same set in Mittelkirchen, as the name is
written today. In addition to the same details of
ownership and the same date, they bear the following
texts: *Wenn mich nur mein Männchen liebt, bin ich schon
geborgen* (If only my husband loves me, then I am safe
and sound) and *Wer Gott und ein hübsch Mädchen liebt,
und beides wie er soll, der lebt auf Erden recht vergnügt
und geht ihm ewig wohl* (He who loves God and a pretty
girl, and both as he should, lives right happily on earth
and prospers in eternity) (Inventory Nos. 1887.260 and
263).

All four dishes were acquired together in the Altes Land,
and one must assume that the complete set originally
consisted of several more dishes, probably eight or
twelve, which were made especially for a wedding and for
decorative purposes. They were displayed on a shelf in
the main hall of the farmhouse, near the open hearth. The
name Stechmann occurs frequently in the Altes Land. In
the village of Mittelkirchen on the little river Lühe alone,
there are still today at least four families of this name,
including, as was usual with such a name, two fruit
farmers. These dishes could have been made in the
neighboring little town of Horneburg, or in Stade or
Buxtehude, which are not much farther away.

Literature: Brinckmann, p. 262; Jedding (1976), p. 94.

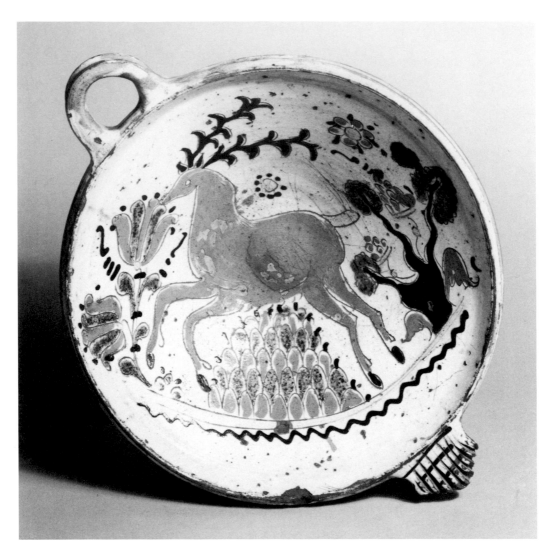

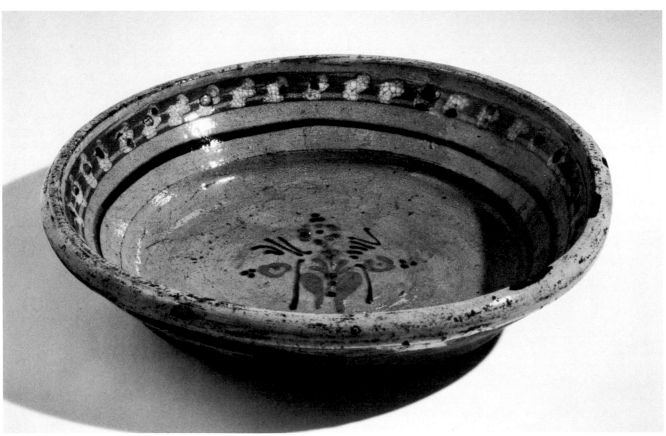

21.
Dish

Winsen Marsh (on the left bank of the Elbe southeast of Hamburg) (?), 2nd half of the 18th century

Lead-glazed earthenware; greyish-yellow clay, whitish-yellow slip, decorated in brown, green, yellow and manganese black, sgraffito which appears brown

Diameter 25.7 cm., Height 8.5 cm.

Museum für Kunst und Gewerbe, Hamburg, Inventory No. 1924.124

The small, flat base, which on the outside is shaped as a foot, merges into a wide, slanting wall which ends in a highly profiled, steep rim with a sharp edge. On one side of the dish there is an eyehook-shaped handle for hanging on a shelf; on the opposite side is a flat, ribbed grip. To observe it correctly, the dish must be viewed with the eyehook-shaped handle above. Center and wall are decorated with a powerful stag leaping to the left over a bushy hill. The stag leaves behind it a gnarled tree with three branches, stylized leaves and fruits, and is approaching a plant with two flowers, which resembles a tulip. Two smaller flower rosettes fill the space above the stag.

The dish was used in the Winsen Marsh, and it is not unlikely that it was also made there. Similar dishes with only one eyehook-shaped handle and a flat grip opposite have been found in Lower Saxony, particularly in the south and southeast of that land, along the Werra by Hedemünden and near Brunswick. They do not occur in Schleswig-Holstein (there such dishes normally have only one handle or a pair of identical handles) but are widespread in Hesse. In Hedemünden and Hesse, from where wares were sold up the Weser as far as Bremen, the type and coloring of the decoration are quite different from this dish, which seems more to resemble those of the Altes Land.

Literature: Jedding (1976), p. 31, fig. 12: pp. 91-92, no. 12; Meyer-Heisig, pp. 31-32, fig. 21.

22.
Dish

Probably Dwoberg (today a part of Delmenhorst, west of Bremen), end of the 18th century/beginning of the 19th century

Lead-glazed earthenware; brownish-yellow to reddish clay, without slip, appears yellow under the glaze (slightly greyish as a result of craquelure), painted in reddish-brown, dark-brown, green and white

Diameter 31.5 cm. to 32 cm. (slightly distorted), Height 7 cm.

Altonaer Museum in Hamburg, Norddeutsches Landesmuseum, Inventory No. 1938/167.

The dish has a large flat base, a short rather steep, gently curving wall and a border rising at a slant with a thickened edge, flanged on the outside. The center is decorated with a little flower framed by curlicues; the border, below by a narrow dark-brown ring, and above, by a broad ring with white spots on which little dark-brown, almost black dots have been painted. These black dots have partially flaked off.

This piece belongs to the standard ware, which is shown here so that the wide range of types and the derivation of decorative crockery from such standard forms can be recognized. It was acquired in Holm, near Wedel, northwest of Hamburg, but appears to come from Dwoberg. Dwoberg, which is today a suburb of the town of Delmenhorst, can provide evidence of being a pottery center for over 300 years. Here, mostly standard ware was produced which was very popular because of its good quality and was sold over a wide area. Thus it not only came in large quantities to Bremen, where it is often very difficult to distinguish from the local pottery ware, but apparently also was sold much farther north.

Literature: Grohne, pp. 72-76.

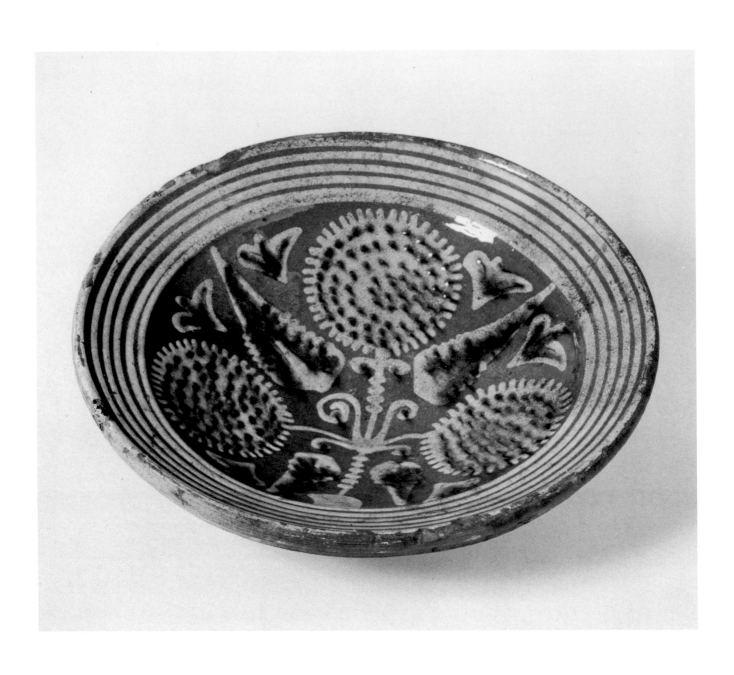

23.
Dish
Wanfried (in Northeast Hesse on the Werra), beginning
of 17th century
Lead-glazed earthenware; reddish-yellow clay, light
reddish-brown slip, painted in light-yellow and green
Diameter 24 cm., Height 6.1 cm.
Städtisches Museum Flensburg, Inventory No. 8532

Whereas, on the outside, the wall slants upwards in a clear angle from a flat foot; on the inside, wall and base merge into one another in trough-like shape up to the edge. The edge is thickened on the outside like a rim; underneath, on the wall side, it is fluted and surrounded by a groove.

The decoration consists of a picture in the center and a broad band of what appear to be yellowish-white concentric circles typical of Wanfried ware but, in reality, are bands applied in spirals by the wheel on the inside to the edge. In the center, in white with some blended green, is a plant divided almost in the middle of the dish into three large, circular, daisy-like flowers, with triangular leaves and tendril volutes between them. The remaining free spaces are filled up to the circles with so-called triple buds.

The dish was found in the tidal flats of the North Frisian island of Pellworm. This part of the Schleswig-Holstein North Sea coast has always suffered from severe tidal storms, resulting in the loss of numerous settlements. For a find in the tidal flats, its state of preservation is excellent, and it can only be assumed that it was swept away in a major tidal surge and preserved in the ooze. A storm of this type hit Pellworm in 1634. The flood destroyed vast areas and led to the separation of Pellworm, now only 37 sq. km. in area, from the nearest island, Nordstrand, approximately 8 km. distant. This historical review confirms the dating, which must be before 1634.

The Wanfried pottery production saw its heyday, coinciding with its period of heavy export, between 1585 and 1623. It plays a major role in the supply of decorated dishes and plates for North Germany, the Netherlands and even England and Denmark. However, in spite of new findings, very little is known about the actual details and conditions of Wanfried production.

The little Hessian town of Wanfried lies on the middle reaches of the Werra, close to the Thuringian border. The earliest known products date from ca. 1584/85; the latest, 1653. But the export, which was conveyed mainly upstream along the Werra and the Weser, came to a stop from 1622 to 1625 in the turmoil of the Thirty Years War. Why pottery flourished—obviously encouraged by the sovereign—in this particular spot, and why potters moved here from Treffurt only 10 km. upstream remains as obscure as the reason for the success of these wares. To judge by the few surviving pieces in the surroundings and the many in the export areas, it appears that they were mainly produced for export. The reason for their success remains even more inexplicable because in all the areas in which they were sold—the Netherlands, England and Denmark—there are excellent deposits of clay. The local potters produced very simple, undecorated standard ware—mainly clay cooking utensils such as three-legged pots and the like—but could easily have changed to the production of better class wares.

At any rate, the Wanfried pottery markets are districts or places with definitely prosperous inhabitants who, at this time, were going over from wooden and pewter plates and dishes to this type of earthenware. After this export had dried up, they turned to the products of the now flourishing faience industry.

Only a few such wares have been discovered in Schleswig-Holstein to date. In many places where the people could have afforded them, they have probably not survived. But one must, as in the Netherlands, try to collect information from the contents of rubbish pits and the like. In this instance, ooze from the tidal flats has preserved this dish from the once rich island of Pellworm.

Literature: Naumann

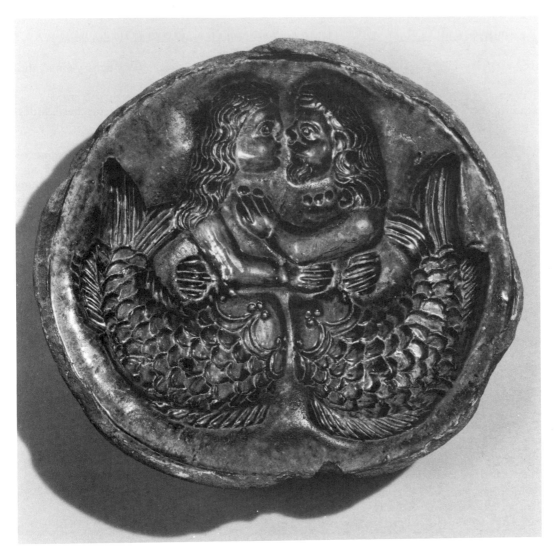

26.
Mold for Rice, Pudding or Pastry (with casting)
Schleswig-Holstein, 2nd half of the 17th century
Lead-glazed earthenware; red clay, yellow slip, green-
 colored glaze
Length from top to bottom 21 cm., Width 22.2 cm.,
 Height 5.5 cm.
Altonaer Museum in Hamburg, Norddeutsches Landes-
 museum, Inventory No. TT 20

The thick-walled form differs from those described in nos. 24, 25 mainly in that it has no legs but lies on its rim or its back. Represented in strong negative relief are two sea creatures with large scaly fishtails, embracing each other; left the mermaid, right the bearded merman. The whole is designed on generous lines, and, in the negative form, the details in relief—scales, hair and the like—are easily recognizable and carefully elaborated. The form has two little holes at the deepest points.

Representations of such sea creatures were very popular, particularly in the coastal regions. They are to be found in the animal books, the bestiaries of the Middle Ages, and play a great role in Renaissance ornamentation and its dependence on classical mythology. From the ornamental etchings of the Renaissance they were taken over and used in silversmith work, sculpture and woodcarving for architecture and furniture or ceramics and to decorate sea charts. They were also popular motifs on the Nether-

lands' tiles of the 17th and early 18th centuries, and from there were exported to North Germany.

As the mythological significance of the individual sea creatures could scarcely be known to the craftsmen, the necessary attributes for their identification were often confused or omitted. In this mold the ancient gods, Poseidon and his wife Amphitrite, might be shown. It could also be Poseidon or his son Triton and one of their many lovers among the Nereids, the fifty mermaid daughters of Nereus, the fortune-telling god of the sea. Finally, it was thought that the seas were peopled by a host of other fishtailed gods and goddesses, the Oceanids. In this case, it is possible that the potter chose, at random, a pair of sea-dwelling lovers as an appropriate illustration for a wedding present or a wedding feast.

For function and provenance see nos. 24, 25.

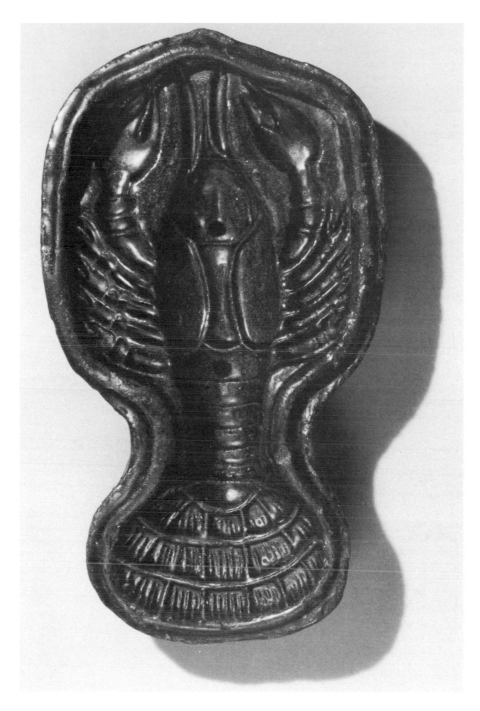

27.
Mold for Rice, Pudding or Pastry (with casting)
Holstein, 2nd half of the 17th to 18th century
Lead glazed earthenware; red clay, brown to
 manganese-colored slip, yellowish-brown colored
 glaze
Length 22 cm., Width 12 cm., Height 5 cm.
Altonaer Museum in Hamburg, Norddeutsches Landes-
 museum, Inventory No. AB 2404

The thick-walled form corresponds in type to no. 26. It too has no legs so that it lies on its rim or back. Represented in strong negative relief is a crayfish, which, apart from decorative treatment, particularly of the tail, is an excellent copy zoologically. There are two little round holes at the deepest points.

According to the inventory the mold supposedly comes from the village of Kellinghusen near Itzehoe, north of Hamburg, but it may come from another pottery in central Holstein. Apart from its use mentioned in no. 24, particularly for solid rice pudding, the crayfish form was also suitable as a mold for making crayfish in aspic which, after cooling, was turned onto a flat dish for serving.

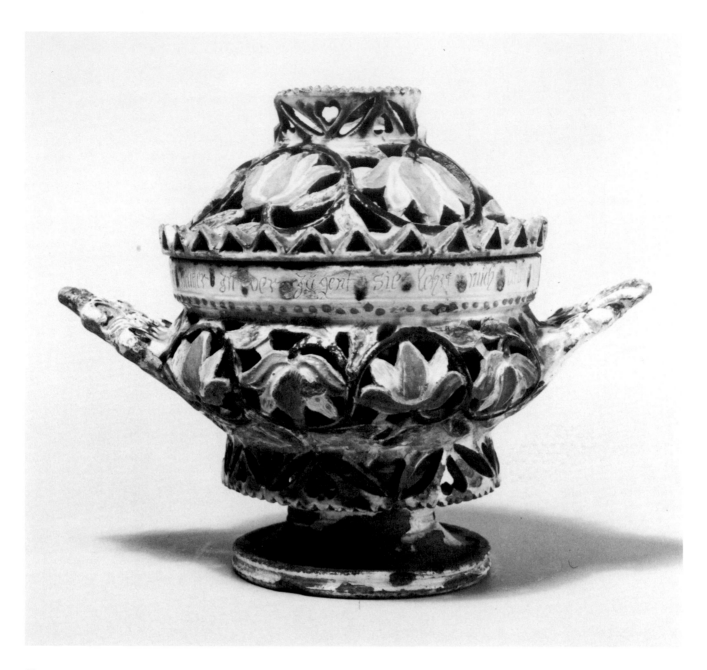

28.
Tureen with Lid
Probstei (northeast of Kiel) (?), dated 1704
Lead-glazed earthenware, inside and out; pierced work;
 reddish-yellow clay, whitish-yellow slip, painted in
 dark and reddish-brown, green and a little brown;
 inscriptions scratched in
Height 20.5 cm., Width 25.5 cm., Maximum Diameter
 16.5 cm., Handle of lid broken off, glaze chipped
Museum für Kunst und Gewerbe, Hamburg, Inventory
 No. 1884.49 a + b

A hemispherical bowl with a double wall stands on a circular foot, ribbed at the edge, and a cylindrical, lightly flanged shaft. The outer wall is decorated with a circular flower tendril of pierced work and ornamental, festooned border. The two triangular flat handles are decorated with tendril volutes and flowers.

The lid, unglazed inside, also has a double wall; the outer wall formed out of the same pierced flower tendril as the bowl. A serrated border forms the rim of the lid. An elevated ledge as a crown, with the same pattern as the

base of the bowl, forms the handle, two thirds of which is broken off and which presumably had a sculptured embellishment in the center. A thicker glaze has made the inside of the bowl mustard-yellow. On the inner edge a wide sieve insert is molded on.

The legend on the upper rim of the bowl reads: *Mein Mutter In der Jugent sie lehrt mich aller vnd Tugent aller höflichkeit Wie die leitte reden In Franck reichen.* Following this, above one of the handles: *Jochim Sas.* In this inscription *und* and *Tugend* have been interchanged; the

correct reading would be: Meine Mutter in der Jugend, sie lehrt mich alle Tugend und alle Höflichkeit, wie die Leute reden in Frankreich, Jochim Sas (My mother taught me in my youth every virtue and courtesy, and how the people speak in France, Jochim Sas) or in modern spelling, Joachim Sass. Below the handle, the inscription continues: *die Frauw Engel, hamerrichs: sohl diese schale: Jochim Sas / zum gedechtnis stihen lassen / Nach Ihrem tode sohl Ihre liebe Junfer Tochter Engel sie haben / Anno 1704* (Wife Engel Hammerichs should keep this bowl in memory of Jochim Sas. After her death her dear young maiden daughter, Engel, should have it).

The tureen is probably the earliest dated example of a piece of pottery which can be ascribed to East Holstein, and specifically the Probstei. The next oldest date, 1735, stands on a Probstei dish with a five-leafed flower in the Germanisches Nationalmuseum in Nuremberg.

In form and function, this tureen belongs to the *Möschenpötte* (see nos. 29-33). From its shape, it is a tureen originally used for keeping warm and serving gruel or soup to women in childbed. The two "ear handles," originally fitted on horizontally in imitation of the metal vessels used for the same purpose, enabled the tureen to be suspended in a larger vessel filled with hot water. But the tureen was scarcely suitable for practical use in this richly decorated form. Such bowls, whose lid ornamentation often consisted aptly of a cradle or a pelican in relief, tended rather to be wedding gifts and were part of the bride's dowry. They could, as indicated in the inscription above, also be bequeathed to a daughter. They were decorative show pieces, from which, on suitable festive occasions, the woman in childbed was served with strengthening and sometimes alcoholic nourishment. Normally, more simple bowls were used. In this case the sieve insert for the spices indicates that the vessel could have been used to serve spiced beer or some other spiced alcoholic drink.

The twice-mentioned Jochim Sas seems to have been the maker. The name of Sass is frequently found in East Holstein and also occurs amongst the journeymen potters in Preetz—but the documentary evidence of this is later and the man in question was born in Neustadt. Ascribing the tureen specifically to the Probstei appears to be rather doubtful, as the use of blue is unusual—at any rate, in the Probstei works of a later date. The family name of Hammerichs is not unusual in Schleswig-Holstein and occurs fairly frequently, particularly in the surroundings of Kiel. But it was not one of the usual Probstei names. The piece was donated to the Museum für Kunst und Gewerbe by the noble family of Reventlow. But as this family was spread all over Schleswig-Holstein, it is not possible to obtain from its members any hint as to the original place of manufacture.

Literature: Brinckmann, p. 262; Jedding (1976), p. 24, fig. 4; p. 88, no. 4.

29.
Gruel Pot *(Möschenpott)*
(Illustrated on page 10)

Tellingstedt (in Norderdithmarschen, east of Heide) (?), dated 1723
Lead-glazed earthenware, inside and outside, pierced work; reddish-brown clay, outside white slip, painted in blue, sea-green and ochre. Scratched drawing and legend
Height 18 cm., without lid 14 cm., Diameter 10.5 cm., Width with handle 16 cm., glaze flaked off in a few places
Altonaer Museum in Hamburg, Norddeutsches Landesmuseum, Inventory No. AB 5680,1; on long-term loan from the Museum für Kunst und Gewerbe, Hamburg, Inventory No. 1895, 163 a + b

The basic form is the three-legged pot with handle, used for centuries in North Germany as a smaller cooking pot (Low German: *Stert pott*). This decorative vessel has a double wall, the outer of which is spherical in shape and very finely pierced. Its edge widens on the outside and its baluster-shaped hollow handle, with a pierced end like a crown, rises at an angle. The flat lid also has a double wall, the outer one pierced and ending in a profiled knob. In contrast to the pot, the lid, which fits into a groove on the wall of the pot, is not glazed inside. The feet are set at a slant and slightly bent. The upper parts, seen from the front, are hollow.

The whole surface of the wall is decorated by a sweeping tendril with three large flowers. The central one opposite the handle radial in shape, the two others resembling tulips. The same pattern, with an extra radial flower, is repeated in miniature on the lid. Lid and pot edge bear inscriptions. On the lid: *Kom mein Vögelein und singe mier von meiner liebste ein Liedelein. Anno 1723* (Come, my little bird, sing me a song of my beloved). On the pot, beginning at the handle: *Kein Feuer, kein Glut kan brennen so heiß als heimliche Liebe die niemand weiß* (No fire, no embers can burn as hot as a secret love which no one knows). This is the beginning of an old folk-song. Under the pot a double star is painted. Especially noticeable is the attempt to achieve extremely fine work with a faience effect.

The inventory of the museum provides no information about the previous owner. When it was acquired, it was ascribed to Tellingstedt, as the place of production. But this is only a vague supposition as there are no authentically confirmed comparative pieces. There is, however, a certain resemblance to the admittedly rather cruder tureen lid of no. 28. For the function see nos. 31 and 28.

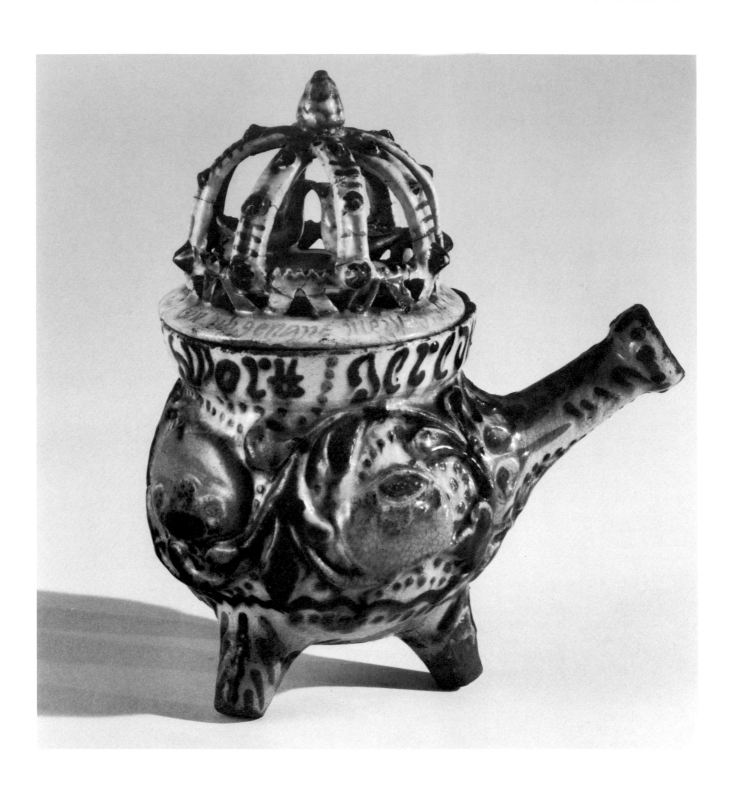

30.

Gruel Pot *(Möschenpott)*
Dithmarschen (Tellingstedt), middle of the 18th century
Lead-glazed earthenware, inside and outside, with sculptured design; reddish-brown clay, light-yellow slip, painted in dark-brown, ochre, green, yellow and blue
Height with lid 18 cm., without 11 cm., Diameter 9.5 cm., Width with handle, 15.5 cm., lid cracked
Altonaer Museum in Hamburg, Norddeutsches Landesmuseum, Inventory No. AB 5680,2; on long-term loan from the Museum für Kunst und Gewerbe, Hamburg, Inventory No. 1878,447 a + b

The three-legged pot with handle is also the basic form of this pot. It consists of a spherically shaped bowl with decor in strong relief and a rim rising slightly outwards. It has three short slanting legs and a hollow handle open at the end for the insertion of a wooden grip; this was common to many pots in everyday use. The lid rests in a groove of the rim and curves slightly over the edge; in the center are two cooing doves in relief. It is surmounted by a pierced crown which acts either as a protection or a cage for the birds. The bottom of the crown consists of a pointed border from which eight curved bands rise and meet at the top in a pine cone.

The decoration of the pot wall consists of a leaf tendril in relief with four pomegranates. The marks of pressure around the handle also provide a very sculptural effect.

Lid and pot rim both bear inscriptions. On the edge of the lid under the glaze is scratched: *Johan Christoffer Widenroht bin ich genant mein Gluk stet in* [Gottes Hand] (Johan Christoffer Widenroht is my name, my good fortune is in God's hand). On the rim of the pot is painted: *Ich J: hab: ein: wortt: geredt* (I, J, have spoken a word). At this point, underneath, above the base of the handle are the initials *AH*, probably those of the owner of the pot.

The pot came to the museum from Meldorf in Dithmarschen. Thus its production in Tellingstedt, where records of pottery making exist since at least 1680, is quite possible, for it seems that the numerous other Dithmarschen potteries were not only established much later but mostly produced only simple standard ware. But this pot gives evidence of great skill and long experience.

For the function see no. 31.

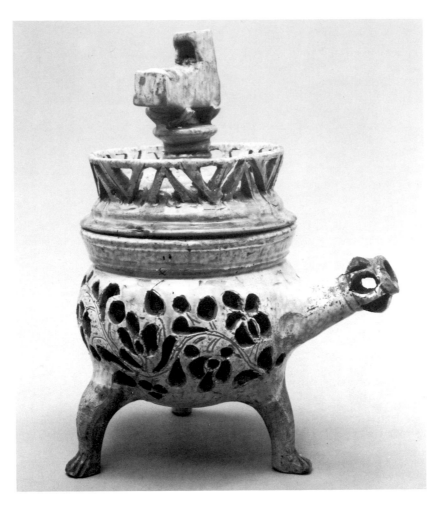

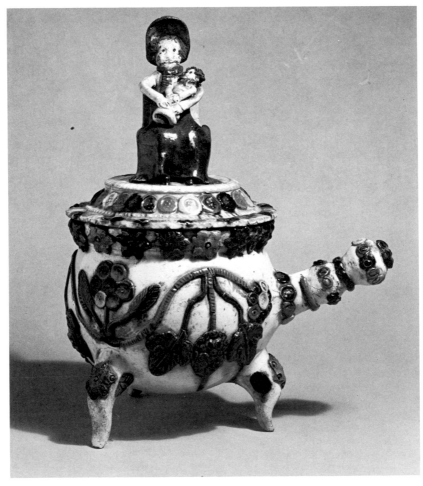

32.

Gruel Pot *(Möschenpott)*

Probstei (northeast of Kiel) (?), 2nd half of the 18th century

Lead-glazed earthenware, outside and in; pierced work with sculptural design; greyish-yellow clay, whitish-yellow slip which appears honey-colored because of the thick glaze, unpainted, scratched drawing of tendril

Height 23 cm., Diameter 12 cm., Width with handle 16.5 cm.

Museum für Kunst und Gewerbe, Hamburg, Inventory No. 1905.669 a & b

The basic form is a three-legged pot with a double wall, the feet of which are here claw-shaped. Leaves and flowers are cut into the outer wall and are linked together by the scratched tendril. The end of the handle is a tube-shaped opening above a pierced knob, as was the case with normal household pots, into which, here, a longer wooden handle was inserted. The lid, unglazed inside, is fitted like that of the *Möschenpott*, no. 31, with a small gallery which is designed as a pierced broad strip and encloses a box-shaped cradle on a high round plinth.

The piece was acquired in Kiel. Its provenance has been ascribed to the neighboring Probstei. This is probable judging by form and decor, but not confirmed.

The function was the same as that described in no. 31. The pot was essentially a show piece; the cradle indicates that it is a wedding present and provides the reference to baby and baby food.

Literature: Jedding (1976), p. 29, fig. 10; p. 91, no. 10.

33.

Gruel Pot *(Möschenpott)*

Schleswig-Holstein, Holstein part, ca. 1830

Lead-glazed earthenware, inside and out; sculptural design; greyish-yellow clay, cream-colored slip, applied relief decor, painted in green, brown, manganese black and orange

Height 25.5 cm., Diameter 12.5 cm., Width with handle 19.5 cm.

Museum für Kunst und Gewerbe, Hamburg, Inventory No. 1911.17 a & b

The basic form of this show piece, with only a single wall, is also the three-legged, hemispherical handled-pot of the usual local shape, with the curved legs ending in a point and the rim set off at a slant. The handle is baluster-shaped, has a round knob and ends in a rose. The relief decor is stamped with seals and consists of a brown tendril on which hang grapes and large flowers with their respective leaves, as well as various little flowers and rosettes joined together in circular strips. The handle of the slanting lid, with its grooved rim and its round rosette-like panels, consists of a young woman sitting on a chair. She is wearing a large green poke bonnet, fashionable around 1830/40, a dress with shawl collar and a wide green skirt. She is holding a baby in swaddling clothes on her lap with both hands. The inside of the lid, as is usual in the case of these pots, is unglazed. For the function see no. 31.

According to the previous owner, the *Möschenpott* comes from the neighborhood of the town of Elmshorn, north-west of Hamburg. A comparable piece with very similar but rather coarser decor is a *Möschenpott* dated 1830 in the Schleswig-Holsteinisches Landesmuseum in Schleswig which, according to the inscription, was produced by the potter, Wilhelm Wiese, in Schönberg, the principal place in the Probstei. It is possible that this pot also comes from there. The technique of applying the decor, by which little handmade or stamped clay panels are stuck on before firing, was known in Schleswig-Holstein, mainly from the pottery originating in West Hessen, i.e. the Marburg area. This pottery was imported to Schleswig-Holstein in large quantities in the first half of the 19th century (see nos. 113-114).

Literature: Jedding (1976), p. 44, fig. 25; p. 97, no. 25; Schlee (1978), p. 170, fig. 284; p. 286; *Folklig Konst*, no. 84, fig. 84.

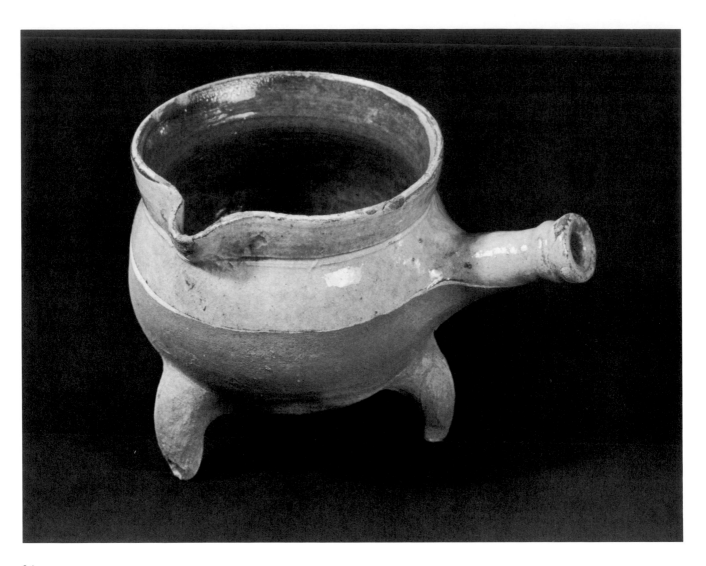

34.

Handled Pot *(Stertpott)*

South Dithmarschen, probably Windbergen, 1st half to
 middle of the 19th century

Lead-glazed earthenware; brownish-red clay, on the
 upper part of the outside, slip appears yellow through
 the glaze; unpainted

Height 11 cm., Diameter above, 10.2 cm., Maximum
 10.5 cm., Width with handle 16 cm.

Dithmarscher Landesmuseum, Meldorf, Inventory No.
 948a

The little handled pot, known in Low German as
*Stertpott (Stert =*tail), had the shape, developed in pre-
mediaeval times, of a round pot with three longer or
shorter curved legs ending in a point; a slanting rim, often
with a pulled lip; and hollow handle slanting upwards
into which was fitted a wooden handle. Inside it is glazed
without slip; outside, glazed over the slip only on the
upper part as it had to be used over an open fire. The clay
handle was fairly long to prevent the wooden handle from
catching fire.

These were the standard cooking pots for smaller quan-
tities of food. They were made in various sizes up to 15-20
cm. diameter. For larger quantities of food, similarly
shaped pots of iron or bronze were used and fitted with a
semicircular handle for hanging on the pot-hook. As
these were very simple and easily replaceable utensils,
they were used until they leaked or were broken, and

were then thrown away or smashed at the next eve of a
wedding celebration. This is why in museums and
collections only a few pieces occur. After the introduc-
tion of the English kitchen range with its iron stove-plate,
these pots could not be used. This change occurred, in the
country, in North Germany in the second half of the 19th
century, in a few cases actually after World War I. Hence
these simple pots are today often rarer than the ornamen-
tal vessels copied from them, for instance the artistically
shaped *Möschenpötte* (gruel pots), which were always
carefully looked after.

It is not possible to ascribe this pot to a particular
workshop or pottery center, as such pots were standard
ware in all potteries in Schleswig-Holstein. The prove-
nance can only be assumed to be in the vicinity of where it
was found.

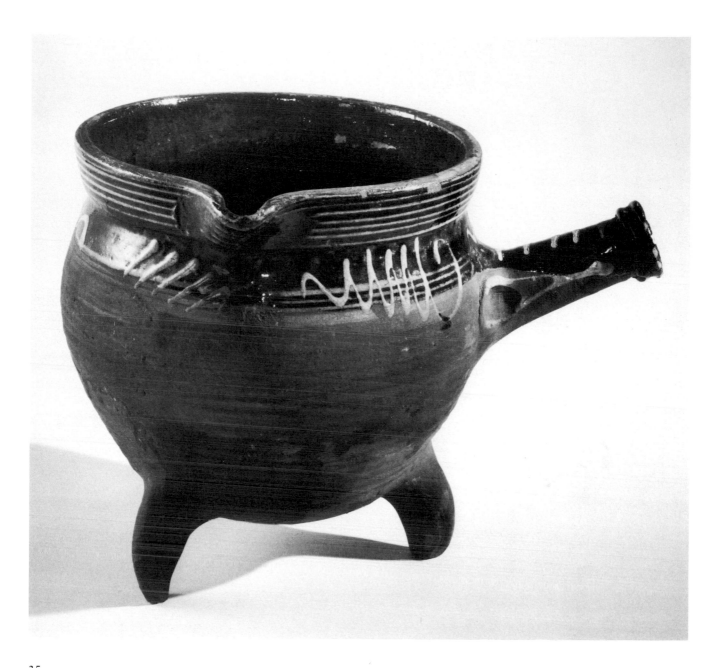

35.

Handled Pot *(Stertpott)*
North Frisia (?), middle of the 19th century
Lead-glazed earthenware; red clay, brown slip, painted in
 dark-brown and yellow
Diameter above 19.5 cm., Width with handle 29 cm.,
 Height 21 cm.
Altonaer Museum in Hamburg, Norddeutsches Landes-
 museum, Inventory No. 1925/150

The large spherical pot, with the rim slanting outwards in the form usual for these cooking pots, has three short, curved legs. The handle has been cleanly pressed on with the fingers. It is hollow so that a wooden handle can be inserted and is thickened at the end with a grooved rim. A spout has been pressed in on one side of the edge, obviously after painting. The inside appears greenish-yellow to reddish-brown through the glaze on thin slip. Outside, only the rim is painted with different, narrow wavy lines, layers of stripes, curlicues and circular bands in yellow. It is also glazed from the edge to the shoulder. Below the rim the pot is unglazed, but grooves from turning have been left and serve as decoration.

These pots were used from very early times for cooking, storing, and distributing food and liquids, particularly milk. If slowly warmed over a low flame and allowed to cool gradually, they were heat resistant to an open fire. This piece was used on one of the North Frisian islands (Halligen) but need not have been made there. Of all Schleswig-Holstein pots, these resembled each other most and could naturally be traded over wide areas. (see a damaged example from Uetersen in Fig. 4.)

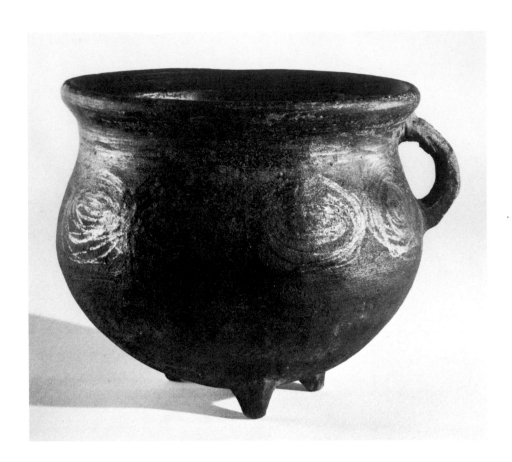

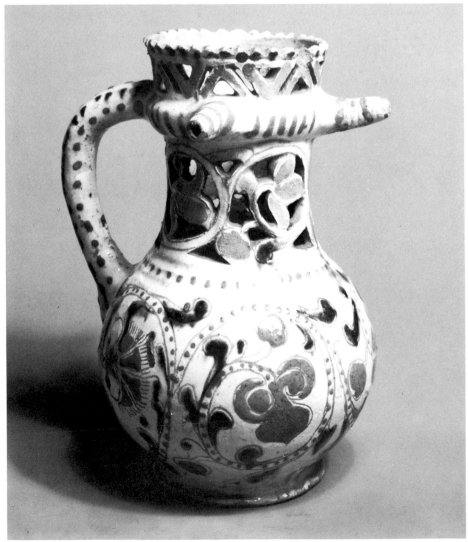

36.
Cooking Pot (*Jüdepott,* i.e. Jute pot)
West Jutland, 19th century
Smoked earthenware; brown clay, smoothed decor
Diameter 17.5 cm., Width with handles 19.5 cm., Height
16 cm.
Altonaer Museum in Hamburg, Norddeutsches Landes-
museum, Inventory No. 1919/43

The spherical shaped pot, with three very short stumpy legs and a handle attached horizontally, reminds one of prehistoric vessels and is actually produced in the same way. This ware, in West Jutland, was hand shaped not by craftsmen but by peasants, particularly women. No potter's wheel was used and it was fired at a relatively low temperature. The sole decor consisted of ring spirals on the shoulder and rims smoothed by scraper or long flat polished stones. Similarly, such ring spirals could also be applied to the inside, as is the case with three of them in this pot.

These pots differ from prehistoric prototypes mainly through their three legs which enabled them to be used for cooking on a stove. This ware was used principally as cooking pots and exported in large quantities by horse and cart as far as the Lüneburg Heath and the Lauenburg area.

The sealing was done not by glazing but by smoking—the age-old technique which had been used before glazes were known. At the peak of the firing process, damp twigs were added. The tar products released dripped onto the surface, sealed it, and blackened it. And further blackening would often occur because the smoking process caused a reduction in the oxygen supply. The absence of glaze and the relatively soft firing made these pots especially suitable for cooking and storing pickled foods. They were, of course, rather fragile, but also

cheap. The fact that they were unglazed and cost little ensured them a market until the end of the 19th century, by which time people in the country had gone over from the open hearth to the iron English kitchen range with hot plate and stove rings. The use of glazes containing lead had been forbidden by the Reichs Law (1885) and cheap enamel crockery finally outstripped the use of the old pottery ware.

However, these pots have always held a fascination for the rural population. They appeared so strange and their black color combined with their relatively light weight whetted the popular imagination so that in Schleswig-Holstein they were not only known as *Jüde* or *Jüttepötte* (Jute pots) but also as *Taterpötte* (from Tartars, a term used for Gypsies and applied to all nomadic, foreign peoples).

This relatively small pot comes from Hof (farm) Segelsbüll in the parish of Neuenkirchen, northwest of Niebüll in North Frisia. The Altonaer Museum possesses considerably larger examples, but the clay of these is too soft for travel. One of these is a two-handled pot of the same form, 30 cm. in diameter and 29 cm. in height, which was used in Pinneberg, north of Hamburg (Inventory no. AB 5974). The largest example is 37 cm. in diameter and 30 cm. in height, used in the Lauenburg area (Inventory no. 1949/79).

37.
Puzzle Jug (*Vexierkrug*)
Flensburg (?), 2nd half of the 18th century
Lead-glazed earthenware inside and out; pierced work;
reddish-yellow clay, whitish-yellow slip, painted in
reddish-brown and green, sgraffito
Height 17.5 cm., Diameter 11 cm., maximum Width 14
cm.
Museum für Kunst und Gewerbe, Hamburg, Inventory
No. 1900.22

The pear-shaped jug has a pierced neck, whose flower tendrils, rolled into spirals, match those painted on its belly. Shoulder and hollow handle are painted with rows of brown dots. The hollow handle runs into the interior of the jug just above the base. The neck merges into a hollow flange with three spouts. On the flange is set a vertical collar with a pierced ornamental rim. In the light-brown interior, as well as on the edges of the pierced walls, the glaze lies directly on the clay, with no intermediate layer of slip.

The jug was acquired in Flensburg and is supposed to have been used in the district of Angeln. The attribution is uncertain. Flensburg suggests itself as the place of production because of the provenance and the comparison with other pieces definitely known to have been made there. An attempt has been made to ascribe it to the Probstei. Clay and decoration would make this possible,

but it would be improbable because of the distance to the place where it was used, which had no commercial relations of any note with the Probstei and, at that time, generally relied on Flensburg to satisfy its demands.

Puzzle jugs such as these served as practical jokes at feasts or guild drinking parties. Anyone who knows how to use the jug can suck out the wine, beer or other liquid in the belly through the handle, the flange and one of the spouts by tilting it slightly and stopping up the other spouts. The ignorant or the unskilled user spills the drink through the pierced neck or finds himself faced with the liquid pouring out of all three spouts.

Literature: Schlee (1939), p. 44, fig. 152; Jedding (1976), p. 28, fig. 9; p. 90, no. 9; Schlee (1978), p. 169, fig. 279; p. 286.

38.
Jug with Three Handles
Surroundings of Hamburg, probably 18th century
Lead-glazed earthenware; brownish-yellow, partly
 rather reddish clay, no slip inside, outside partially
 glazed, spots of green glaze
Height 28 cm., largest diameter 27 cm., Diameter at
 mouth 11.2 cm.
Altonaer Museum in Hamburg, Norddeutsches Landes-
 museum, Inventory No. 1943/53

The wall starts from the base as in a dish, at 9 cm. begins to curve gently, rises vertically and then runs in hemispherical form into the relatively broad, short neck with a sharp edge. Three broad eyelet-shaped handles, bent into a triangular shape, are attached vertically to the shoulder. About half-way up, a narrow flange, which has been pressed on in a wavy pattern with the fingertips, encircles the belly. In addition to the inside, the neck and the upper part of the shoulder and handles are glazed, rather colorlessly so that there the clay appears yellowish-green; on the neck still quite greenish. Odd drops of glaze have run over the belly.

On closer inspection and by feeling the wall on the inside, one discovers that the jug was made in two pieces according to an old well-proved process and fitted together at the flange with liquid clay. The lower part has a base and is dish-shaped; the upper part has no base, is hemispherical and is fitted with a neck.

The exact provenance of the jug, which was acquired commercially, is unknown, but seems to be in southern Holstein or even in Hamburg itself. Earthenware jugs are rare enough in Schleswig-Holstein; earthenware jugs with three handles even more so. (Examples of jugs with three or four handles are more likely to be found amongst the imported stoneware jugs.) The exact use of these jugs has not been recorded, but from the narrow neck and the three handles it was probably a vessel used for transport. It could be hung under a cart or carried in pairs on a yoke with thin ropes threaded through the handles. It was probably used mainly for carrying water. Possibly, it also had a lid of earthenware or of wood. The signs of damage, particularly on the lower part of the wall near the base, point to a damp location or to constant wetting from, for instance, use at a well. The water would run down the outside, penetrate the clay and lie for a long time in the bottom of the jug.

39.
Jug with Two Handles
North Frisia (?), 1st half of the 19th century
Lead-glazed earthenware; light brownish-yellow to reddish yellow clay, slip with light-greenish sheen inside and outside, above this from the edge to the shoulder reddish-brown slip, colorless glaze inside and on neck and shoulder, green glaze spots
Height 25 cm., greatest Diameter 17 cm., Diameter at mouth 9.3 cm.
Altonaer Museum in Hamburg, Norddeutsches Landes-museum, Inventory No. 1925/89

The jug has a slightly projecting foot and a bulbous wall, in cross-section almost elliptical. On the wall sits a vertical neck, barely 3 cm. in height, ending in a wide mouth. Fixed opposite one another onto the shoulder are two small vertical eyelet-shaped handles, which have been pressed in with the fingertips. The glazed shoulder is marked off from the belly by a turned groove and appears brown under the glaze. There are spattered spots of green on the shoulder as well as some unintentional spots of colorless glaze on the belly.

According to previous owners of similar jugs, the jug was used on the North Frisian island (Hallig) of Hooge, mainly for storing molasses. (Sugar-beet factories have existed in Germany only since 1802; the first in that year in Cunern in Silesia. Previously, honey was used for sweetening; this was also kept in such jugs.) As the jug could not have been produced on the island, it was probably made and acquired on the North Frisian mainland.

40.
Jug with One Handle
Schleswig-Holstein, 1st half of the 19th century
Lead-glazed earthenware; whitish-yellow clay, reddish-
 brown slip outside from edge to shoulder
Height 32 cm., greatest Diameter 19.5 cm., Diameter at
 mouth 3 cm
Altonaer Museum in Hamburg, Norddeutsches Landes-
 museum, Inventory No. AB 5973

The bottle-shaped jug has a slightly projecting foot, an almost elliptical belly and a very narrow neck with a thickened edge. The relatively wide eyelet-shaped handle, attached horizontally to neck and shoulder, has a broad groove running along its center and has been pressed onto the shoulder with the fingertips. Two grooves mark where the shoulder runs into the neck. The consistency of the slip varies; on the lower part of the neck it is so thin that in parts the whitish-yellow clay shines through. Apart from the inside, only neck and shoulder are glazed. Drops of both slip and glaze (under the latter the clay appears yellow) have run down from the shoulder onto the belly.

Nothing is known of the exact provenance of this jug. As it was registered in the old inventory of the museum, it was almost certainly acquired in Schleswig-Holstein. Such jugs, which are closed with a cork, were used mainly for vinegar if they were of stoneware. As earthenware, they would also have occasionally been used for this purpose, although lead glaze is unsuitable for storing vinegar. This jug is more likely to have served as a storage vessel for oil or for transporting water or beer to workers in the fields.

41.
Dish

Holstein, dated 1710

Lead-glazed earthenware; light-grey to greyish-yellow
clay, brick-red slip appearing reddish-brown through
the glaze, painted in white, ochre and green; in parts,
deeply scratched leaves on the edge

Diameter 32.5 cm., Height 5 cm., Paint on the center
partially rubbed off

Altonaer Museum in Hamburg, Norddeutsches Landes-
museum, Inventory No. 1953/124

The heavy, flat dish with thick clay has a large base,
scarcely hollowed, with a short concave wall onto which
is added a wide, gently sloping border. The edge under-
neath is thickened to a wide flange. The center bears the
inscription: *Ah bleib bey uns | herr Jesu Christ, | dein
göttlich wordt das | helle Licht laß ja bey | uns auslöschen |
nicht. etc. | Anno 1710* (Ah, remain with us, Lord Jesus
Christ, let not Thy Divine Word, the brightness of Thy
light be quenched among us etc.). The border is decorated
by two lateral leaf tendrils which emerge from a leaf
rosette below. Above, two triangular heaps of balls

(originally grapes or pine cones) enclose a similar leaf
rosette.

The inscription is the beginning of a hymn. The dish,
originally designed to be an ornament, was later used not
only for spooning out food but also for cutting meat so
that the text on the paint has been severely damaged. The
dish was last used in Kellenhusen on Lübeck Bay in the
Baltic. It is possible that it was produced by a potter in the
nearby town of Neustadt, East Holstein.

42.

Pot with Handle

(Illustrated on page 2)

Holstein, dated 1728
Lead-glazed earthenware, inside and outside; red clay,
light-yellow slip, painted in reddish-brown and green,
scratched drawing and legend
Height with handle 28.5 cm., without 15.5 cm., Diameter
19 cm., handle repaired, two cracks
Altonaer Museum in Hamburg, Norddeutsches Landes-
museum, Inventory No. 1105 = AB 374

The pot has the form, usual in Schleswig-Holstein and
Denmark, of a vessel used for carrying food such as gruel
or soup. (Corresponding types in South and Central
Germany are more elongated.) The pot rests on a very
small foot, the upper part of which is pulled in. It is
almost spherical; the wall, hardly curved to start with,
rises at an angle and ends in a rim which slopes outwards,
its edge thickened on the inside. The broad semicircular
handle attached to the edge has been sculpturally shaped
by drawing the handle rims outwards and upwards and
then pressing them into a wavy shape with the fingers
onto the upper surface of the semicircle. Originally this
pot almost certainly had a lid.

The two sides of the pot are decorated differently. One
side bears, in a wreath of leaves, the legend *S D M / SOLI
DEO GLO / RIA ANNO / 1728* (SDM/Honor be to God
alone). This wreath is held by a royal couple depicted in a
naive scratched drawing. Over each of them appears a
plant with tulips, carnations and other flowers; right, the
man with crown, sash and lilies of the valley in his free
hand; left, the woman, likewise crowned and in fashion-
able dress, with the Imperial globe in her free hand, and a
short chain with a large cross round her neck. On the
other side stands, as a large central figure, a woman in the
same fashionable dress and a violin in her right hand (i.e.
on the pot, left). The clothing consists of decorated
breastplate, bodice with white sleeves and lace fringes and
a wide, multi-colored, striped rock in various patterns.
She is wearing a conspicuously long (pearl) necklace. On
the right of the lady, a boy clad only in trousers and shoes,
hovers above the flowering plant. He is obviously Amor,
because in his right hand he is holding a bow, which at
first glance seems to be held by the lady in her left hand.
The inside of the pot appears reddish-brown as it has been
glazed without slip.

The pot was acquired in Altona-Oevelgönne in 1902,
without the museum inventory making any further
mention of its provenance. The piece was probably
produced in southern Holstein. No similar comparable
works are known.

43.

Brandy Bowl

Holstein, dated 1734
Lead-glazed earthenware inside and outside, with
sculptural design; red clay, white to light-yellow slip,
painted in ochre-brown, dark-brown and green,
sgraffito
Height 11 cm., to edge 9.5 cm., Diameter 17.2 cm.,
Width with handles 24 cm., extensively repaired
Altonaer Museum in Hamburg, Norddeutsches Landes-
museum, Inventory No. AB 373

The dish has the form which was presumably used in
Hamburg for silver brandy bowls around 1660 and until
about 1760. There was a certain thickening in the form
during the first third of the 18th century; this became
widespread in Hamburg and the whole of the Lower Elbe
region, but particularly in the Holstein Elbe Marsh. A
relatively shallow dish with a trough-shaped base rests on
three spherical feet, which slant outwards. The wall,
curving slightly outwards, rises vertically. At the top it is
pulled in and the edge is pulled out. Two eyehook-shaped
grips are attached to the wall, one of them exactly above
one of the three feet. The tops of the grips merge into
sculptured heads set at an angle to the edge of the bowl.
Six long-haired, female heads from the same mold
(perhaps cherubs' heads) are pressed onto the wall, three
on each side with tulips in between. Outer edge and upper
parts of the handles are dotted. Scratched into the base is
the owner's inscription: *Hans / Friedrich / Kollau / 1734.*
The inside of the bowl is mottled brown and is heavily
glazed in brownish-yellow.

The metal prototype is clearly indicated by the sculptural
decoration. In comparison, the effect of the work is
crude, not to say clumsy. Nevertheless it is a remarkable
achievement for clay.

The provenance of this unusual piece is not known and is
made all the more difficult to determine because the
previous owner was not recorded. However, because of
the type of form, a workshop under the cultural influence
of Hamburg must be assumed. Furthermore, the history
of the museum's collecting policy points to a probable
provenance on the right bank of the Elbe, particularly as
Kollau occurs as a surname in southern Holstein. The
quality presupposes a workshop of experience, but
comparable pieces are unknown. The *Möschenpott* (no.
30) is the nearest in appearance to this bowl of all the
works shown in this exhibition. A connection with the
pottery center of Tellingstedt in Norderdithmarschen
seems unlikely because of its distance from the Elbe
marsh. More likely is a workshop in Itzehoe or even one
of the little marsh towns like Krempe, Wilster or
Glückstadt; but we know nothing about their pottery
craftsmen.

These bowls were used for serving sweetened brandy on
festive occasions. In some places the brandy was drunk
with raisins which were put in a few days before. The
guests spooned the drink out of the bowl in a certain order
and in a fixed number of spoonfuls. Especially popular
occasions for this were christenings and weddings, both
of which provided an opportunity for making a gift of
such bowls.

Literature: Meinz (1963), particularly ill. 9; also Meinz,
(1967) nos. 5-7.

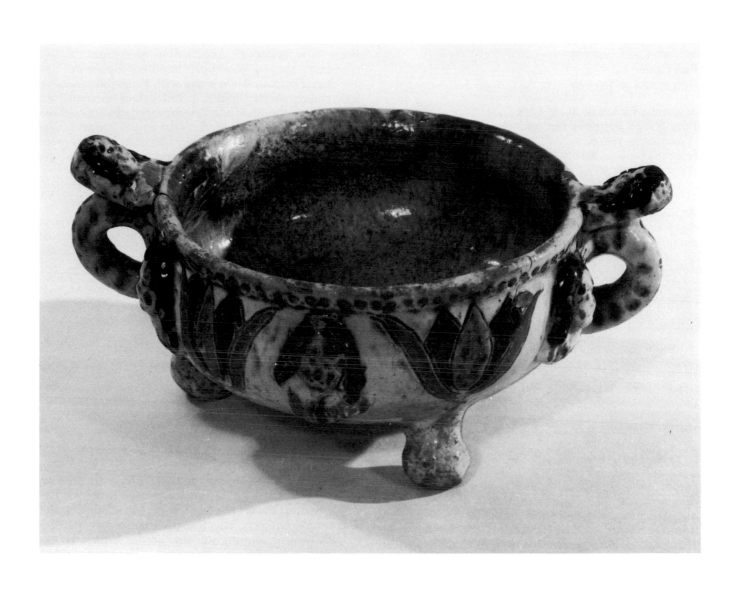

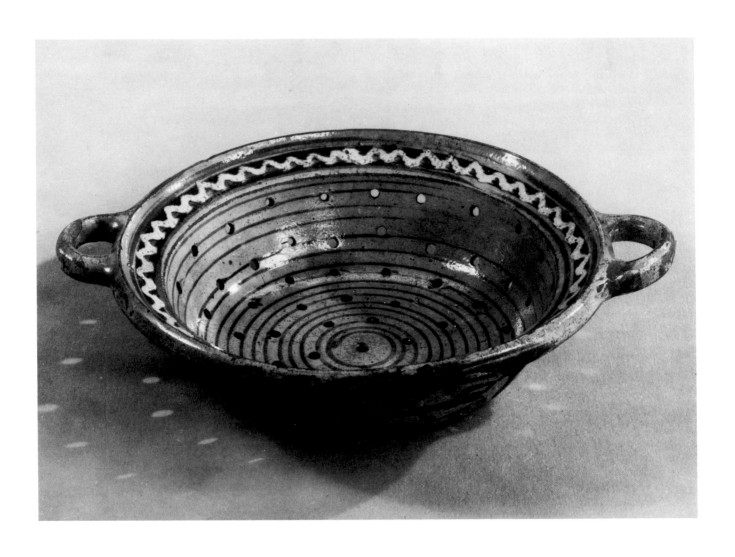

47.
Colander
Southern Holstein, middle of the 19th century
Lead-glazed earthenware; whitish-grey clay, no slip, appears light-yellow through the glaze, somewhat grey through the craquelure, painted in greyish-brown, dark-brown and white
Diameter 31.5 cm., Width with handles 39 cm., Height 9 cm.
Altonaer Museum in Hamburg, Norddeutsches Landesmuseum, Inventory No. R 32

The colander has the same form as the somewhat smaller no. 46 and obviously comes from the same workshop. The decoration on the border consists of a wide, dark-brown band and on it, a wavy white line accompanied by two narrower greyish-brown bands. Base and wall are ringed by a spiral which starts at the base and ends just below the border. As in no. 46, the outside is unintentionally only partially glazed.

As odd reddish-brown spots in the greyish-brown bands show, the coloring was apparently intended to be different; namely, instead of greyish-brown, the color was meant to be reddish-brown as on the border of the colander, no. 46. But as the firing was either too hot or not hot enough, the desired color was not obtained.

Like no. 46, this colander comes from Hof Rieck in Curslack. This piece is included in the exhibition so as to draw attention to the range and variation in a workshop's wares—even in simple standard ware—that could be achieved by decoration or even by firing at different temperatures.

48.
Dish
(Illustrated on page 11)

Probstei (northeast of Kiel), dated 1756
Lead-glazed earthenware; greyish-yellow clay, cream-yellow rather grainy slip which appears yellow through the glaze, painted in light-brown, dark-yellow and green, sgraffito
Diameter 34 cm., Height 6.8 cm.
Städtisches Museum Flensburg, Inventory No. 9811

The dish has the normal form of the so-called gruel dishes. The slightly trough-shaped base merges into a concave wall, which is relatively short, almost vertical, and ends in a rim for scraping the spoon. This rim, whose edge is scarcely tapered, is about 2.5 cm. higher than the 4 cm. border, which gives the effect of a circular ring.

In the center is a woman with a tulip in her hand between two flowers under the date *1756*. In spite of all abstraction and misleading coloration, one can clearly see that her fashionable clothing is of the court or the haute bourgeoisie—in no way countrified. Her upper garment or manteau, which she is wearing over a low-cut bodice, has narrow, elbow-length sleeves out of which protrude lace cuffs of a different color. She is also wearing the long skirt open at the front, which here, in contrast to the prevailing fashion, appears to be of a different material from the manteau and, on the right, allows a sight of the hooped skirt with a wide flounce of another color, as was actually worn at the time. Wall and rim are accentuated on the inside by narrow lines of dots. The border and the outside of the rim are each decorated with a circular flower tendril.

The pottery wares of the Probstei in the 18th century are much superior in such generous, two-dimensional, figurative pictures to those of other districts of Schleswig Holstein. Even if the coloration of the Ditmarschen ceramics from Tellingstedt is similar, nevertheless no such figurative decors are known there. We do not know what originals from graphic works, pattern books or other ceramics were used to copy from. However, it is noticeable that the persons depicted are always in the fashionable clothing of the upper classes but not of the peasants. Even farmworkers and maids appear in that clothing, which seems most suitable for vessels designed to be used on festive occasions. Although a comparatively large number of such pieces have survived which were actually used in the Probstei region itself—more as decoration than as standard ware—it has not been possible up to now to ascribe them to a particular place, let alone a particular workshop. One of the reasons may be that the charm of these ceramics was recognized very early—from the middle of the 19th century—by dealers and collectors, so that the pieces in our museums seldom come directly from farmers but mostly second hand, without any data concerning the actual previous owners, through whom one might have been able to arrive at some conclusions.

Literature: Meyer-Heisig, p. 29, colorplate I.

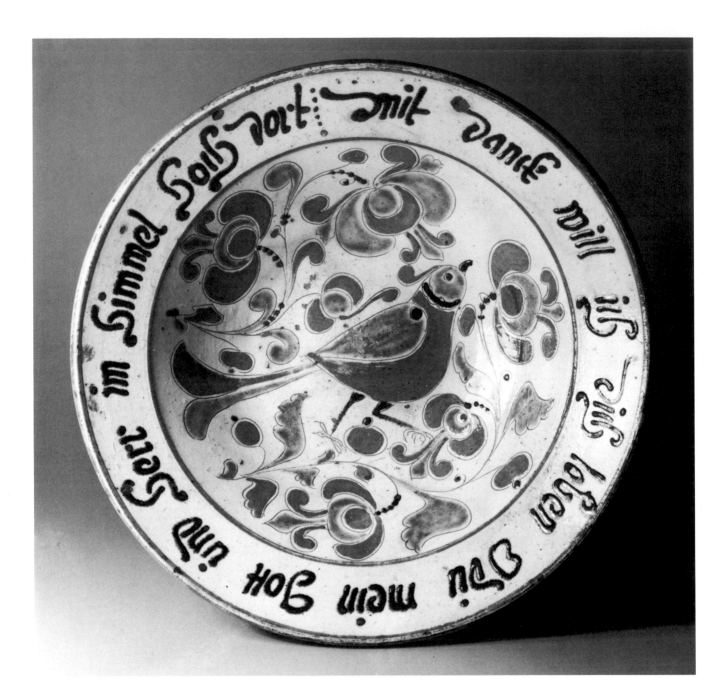

49.
Dish
Probstei (northeast of Kiel) (?), middle of the 18th
 century
Lead-glazed earthenware; red clay, whitish-yellow slip,
 decoration in reddish-brown, green and manganese,
 sgraffito
Diameter 31.5 cm., Height 7.6 cm.
Museum für Kunst und Gewerbe, Hamburg, Inventory
 No. 1881.172

The dish has a fairly flat base; on the inside it merges into
the wall, which on the outside rises sharply at a slant. The
border thickens a little as it slopes outwards; the thick-
ened edge slightly overhangs the border. The dish is
decorated on wall and center with a long-tailed bird and
above it and below it, in each case, with a curved tendril
with large tuliplike flowers. The border bears the
manganese-colored legend: *mit danck will ich dich loben
o du mein gott und herr im himmel hoch dort* (With
thanks I will praise Thee, O Thou My God and Lord in

Heaven above), obviously an excerpt from a hymnbook
or a prayer.

The dish comes from the surroundings of Lübeck. With
its generous, sweeping style of painting, the freely
executed legend and the color combination, it resembles
most closely the Probstei pottery wares, but it also could
have been made near Lübeck, where it was found.

Literature: Brinckmann, p. 262; Karlinger, ill. p. 381
below; Jedding (1976), p. 30, fig. 11; p. 91, no. 11.

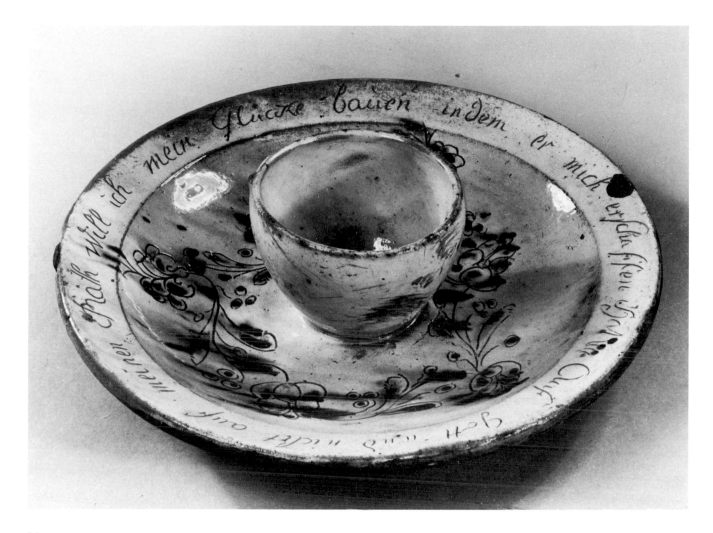

50.
Double Dish

Holstein (Probstei, northeast of Kiel) (?), end of the 18th
 century

Lead-glazed earthenware; reddish-brown clay, light-
 yellow slip, painted in brown, green and a little
 manganese, scratched drawing and legend

Diameter of the larger dish 28 cm., of the smaller dish 10
 cm., Height of the larger dish 4.7 cm., overall height 9
 cm.

Altonaer Museum in Hamburg, Norddeutsches Landes-
 museum, Inventory No. AB 369

The double dish consists of a flat, plate-like, larger dish,
whose base and wall merge into a trough shape and are
continued by a slightly rising border, thickening towards
the edge. In the middle a beaker-shaped bowl with steep,
slightly bulbous walls, rests directly on the base of the
larger dish without altering the latter's outside shape (in
contrast to nos. 102-104).

The center around the bowl is decorated with a sketchily
drawn and even more sketchily painted, almost mottled
flower tendril, and the border bears the inscription: *Auf
Gott und nicht auf meinen Rath will ich mein Glücke*

bauen indem er mich erschaffen hat (I will base my good
fortune on God and not on my own counsel, because He
has created me). The bowl is without decoration.

The double dish, whose function is explained in nos. 102
and 103, has the form, typical for Holstein, of the groats
or fish dish; this differs from the usual type from near
Flensburg in Schleswig, the northern part of the country,
particularly in the shaping of the bowl.

Literature: *Folklig Konst*, no. 67.

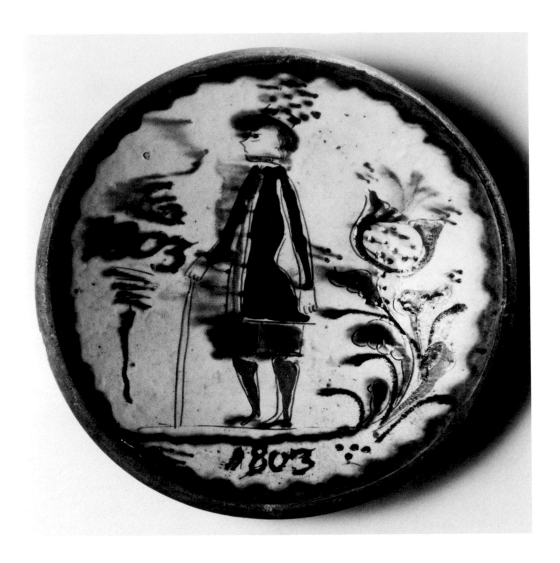

51.
Dish
Probstei (northeast of Kiel), dated 1803
Lead-glazed earthenware; red clay, inside light-yellow,
 outside brownish-yellow slip, painted in green, brown
 and dark (manganese) brown, sgraffito
Diameter 30 cm., Height 6.5 cm.
Schleswig-Holsteinisches Landesmuseum, Schleswig,
 Inventory No. OB 588

The plate-like dish has a flat, on the inside slightly convex, base which merges like a trough into the slightly sloping wall. The outside of the edge is thickened like a flange; on the inside it forms a very small vertical rim.

Base and wall are decorated with a strolling gentleman. He is wearing a tight-fitting, long-sleeved coat, knee-breeches and flat hat, and carries a walking-stick in his right hand. On his left, above a layer of lines, appears the date *1803*, which is repeated under the man. On his right, a tulip-shaped flower grows out of the base.

The dish is one of the later Probstei works decorated with large figures of persons; it was these that made Probstei pottery so well known and popular in the second third of the 18th century with their pictures of gentlemen and horsemen, ladies with deep décolleté and maids (see no. 48). That the potters in this region were always finding new variations on these designs, which occasionally even took into account changes in clothing fashions, is proof of the popularity of such pieces. To date there is no knowledge of any direct repetition of decors.

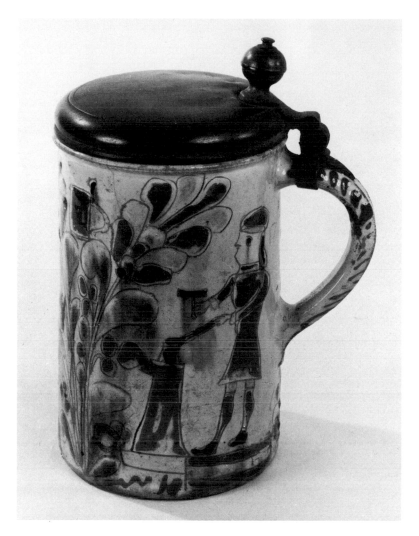

52.

Tankard with Pewter Lid

Probstei (northeast of Kiel), dated 1776

Lead-glazed earthenware, inside and outside; red clay, light-yellow slip, painted in reddish-brown, blended sea-green and a little yellow, sgraffito, pewter lid

Height including thumbpiece of the lid 25 cm., without 21 cm., Diameter below 12.5 cm., above 13.2 cm.

Schleswig-Holsteinisches Landesmuseum Schleswig, Inventory No. 1927.10

The tankard has the usual cylindrical form for such beer drinking vessels, with a flat base and a horizontally attached ear-shaped handle, formed out of a grooved flange. The upper edge projects slightly over the wall to provide a surface for the lid to rest on; the edge is drawn into a groove and forms a little rim around the mouth of the tankard.

The painting consists of a large leafy plant opposite the handle; on the top right of the plant stands a small tankard. Right, between plant and handle, a smith in a tight-fitting coat and cap is working at an anvil on the tiled floor; he has a hammer in his right hand and the workpiece in his left. On the other side, left between plant and handle, a gentleman, carrying a sword and wearing the fashionable jerkin, knee-breeches, shoes and tricorn, is walking behind a strutting bird, either a peacock or a rooster. Under the handle stands the date *1776*. The inside is not slipped and appears brownish-yellow through the glaze.

The flat pewter lid with its spherical thumbpiece has on top neither decoration nor legend. On the inside of the lid three stamps have been hammered in, in the shape of a triangle: the nettle leaf with the boat in the heart-shaped shield, the inspector's mark of the city of Kiel and below, the striding lion with *H F L 1761*, the master's mark of the Kiel tinsmith, Hans Friedrich Löwe (Master 1761; died 1806).

Tankards of this type in earthenware are fairly rare. It seems that the potters found they did not compete with either the pewter or the faience tankards. Early prototypes were the tankards in faience which came principally from the faience manufactory in Hannoversch-Münden in southern Lower Saxony but were also produced on a smaller scale in Kellinghusen near Itzehoe, north of Hamburg.

Literature: Schlee (1939), fig. 148; Hintze, vol. III, no. 1111.

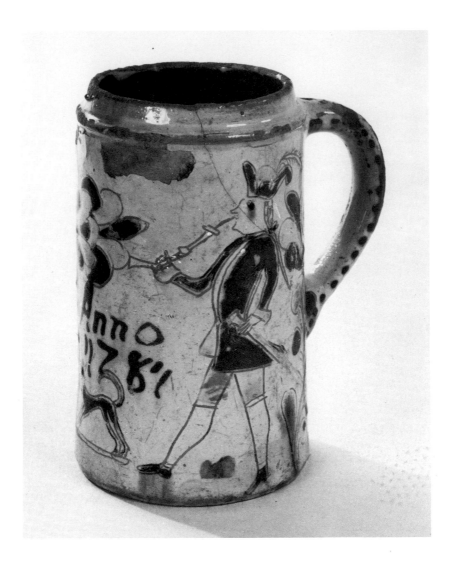

53.

Beer Tankard

Probstei (northeast of Kiel), dated 1781

Lead-glazed earthenware; greyish-yellow clay, light-
 yellow slip, painted in reddish-brown, sea-green and
 yellow, sgraffito

Height 16.5 cm., Diameter below 9.5 cm., above 9 cm.

Schleswig-Holsteinisches Landesmuseum, Schleswig,
 Inventory No. OB 1070

The tankard is appreciably smaller than no. 52, but has
the same form except for a slight narrowing of the
diameter in the middle. On the wall, opposite the handle,
stands the date *Anno / 1781* with two flowers above it and
a dog below it. On the right a gentleman is strolling,
fashionably dressed in jerkin, knee-breeches, shoes,
tricorn with feather over a pigtail, carrying a sword and

smoking a pipe. On the opposite side, a lady in a low-cut
bodice and long skirt is smelling a flower. On both sides
of the handle there is also a large flower.

The pewter lid is missing. But the hole in the handle for
attaching the lid is still there.

Literature: Schlee (1939), fig. 147.

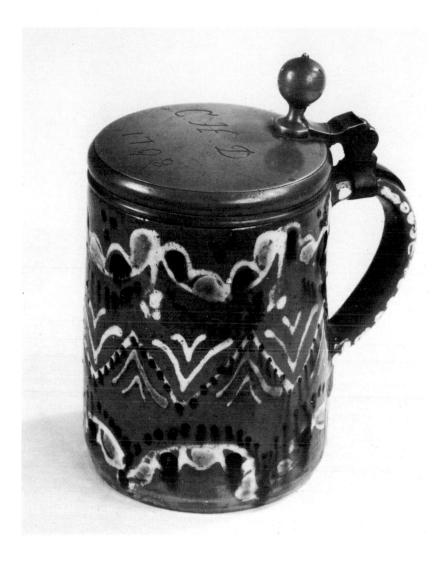

54.

Tankard with Pewter Lid

Probstei (northeast of Kiel) (?), pewter lid dated 1798

Lead-glazed earthenware, inside and outside; yellowish-brown clay, brown slip inside and outside, painted in manganese brown, white and green; pewter lid

Height including thumbpiece of the lid 18 cm., without lid 14 cm., Diameter below 10.5 cm., above 9.8 cm., Width with handle 15 cm.

Altonaer Museum in Hamburg, Norddeutsches Landesmuseum, Inventory No. 1955/15

This vessel has the usual form for beer tankards: a cylinder tapering upwards from a flat base and with an ear-shaped handle in the shape of a band, vertically attached. The wall is encircled with three ornamental borders, the middle one with jagged points, and the other two with symmetrical pendants. The painting of the handle consists of dots on the edges and cross bars.

The tankard is fitted with a flat pewter lid with a spherical thumbpiece and the engraved inscription: .C.H.D. / 17.98. The inside bears the mark of the Lübeck tinsmith, Diedrich Christian Augustins (1737-1812); the outside, the Lübeck inspector's mark.

It is possible to ascribe the tankard to the Probstei mainly because the Kiel dealer stated that she had acquired it there. The reverse coloring on the tankard—a dark background on which the painting is lighter—is typical of that seen on many pieces made in the Probstei in the first half of the 19th century (see also no. 66). This apparently conformed with a change in the taste of the customers. It is possible that the date of the tankard is somewhat later than that of the lid, for lids were often used again when their original tankards had been broken.

Nothing exact is known about the use of beer tankards as compared with beer bowls. It appears, however, that beer tankards, which to date have only occurred as single specimens, were meant for the use of the individual alone, whereas warm beer and cold soup dishes were used on major festive occasions for communal drinking. ("Cold soup" was the name given to cold fruit soups as well as to cold mixed beverages of beer or wine, honey and spices.)

Literature: Hintze, vol. III, no. 1500.

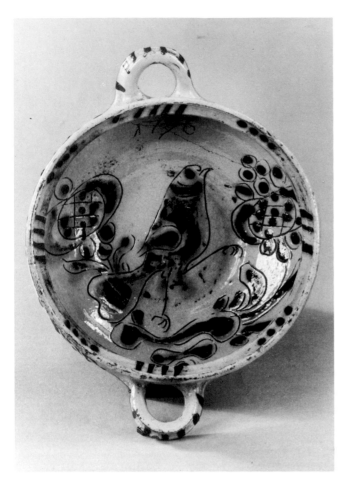

55.
Warm Beer Dish
Probstei (northeast of Kiel) (?), dated 1796
Lead-glazed earthenware; red clay, light-yellow slip, painted in brown and green, sgraffito
Diameter 16.5 cm., Width with handles 23.5 cm., Height 7.5 cm., cracked on top
Altonaer Museum in Hamburg, Norddeutsches Landesmuseum, Inventory No. 1583

The little two-handled dish has the same form as the following nos. 56-61. The little base on the outside forms a flat shoe. The wide, sloping wall is concave and pulled in at the top; a narrow rim with a sharp outward bend is attached. The two eyehook-shaped handles are added to the shoulder of the wall and have a band-like profile.

The center and the lower, slanting sector of the wall are decorated with a strutting bird and two flowers rising out of the same background; above is scratched in the date *1796*. The inside of the rim is decorated with rows of dots and layers of lines; the shoulder of the wall outside, on both sides of the handles, with a flower and hook patterns; the handles are hatched in brown. The outside below the shoulder is unglazed. An unknown potter's mark has been scratched into the base—it looks like a double *C, G* or *D*.

Like the warm beer dishes of the following catalogue numbers this piece was also acquired for the museum in the Vierlande, southeast of Hamburg, without, however, the exact provenance being noted in the inventory. A second piece belonging to the same set was lost in World War II. For use and place of production see nos. 56-58.

56-58.
Three Warm Beer Dishes
Probstei (northeast of Kiel) (?), dated 1830 and 1832
Lead-glazed earthenware; red clay, cream-yellow slip which appears yellow under the glaze, painted in light-brown and green, scratched drawing and legend appear dark-brown
Diameter 17.3 to 17.5 cm., Width with handles 24.5 to 24.8 cm., Height 7.5 cm.
Museum für Kunst und Gewerbe, Hamburg, Inventory Nos. 1903.469 c,e,f

The little dishes have a small flat base, which on the outside is used as a foot; the sloping wall is attached with a definite bend; the rim is pulled in at an angle, and the edge on the outside is not thickened and has two eyehook-shaped handles. Rim and edge are also glazed on the outside.

Center and wall are decorated as follows: in *c*, with a cock crowing and strutting on a tulip, and above, the initials *L B . RK. / 1830;* in *e*, with a Vierlande farmer between two leafy plants, dressed typically for this region in a top hat, jacket with silver buttons, knee-breeches and flat shoes, and carrying a stick and a meerschaum pipe; above are the initials *L B R K / 1832;* in *f*, between two leafy plants, a Vierlande peasant girl, easily recognizable as such from her broad-brimmed straw hat, her bonnet with the big bow (known as *Krei,* or "crow"), the close-fitting waistcoat with bodice visible from the front, relatively short skirt with apron, and a flower in her hand as a sign of the widespread cultivation of flowers in the Vierlande. Above again are the initials *L B R K / 1832,* and below also *1832* but smaller. The edge is additionally decorated on the inside with groups of lines and dots in brown and green, the rim on the outside with groups of hook-shaped and branch-like ornaments in brown and green, and the handle with brown lines.

The three dishes belong to a set of the same vessels which, when purchased, still numbered eight of originally many more pieces. Meanwhile only six survive. The other three (Inventory nos. 1903.469 a, d, g) show under the same initials *L B R K* a farmer dated *1830,* a soldier dated *1832,* and a dove dated *1830.* They were acquired by Hermann Riecken in the village of Kirchwerder in the Vierlande. According to his information, the initials refer to his grandmother, *Lisb*eth *Riek*en.

The Vierlande, a fertile marshy region which consists of four villages lying on the right bank of the Elbe, southeast of Hamburg, is part of the territory of the Hanseatic city and has for centuries been its most important nearby source of supply for grain, vegetables, fruit and—since the end of the 17th century—flowers, all of which meant considerable prosperity for the inhabitants. For the provenance of these dishes, one assumes a village in the Vierlande itself or the little town of Bergedorf which functioned as a center. But as no other household pottery wares of any note are known to have come from there, and as the dishes in form and decor show a great similarity to the pottery wares of the Probstei, it seems that they were probably products of the latter which were bought as dowry articles in the Bergedorf market, ordered in two separate lots. However, the provenance has also been ascribed to Lauenburg or to the northern part of the former Kingdom of Hanover, the modern Lower

Saxony. But no other comparable pieces have been found there.

These little dishes are drinking vessels. On festive occasions they were used to serve warm beer. Made out of home-brewed, top-fermented beer, often with spices added, warm beer was, until the middle of the last century, the most important drink for festive occasions in North Germany before its place was taken by tea and coffee or cold, bottom-fermented "Bavarian beer" and wine. As the dishes were also often used at the very long drinking sessions after funerals to serve the so called *Dodenbeer* (dead beer), in some places they are known as "*Liekbeerschöteln*" (corpse beer dishes). When not in use, they were usually hung up for display so that all could appreciate the prosperity of the house.

Literature: Jedding (1976), p. 40, fig. 21; p. 95, no. 21; Meyer-Heisig, p. 28.

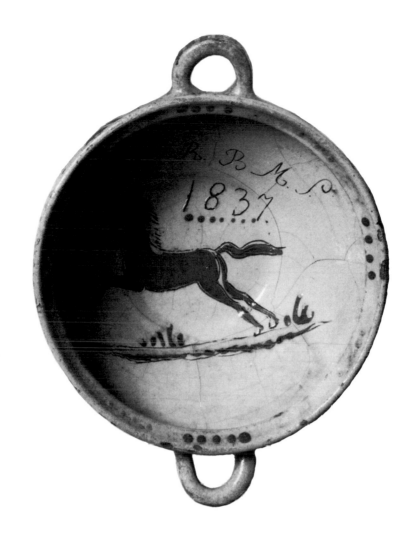

59-61.

Three Warm Beer Dishes

Probstei (northeast of Kiel) (?), dated 1837

Lead-glazed earthenware; red clay, cream-yellow slip which appears yellow under the glaze, painted in reddish-brown, scratched drawing and legend appear dark-brown

Diameter 17.8 cm. to 18.6 cm., Width with handles ca. 24.5 cm., Height 7.7 cm. to 8.3 cm.

Museum für Kunst und Gewerbe, Hamburg, Inventory Nos. 1902.360, 362, 364

For form, provenance and use see nos. 56-58. The dishes quite obviously came from the same workshop and were also acquired in the village of Kirchwerder in the Vierlande. Under the initials *G. D. R. B. M. S.* and the date *1837,* they are decorated respectively with a ship of the stumpy barge type and a repetition of the date *Anno 1837* (1902.360), a three-stalked flower (1902.362) and a horse (1902.364). The museum possesses a fourth dish of this set with the picture of a three-stalked flower (1902.361). In addition, the edge on the inside is decorated with groups of dots in brown and green, the outside of the rim with branch-like ornaments in brown and green, and the handles with brown stripes. The barge, fitted with a squat mast for a square sail, was the oldest type of vessel on the Lower Elbe and was used not only for fishing but also for the transport of vegetables, fruit and flowers from the Vierlande to Hamburg. It has not been possible to determine what the initials on these dishes stand for.

The Museum für Kunst und Gewerbe possesses a further set of five dishes of exactly the same type, dated 1841. Under the initials *M L A B* (= *M*agdalene *Al*be*rs*) they are decorated with a cock, a horse, a flower, a hare and a dove respectively (1906.144-148). These dishes from the same pottery must have come into fashion in Kirchwerder after a farmer's daughter or wife had started buying such articles.

Literature: Jedding (1976), p. 95, no. 21.

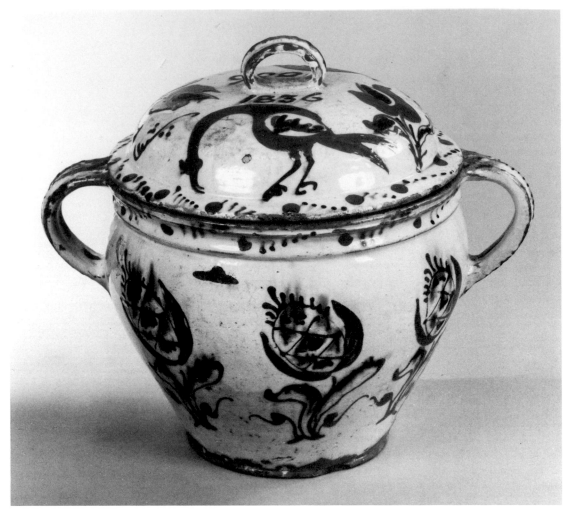

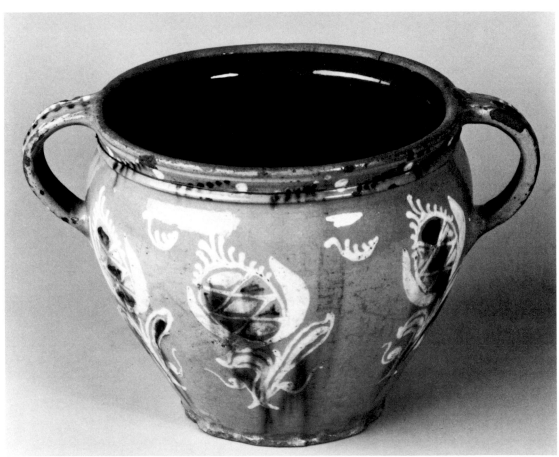

65.
Harvest Pot with Lid
Probstei (northeast of Kiel), dated 1836
Lead-glazed earthenware, inside and outside; light-
 brown to yellow clay, no slip inside, painted in brown,
 dark-brown and green
Height without lid 24 cm., with lid 34 cm., Diameter 29
 cm., Width with handles 39 cm.
Schleswig-Holsteinisches Landesmuseum, Schleswig,
 Inventory No. 1914, 45 a + b

The outside of the base projects slightly in a flange. The
wall rises at a slant for the first two thirds of its height; in
the last third it bends in, forming a bulge, and ends in a
slightly projecting fluted edge. From the upper edge, two
handles are attached running vertically downwards. The
lid, unglazed inside, has an almost horizontal edge, is
slightly curved, and has in its center a ring-shaped,
grooved handle. The wall is decorated with six large
tulips, which resemble those of nos. 62 and 63; while the
lid is decorated with two long-tailed birds, painted in
sweeping style, two tulips and the date *1836*, which
occurs twice. Edges, handles and the lid handle are
brightened by a succession of large and small spots or
rows of little spots.

Large pots such as these do occasionally occur in other
parts of Schleswig-Holstein (see no. 86) as well as in some
Danish districts, but they were nowhere so frequent as in
the Probstei and have become one of the most noticeable
products of the Probstei potters. They were used to carry
soup to the harvest workers in the fields. The grain
harvest, although heavy work, was regarded as a festive
occasion which brought in the wages for a year's toil;
hence these pots were lavishly decorated. The earliest,
rather smaller examples, date from the end of the 18th
century; they did not acquire their imposing size until the
beginning of the 19th century. Elsewhere, workers in the
fields were supplied, as was usual everywhere in Europe,
from the normal pots with handles (see 42, 67-69). The
Probstei was a fertile district with a relatively prosperous
and free peasantry who lived in the midst of nobles'
estates that were worked by serfs. The Probstei was
originally monastic property; hence, many special cul-
tures had developed there. Some were distinguished by a
definite separation from the aristocratic way of life,
others by an imitation of it in many respects, including a
pronounced sense of social status, manifested by a display
of prosperity in the form of buildings, clothing and
household furniture and fittings.

The harvest pot was acquired from the village of Prob-
steierhagen.

66.
Harvest Pot
Probstei (northeast of Kiel), ca. 1835/40
Lead-glazed earthenware; reddish-brown clay, outside
 orange-brown, inside no slip, painted in white, green
 and dark-brown
Height 27 cm., Diameter 20.5 cm.
Städtisches Museum Flensburg, Inventory No. 10705

The pot has almost the same form as no. 65 only it is
somewhat larger. The lid, and thus probably the date as
well, has been lost. Apart from four additional little
leaf-like curlicues, the decoration is remarkably like that
of the pot previously described, only the color effect is
reversed. The pot is thus an example of the change of
coloring which frequently occurred in the Probstei
towards the middle of the 19th century. When the light
slip is replaced by a dark slip, the colors of the decoration
must accordingly change from dark to light.

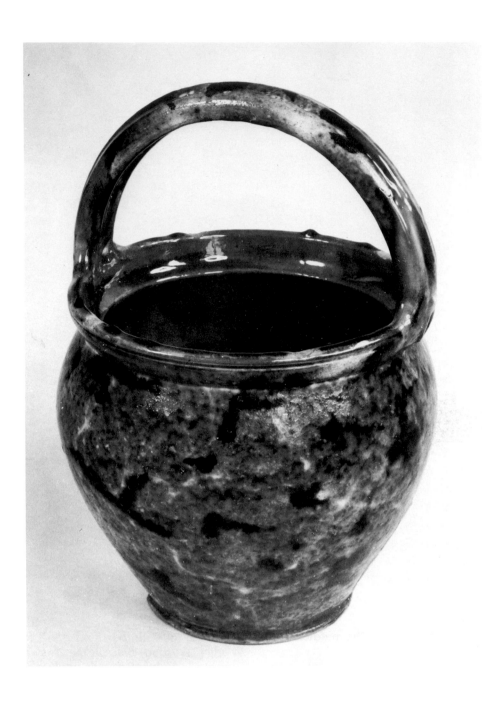

69.
Handled Pot
Probstei (northeast of Kiel), middle of the 19th century
Lead-glazed earthenware, inside and outside; light-
 brown to yellow clay, no special slip, marbled, sprayed
 decor in green and dark-brown, not slipped inside and
 appears olive-brown through the thick glaze
Height with handle 34.3 cm., without 21.5 cm., Diameter
 22 cm.
Schleswig-Holsteinisches Landesmuseum, Schleswig,
 Inventory No. 1924.102

Apart from the fact that this pot, which is meant for everyday use, is considerably larger than the two preceding pieces (nos. 67 and 68), there are only minor differences in form. Most conspicuous is the slight undulation of the edge, caused—unintentionally—by dark-brown drops of glaze leaking at irregular intervals. The lid has been lost. In the painting, through which the grain of the clay surface can partially be seen, coloring dominates. In it, the dark-brown spots of various sizes are relatively loosely distributed.

Vessels with dark-green sprayed decors and slips were, alongside the light-yellow and manganese black, another principal product of Probstei potters in the middle of the last century. It is possible that all these dark-green wares come from the same workshop, but its location and even its name are unknown. This pot was acquired in the village of Heikendorf which lies in the Schrevenborn Estate directly on the Kiel fjord, on the boundaries of Probstei territory.

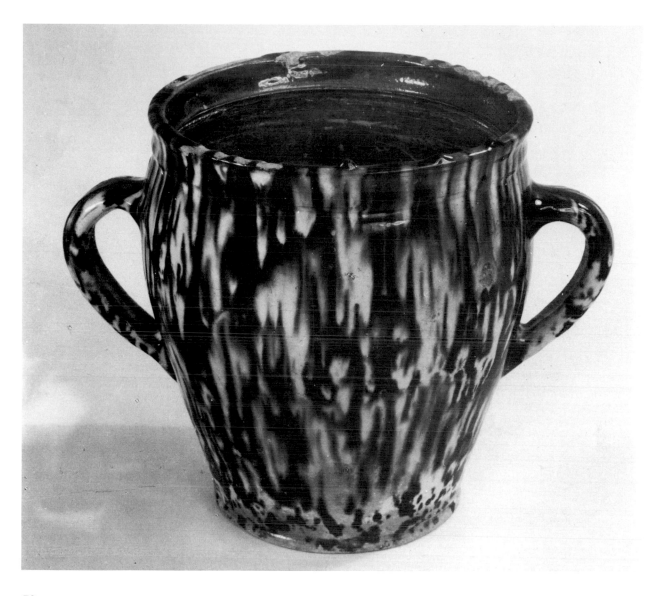

70.

Preserving and Storage Jar

Probstei (northeast of Kiel), middle of the 19th century

Lead-glazed earthenware, inside and outside; light and brownish-yellow clay, whitish-grey slip, marbled in manganese

Diameter 19 cm., Width with handles 19 cm., Height 22 cm., edge chipped

Altonaer Museum in Hamburg, Norddeutsches Landesmuseum, Inventory No. 1954/132

The jar has a flat base, encircled on the outside by a small groove. The high wall bulges outwards and narrows again somewhat at the top. Round the mouth of the jar runs a rim, curved slightly inwards and separated from the wall by a thick bend. The rim regains its normal wall thickness at the edge. This rim profile enables the jar to be closed by tying paper or cloth round the mouth or fitting a ceramic or wooden lid over it. Two vertical ear-shaped handles are attached to opposite sides of the jar, just above the center.

The marbling is achieved by a spray application of manganese brown. The inside of the jar is not slipped and appears olive-green to brownish-yellow through the glaze.

For use see no. 105. The storage of pickled foods has caused considerable damage to the glaze inside the jar.

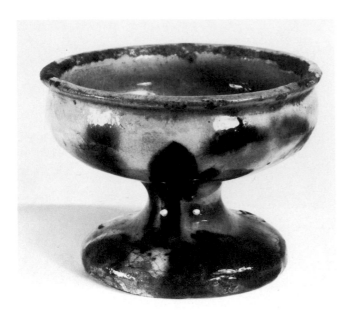

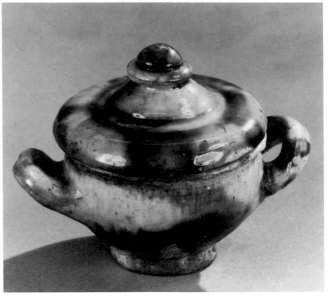

71.
Salt-Cellar
Probstei (northeast of Kiel), 1st half of the 19th century
Lead-glazed earthenware, inside and outside; greyish-
 yellow clay, greyish-yellow slip, marbled in green,
 brown, light greyish-brown
Height 5.9 cm., Diameter 7.9 cm.
Schleswig-Holsteinisches Landesmuseum, Schleswig,
 Inventory No. OB 694

The little vessel in the form of a squat goblet with a pulled
out edge is slipped inside and out, but marbled only on
the outside. It is one of those little receptacles for
everyday use which were produced in large numbers but
of which only few examples have survived.

72.
Salt-Cellar with Lid
Probstei (northeast of Kiel), middle of the 19th century
Lead-glazed earthenware; brownish-yellow clay, white
 slip appears light-yellow through the glaze, painted in
 green and ochre
Diameter 7.5 cm., Width 11 cm., Height with lid 8 cm.,
 without 5 cm.
Altonaer Museum in Hamburg, Norddeutsches Landes-
 museum, Inventory No. 1955/61 a + b

The pot has the form of a tureen lid with eyehook-shaped
handles at the side. The bowl has a small foot and an edge
curved slightly outwards. The lid lies in a groove and is at
first flat and then cone-shaped up to its button-like grip.
The inside of the lid is unglazed.

The piece need not be a salt-cellar; it could also have been
used as a toy for a doll's kitchen, although, to judge by
similar pieces in the Altonaer Museum, it would have
been rather too big. However, such pieces were fre-
quently produced for both purposes.

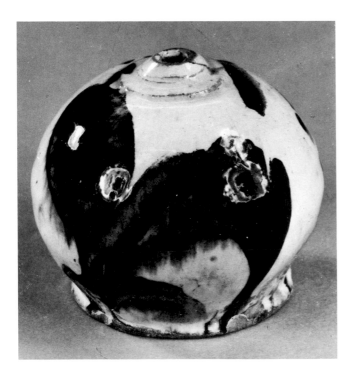

73.
Piggy Bank
Probstei (northeast of Kiel), middle of the 19th century
Lead-glazed earthenware; brownish-yellow clay,
 whitish-yellow slip, marbled in manganese
Height 6 cm., Diameter 7.5 cm.
Altonaer Museum in Hamburg, Norddeutsches Landes-
 museum, Inventory No. 1954/168

The spherical little vessel, shaped on the wheel, has
attached to it, as a base, a foot resembling a baluster. On
top it has a slightly pulled up hole and beneath it a slit. The
marbling is limited to a few large spots. Similar pear-
shaped money-boxes are known in Germany from
Roman times (2nd—3rd century), the Middle Ages and
the Renaissance.

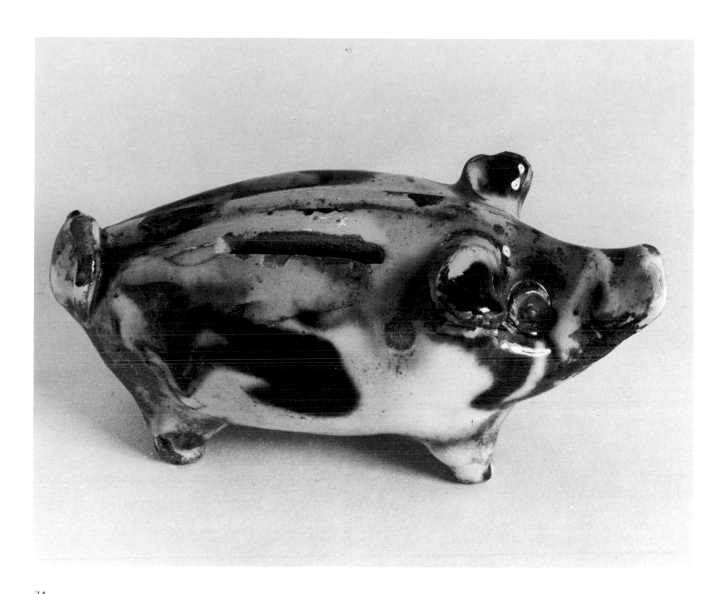

74.

Piggy Bank

Probstei (northeast of Kiel), middle of the 19th century
Lead-glazed earthenware; brownish-yellow clay,
 whitish-yellow slip, marbled in manganese, brown and
 ochre
Height 5.5 cm., Length 12.5 cm., Width 5.5 cm.
Altonaer Museum in Hamburg, Norddeutsches Landes-
museum, Inventory No. 1970/462

This pig is freely formed, has a pointed snout, deep-set
eyes, protruding ears and a curly tail; it has a slit on its
right flank. The marbling has been sprayed on in various
colors but leaves exposed the light background as the
main color.

Money-boxes in the shape of animals have been known in
Germany since the 17th century. The pig in particular has
been regarded since early times as a talisman. The pig is
fertile and useful, and it was said that it could unearth
hidden treasures with its snout. As Antonius Pig, a
money-box dedicated to St. Antony the Hermit (the
patron saint of beggars and the sick), it could be used, as
was the custom in some rural districts, as a collecting box
for the purchase of a slaughtered pig to feed the sick and
the poor. Money-boxes in the form of a pig were
particularly popular in the Scandinavian countries. Thus,
this piggy bank represents both the Low German and the
Danish-Scandinavian tradition.

Such pottery products, savings pots and piggy banks,
mostly date from the 19th century in Schleswig-Holstein,
but were probably being produced much earlier in large
quantities as little presents for old and young alike. For
instance, there is a Lübeck piece dating from about 1500.
But, as they only yielded their contents when they were
broken, only very few examples have survived and today
they are rarities.

Literature: Kroha, *Sparbüchsen,* in particular ills. pp. 11,
15, 19, 23, 31.

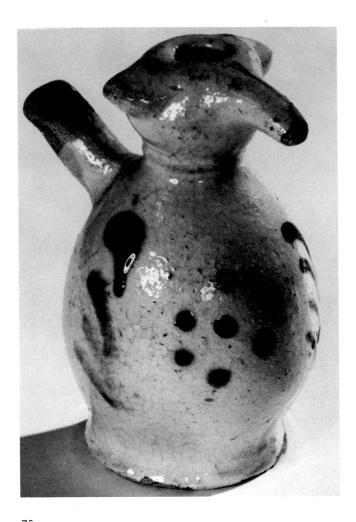

75.

Water-flute (Nightingale)

Holstein, middle to 2nd half of the 19th century

Lead-glazed earthenware; greyish-white to yellow clay,
 whitish-yellow slip, painted in brown, reddish-brown,
 green and ochre

Height 9.5 cm., Diameter 5.8 cm., Width with
 mouthpiece 7 cm.

Altonaer Museum in Hamburg, Norddeutsches Landes-
 museum, Inventory No. 1928/198

The hollow water-flute consists of a bulbous, flask-like
vessel with a flat base. The upper part is made out of a
sphere partially thrown on the wheel and molded by hand
into a shape resembling a bird's head with a long beak.
Attached to the belly, just below the pulled in neck, is a
tubular mouthpiece, flattened at the end into a slit. The
belly was filled with water up to just below the
mouthpiece. On a flute like this it was possible to give a
splendid imitation of bird and animal noises.

Such simple children's toys in this or other forms were
produced as a sideline by almost all potters both as
presents for the neighbors' children and for sale on the
market. Although such toys were widely used, they were
usually fairly quickly broken by the children so that very
few pieces have survived.

This example came to the museum from the fishing village
of Blankenese, west of Hamburg. It was probably
acquired from one of the South Holstein potters at one of
the nearby markets.

Literature: Schwindrazheim, pp. 7-8, fig. 8.

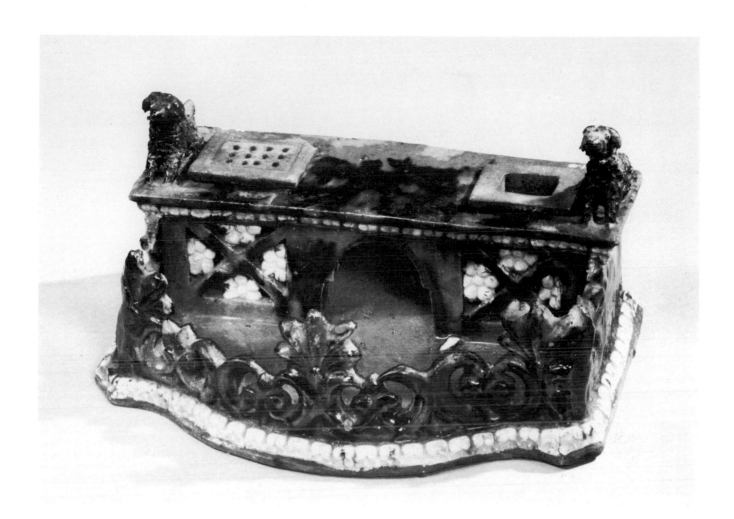

76.
Ink Stand
Probstei (northeast of Kiel)(?), end of the 18th/beginning
 of the 19th century
Lead glazed earthenware, sculptural design and pierced
 work; reddish brown clay, brown slip, painted in
 manganese black and white
Length 19 cm., Width 12.8 cm., Height 6.5 cm.
Schleswig-Holsteinisches Landesmuseum, Schleswig,
 Inventory No. 1905.27

On the back part of a baseplate, which projects in a
sweeping curve, stands a table-shaped box with an arched
opening in the center under the table-top. In each of the
two fields at the side are four white flowers in a diagonal
lattice pattern. The two rectangular receptacles for ink
and sand are set in the "table," and both are guarded on
their outer sides by black, freely modelled poodles. On
the front of the baseplate is a banister of palmette leaves
and *rocaille*-shaped spirals, which have obviously been
molded with forms. White borders surround the edge of
the baseplate and the lower rim of the table. The marked
off part of the table served for keeping articles such as
quills and penwipers.

As with no. 78, ink stands were also included among the
special wares which local potters set themselves to
produce, based on prototypes of faience and stoneware.
This was in addition to their normal manufacture of
standard ware. In this case the market must have been

profitable enough to justify the production of forms for
the parts of the lattice work, for the flowers and for the
relief of the white rims, though one can assume that such
ornaments could be used on other productions in a
different combination.

We do not know the prototype for this piece, but the
faience manufactories, especially in Kellinghusen near
Itzehoe, north of Hamburg, produced many ink stands in
several variations in the last quarter of the 18th century.
These enjoyed great popularity in Schleswig-Holstein
and show many similarities with this piece. In this case at
any rate, they probably inspired the local potters more
than the otherwise much admired English stoneware,
particularly as the Kellinghusen faience ink stands, gener-
ally painted in blue or a mixture of colors on a white
background, occasionally occurred wholly or partially in
black.

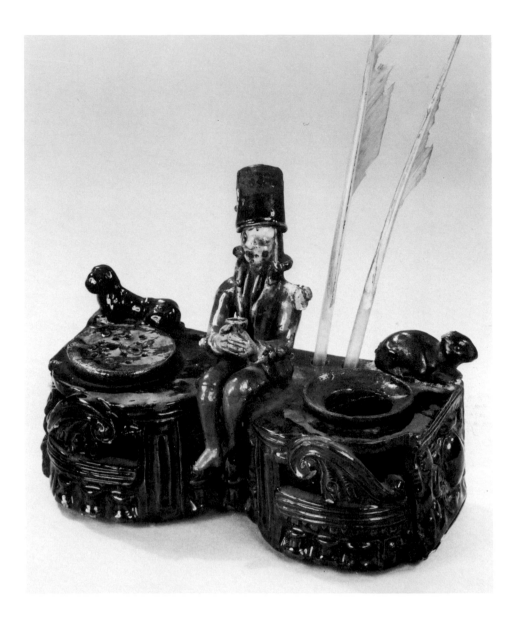

77.

Ink Stand

Schleswig-Holstein, end of the 18th/beginning of the
 19th century

Lead-glazed earthenware, sculptural design and pierced
 work; brownish-yellow clay, manganese black and
 brown slip, some parts painted in white and yellow.

Length 17 cm., Width 7.8 cm., Height 6.2 cm., with
 figure 15 cm.

Schleswig-Holsteinisches Landesmuseum, Schleswig,
 Inventory No. 1921.583

The ink stand is shaped as a rectangular, table-shaped
box. It has been widened in the front by two half
cylinders to accommodate the inkwell and the sandbox. A
putto and a cartouche in relief decorate the sides; the front
is pierced in several places and ornamented with architec-
tural motifs such as volutes and small balusters. Between
inkwell and sandbox, with his legs between the two half
cylinders, sits a man in a uniform jacket with one
epaulette and buttoned knee-breeches, with pigtail and
top hat, in the military style of the end of the 18th
century. In his hands he holds a large pipe, the stem of
which is lost. On the back corners lie a dog and a hare,
facing outwards. Between the two are six holes for
holding quills. Except for the face, hands, epaulette and

buttons, which are painted white and yellow, everything
else is dark brown to match the slip.

Like no. 76, this ink stand is an example of the local
potters' efforts to compete with the products of the
faience manufactories. The exact provenance of this
piece, which was acquired commercially, is obscure, but
it could be the Probstei. The form of the utensil and the
fashionable clothing of the sitting man indicate a date at
the end of the 18th rather than the beginning of the 19th
century. The late rococo ornaments pressed on with
forms continued to be used by rural potters for a
relatively long time, particularly if forms were available.

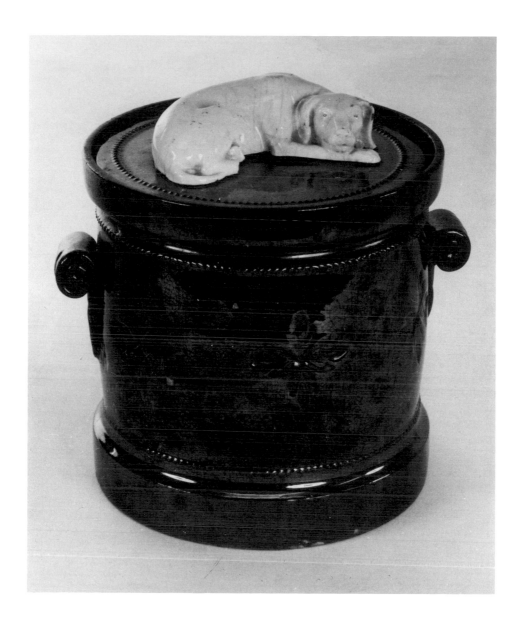

78.

Tobacco Jar

Probstei (northeast of Kiel), 1st quarter of the 19th century

Lead-glazed earthenware, outside and inside; light greyish-brown clay, uniform manganese black slip; the dog is white

Height 15.5 cm., Diameter 15.5 cm.

Schleswig-Holsteinisches Landesmuseum, Schleswig, Inventory No. 1908.3

The jar stands on a wide foot and is cylindrical in shape, with a hardly noticeable bulge. At the top, after a small flange and a groove, it ends in a projecting rim of uniform thickness, like the rim of the foot, but of slightly less height. The flat lid fits into the rim, and its grip is a sculptured recumbent watchdog. The decoration consists of two handles of clay rolled into a volute shape; three four-leafed flowers on both sides of the cylinder wall; and little strings of pearls circling the foot, the flange below the rim and the center of the lid.

This jar fits into the same cultural-historical context as the tureen lid (no. 108). The decoration with strings of pearls is based on the corresponding English stoneware prototypes. The dog was probably copied directly from an English model.

Like ink stands and other vessels not intended for daily use, tobacco jars were used by potters to experiment with fashionable trends in order to keep pace with their customers' demands. With such wares they were trying, outside their normal production, to adapt forms and colors from products in other materials to their own wares: in the 18th century from the technically related faience; in the 19th century mainly from the popular stoneware; and towards the end of the century, even from porcelain. Even when, as in the case of the Probstei, these had no effect on the production of normal standard ware, sales of these special wares seem to have been sufficient—as in the case of this tobacco jar—to produce forms specially for sculptural decoration.

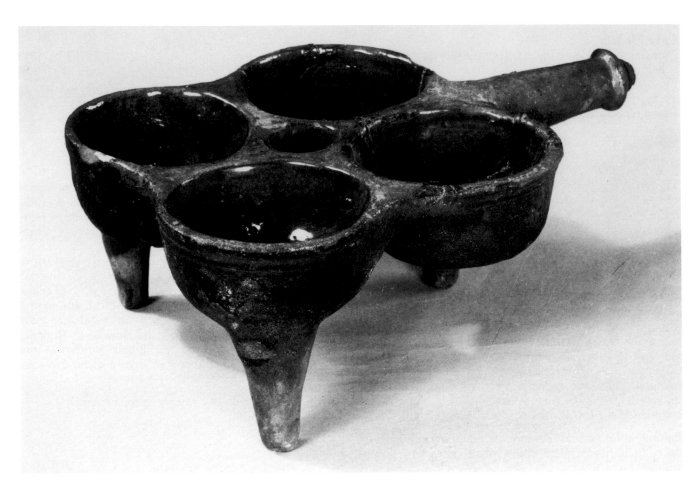

81.

Baking Mold for Pancakes *(Förtchenpfanne)*
Schleswig-Holstein, beginning of the 19th century
Lead-glazed earthenware; greyish-yellow clay without
 slip; the more or less thick glaze appears olive-green to
 brown through the various colorings and firings
Length 26 cm., Height 8.9 cm.
Schleswig-Holsteinisches Landesmuseum, Schleswig,
 Inventory No. OB 885

Four hemispherical bowls are arranged in a square. The
center is shaped into a round hole, and on one side has
been added a handle ending in a profiled button. Of the
three round, rather bent legs which taper downwards,
one has been molded on directly beneath the handle
attachment; the other two have in each case been fixed
into the corners of the bowls on the opposite side. The

coloring in the interior is olive and on the handle, brown;
the pan in not glazed on the outside.

For use see no. 80. The small number of bowls (also
known as "eyes" in Schleswig-Holstein) in comparison
with other pans indicates the mold was used in a small
household, such as that of a retired farmer.

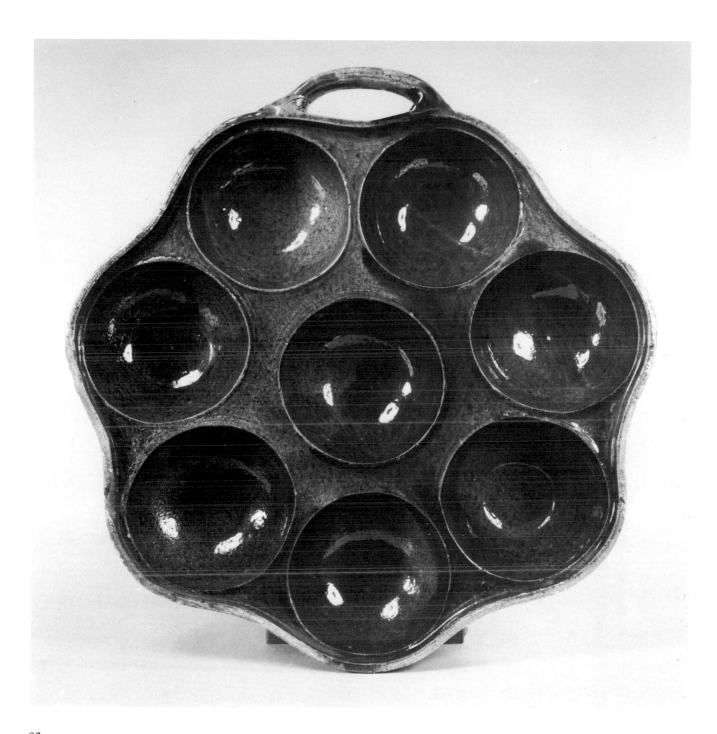

82.

Baking Mold for Pancakes *(Förtchenpfanne)*
Hamburg-Altona or southern Holstein, 1st half to mid-
 dle of the 19th century
Lead-glazed earthenware; whitish-grey to yellow clay,
 manganese colored slip
Diameter 34.5 cm., Length with handle 36 cm., Height
 5.5 cm.
Altonaer Museum in Hamburg, Norddeutsches Landes-
 museum, Inventory No. 1938/26

The pan has one of the most popular shapes for this purpose, common everywhere in North Germany (see also no. 13). Round a hemispherical bowl in the center are grouped six or, as in this case, seven similar bowls, all linked by a plate and surrounded by a common, rather higher rim. A flat handle like an eyehook makes the pan easy to hold or to hang on a hook. Slip and glaze cover only the upper side of the pan and parts of the handle.

The pan comes from an inn in Altona. (The present Hamburg district of Altona was until 1937 an independent town belonging to Schleswig-Holstein.) The pan was either made by a potter in the town or, equally likely, by a potter from Holstein who supplied the Altona market.

For use see no. 80.

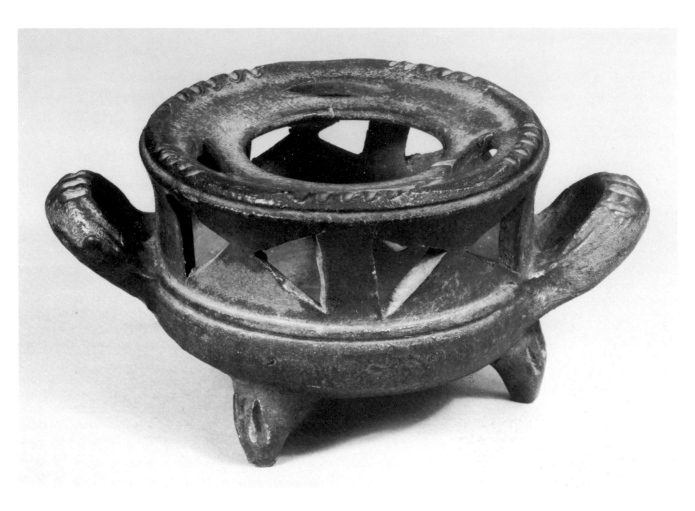

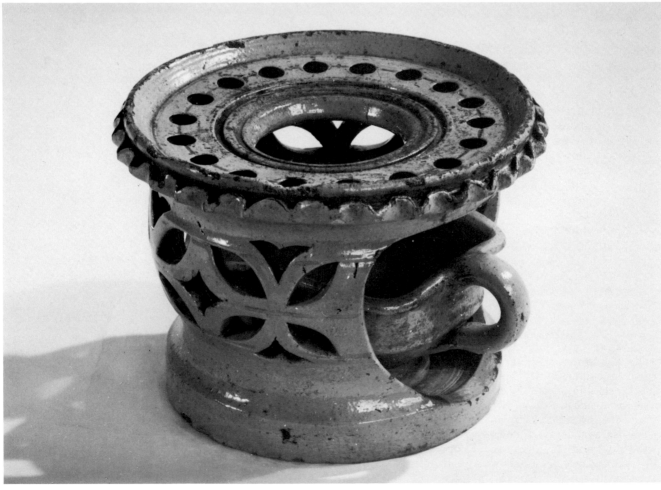

83.

Teapot Warmer

Lütjenburg (in East Holstein, east of the Probstei), 1st half of the 19th century

Salt-glazed earthenware, pierced work; red to reddish-brown clay, appearing dark-brown in the glaze

Diameter 13.5 cm., Width with handles 20 cm., Height 9.4 cm.

Schleswig-Holsteinisches Landesmuseum, Schleswig, Inventory No. 1930.272

This round vessel has a flat base and three legs tapering to a point, each with three vertical grooves. The wall has a flange below, is pulled slightly inwards and ends in a fluted, flanged edge. The edge has a base for supporting the pot to be kept warm. This base, sunk inwards and cut out in the middle, has at each side a lancet-shaped hole. Cut out of the wall are, on each side, two triangles with their apexes almost touching. On the base have been added two powerful, eyehook-shaped grips, set at a slant. Notches on the upper edge and on the grips provide further ornamentation for this piece, which has no colored decoration.

This utensil is also one of those products which North German potters took up, at the earliest, at the end of the 18th century, but in general not before the 19th century. It came in with the habit—not to say fashion—of drinking tea, which was introduced in the 18th century and quickly became particularly widespread in many districts of North Germany and in the small towns. In the country, however, the custom spread only after the beginning of the 19th century. Previously teapot warmers, also called tea cosies, had been of brass, but now potters too began to make them. Many such earthenware teapot warmers have survived from East Frisia, the region in Germany with the highest tea consumption (see no. 84). They were used with a little clay bowl for holding charcoal or peat.

The salt-glaze is unusual for East Holstein. It was seldom used at all in pottery in North Germany, as salt requires for evaporation the higher temperatures needed for firing stoneware, and the clays were mostly not suitable for this. But this teapot warmer is also not stoneware in the strict sense. It was obviously fired to a greater heat than earthenware normally was, but has been subjected to a sintering (welding) process in the lower part only.

84.

Teapot Warmer with Insert for Embers

East Frisia, middle of the 19th century

Lead-glazed earthenware with pierced work; light greyish-yellow clay, brownish-yellow slip, yellow colored glaze

Height 11.7 cm., Diameter below, 13 cm., above 16.5 cm.; Height of insert 5.8 cm., Width and Depth above 10.5 cm., below 9.5 cm.

Altonaer Museum in Hamburg, Norddeutsches Landesmuseum, Inventory No. 1968/268, a + b

The round teapot warmer consists of a squat, baluster-shaped pot with pierced wall and a wide projecting cover plate with a double edge; the lower edge is wavy in shape and pinched in below. The base on which the teapot stands is rather deepened, has a large hole in the center and is surrounded by eighteen small holes. The piercing of the wall forms an abstract flower design. One third of the wall is cut out in the shape of a heart to allow the insert to be pushed in. Glaze covers the outside except for the base, and inside, the upper two thirds including the teapot stand. The insert holds charcoal or peat, and is known in East Frisia as a *Teste;* it is a cup-shaped bowl with a handle at the side, with an almost square upper rim. The only part that is glazed is the side with the handle that remains visible after insertion into the teapot warmer.

According to the previous owner, who lives in Wilhelmshaven, the teapot warmer comes from East Frisia. In form, pierced work and glaze, it corresponds to the workmanship usual there in the first half of the 19th century. For use see no. 83.

Curiously enough, except for these utensils for keeping teapots warm, no other lavishly designed pottery ware from East Frisia is known. Possibly the reason was that the competition from Netherlandish and, in particular, Frisian faiences was so severe that local potters could find no market for more expensive wares.

Literature: Meyer-Heisig, p. 26.

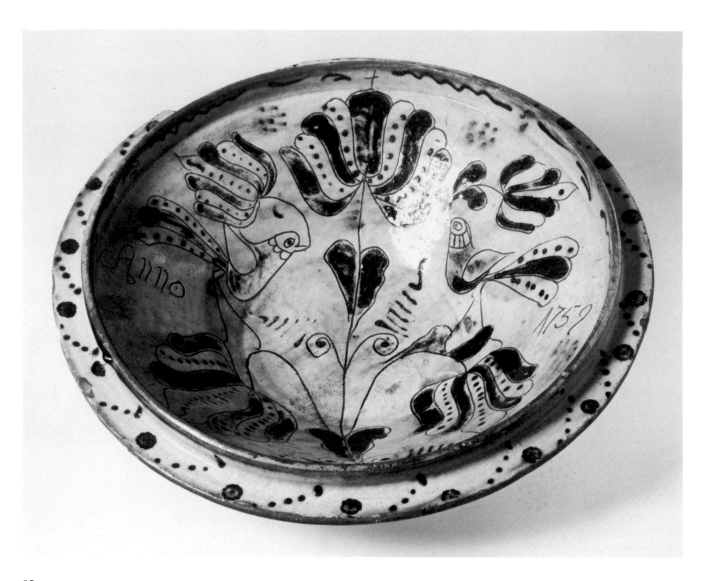

85.
Dish
Tellingstedt (in Norderdithmarschen, east of Heide), dated 1759
Lead-glazed earthenware; greyish-yellow clay, slip almost white, appears light-yellow through glaze, painted in dark-brown and a few blue dots, scratched drawing and legend
Diameter 44 cm., Height 12.5 cm.
Städtisches Museum Flensburg, Inventory No. 6382

Very striking is the depth of the dish and the rim for scraping the spoon, common in groats dishes. The base is relatively small; from it rises the wide wall which, with a sharp bend, slants like a blunt cone ending in a vertical rim about 1.5 cm. in height. On the outside of the rim, added like the border, is an almost horizontal ring with a slightly thickened edge.

The decoration covers wall and center alike. Out of a leaf volute grows a stylized tulip with three stalks; the central one rises almost to the opposite rim; the two lateral stalks both droop, and on both are perched a bird, with a tulip in its beak. The date is divided under the tails, *Anno / 1759*. On the inside, the rim is decorated with wavy bands and branches, the border ring with large dots with diagonal rows of points in between. Following the general custom, the outside of the dish up to the rim and upper border is neither glazed nor slipped.

The dish was used communally for eating groats or thick soups. It is one of the few known early Tellingstedt works. Apart from nos. 29 and 31 which are not definitely confirmed as Tellingstedt, it is the earliest dated example. In form, coloration and decor it conforms with the type that developed for Tellingstedt; here is already the brown that appears rather grey or olive-green on very light slip, the sparing use of other colors and the rather "thin" stalky drawing which one knows from later Tellingstedt works. Of course, one must reckon at this period with a considerable range of variations, as the Tellingstedt pottery first began to flourish in the second half of the 18th century, mainly due to potters settling there.

Literature: Meyer-Heisig, p. 30, fig. 28.

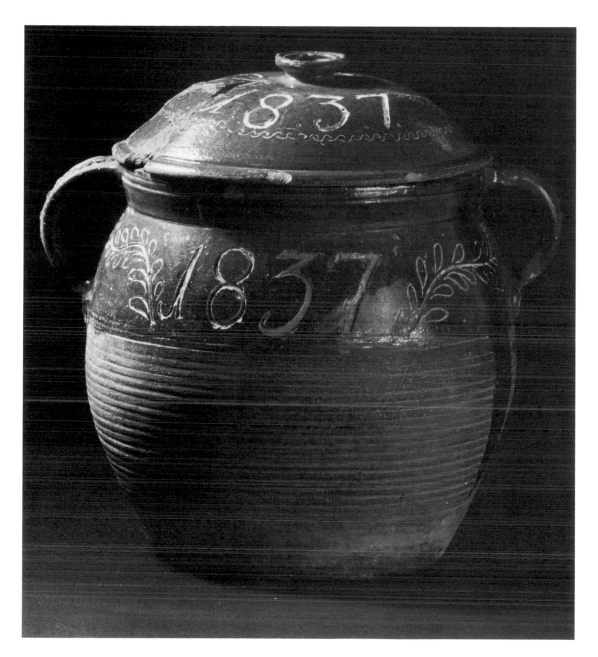

86.
Harvest Pot
Windbergen or Tellingstedt (in Dithmarschen), dated
 1837
Lead-glazed earthenware; greyish-brown to red clay,
 brown slip, scratched legend and drawing, painted in
 yellow
Height overall 45 cm., without lid 35 cm., Diameter 31.5
 cm., Width with handles 45 cm.; Lid broken, yellow
 largely flaked off
Dithmarscher Landesmuseum, Meldorf, Inventory No.
 3895

The large pot with a flat base has a bulbous wall, grooved up to the shoulder, and a rim slanting outwards. The lid is slightly curved, has a profiled button-like grip in its center and rests on the rim of the pot. The two eyehook-shaped handles are opposite one another just below the edge and are pressed onto the shoulder of the wall. Very noticeable is their decoration by finger impressions. The ornamentation is scanty and consists mainly of the large scratched in and yellow painted date *1837* and the owner's initials *CM*. These appear both on the shoulder of the pot

and on the lid, and in each case are flanked by thin leaf tendrils.

The function of these pots is the same as those of the Probstei harvest pots, explained in no. 65. The far simpler Dithmarschen piece shows that harvest pots of this size obviously also occurred in other rich arable districts, although they were less lavishly decorated there. It is possible that the Dithmarschen pots had as their prototypes the Probstei pots.

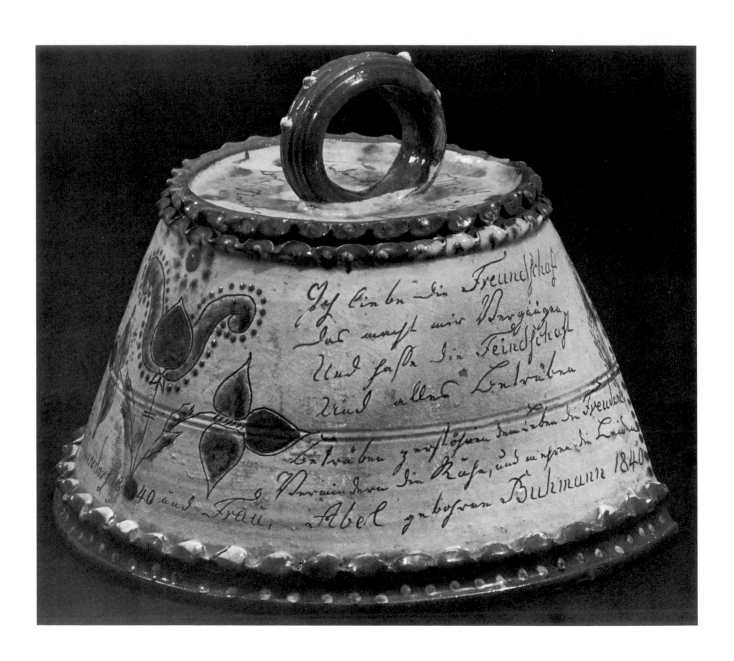

87.

Stove Cover

Windbergen (in Süderdithmarschen, south of Meldorf),
 dated 1840

Lead-glazed earthenware; reddish-yellow clay, yellow
 slip (inside no slip or glaze), painted in brown and a
 little green, scratched drawing and legend

Height with handle 27 cm., without, 20 cm., Diameter
 below, 38.5 cm., above, 21 cm.

Dithmarscher Landesmuseum, Meldorf (no inventory
 number)

The cover has the form of a blunt cone; about a third of
the wall has been vertically cut out, without touching the
upper edge. This makes the method of production quite
clear: the piece was made on the wheel like a large pot
with flat bottom and base ring and straight walls, set at a
slant. Traces of turning remain, and two prominent
grooves are used for division into an upper and a lower
zone. The brown edges have been added both above and
below as a double flange, the waves of which almost
touch. The roof surface has a circular brown flanged
handle.

Around the handle on the roof can be read in gothic
script: *O Mensch | Bedenke | was du thust | Bedenke | das
du | Sterben muß* [t] (O Man take heed what thou doest;
take heed that thou must die). The wall in the center is
decorated with a plant with two leafy stalks, whose
flowers resemble those of the tulip. The remaining spaces
are filled with long, edifying verses of religious and
secular content, mainly in German script. Only the most
important words and proper names appear in Latin
letters: *Bey Müh und Fleiß, | Sich Gott ergeben, | Ein
wenig Glück | Ja Hofnung sehn, | Dieß ist der Weg zum
Heil u. Leben, | Herr lehre diesen Weg mich gehn*
(Devotion to God with effort and diligence, look forward
to a little luck and hope, this is the way to salvation and
life. Lord teach me to go this way). Right of the flower
can be read: *Ich liebe die Freundschaft | Das macht mir
Vergnügen. | Und haße die Feindschaft | Und alles
Betrüben | Betrüben zerstöhren im Leben die Freuden |
Vermindern die Ruhe, und mehren die Leiden* (I love
friendship, that gives me pleasure. And I hate enmity and
everything distressing; distress destroys life's joys, upsets
one's peace and quiet and adds to one's sorrows). The last
line gives the owner's name: *Hinrich Kühl in
Wollmersdorf 1840 und Frau Abel gebohrene Buhmann
1840*. This indicates the year it was acquired, which can
also be the year of the marriage, and shows how strong
the position of the farmer's wife was on Schleswig-
Holstein farms at that time with regard to equality of
rights. Wolmersdorf is a village in Süderdithmarschen
between Meldorf and Windbergen.

The village of Windbergen was, in the middle of the 19th
century, one of the most important pottery centers on the
west coast of Holstein. Of the eight potteries active in
Süderdithmarschen around 1840 (apparently first estab-
lished about 1800), six were in operation at that time in
Windbergen and two in Burg. Apart from standard ware
for everyday use, dishes and stove covers were produced
in Windbergen, and were often decorated with very long
sayings. To date it has not been possible to ascribe these
wares to any particular workshop. Notable on
Windbergen pottery is the preference for German script
in the inscriptions. Here again, it is not certain whether
these are the product of one or several workshops. Only
one or two of the workshops, however, appear to have
had a rather wider market for their wares. The
Schleswig-Holsteinische Landesmuseum in Schleswig
possesses a stove cover dated 1841 which very closely
resembles this example in size, form and decoration, and
was apparently produced at the same place. It is marked
with an owner's name from Gädendorf near Lütjenburg
in East Holstein, proof that an order was placed by a
customer living more than 100 km. away as the crow flies.
This is all the more remarkable when one considers that
these workshops had to compete with the potters from
the Probstei. However, no stove covers made by the latter
are known.

Stove covers, which were also decorative pieces, were
used like the corresponding covers made of sheet brass on
the cast-iron boxes of back boiler stoves. They were
placed against the tiled wall as covers under which food or
tea and coffee were kept warm. Although stove covers of
earthenware occur in the 18th century and probably in the
17th century as well, they appear, from the stocks that
have survived in spite of their fragility, to have been a
regular fashion in many parts of Schleswig-Holstein in
the middle of the 19th century. Previously, preference
had been given to the splendid, gleaming covers of chased
sheet brass, some of which were imported from the
Netherlands. Occasionally these stove covers, particu-
larly damaged examples, may have been used as fire
covers, although fire covers were produced with special
outlets for smoke (see nos. 44, 95). The blackening inside
the stove covers indicates this occasional dual purpose.

Literature: Schlee (1978), p. 168, fig. 275; p. 286.

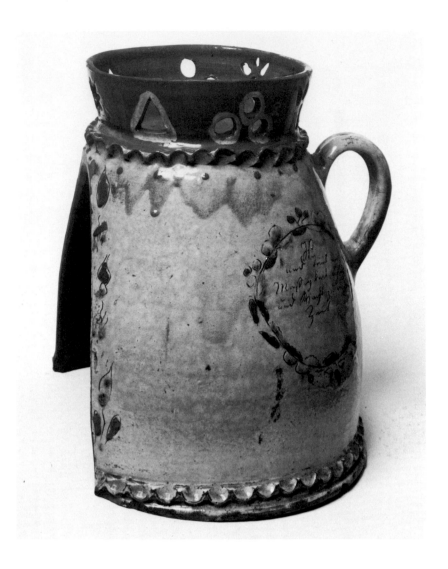

88.
Stove cover
Windbergen (in Süderdithmarschen, south of Meldorf),
 middle of the 19th century
Lead-glazed earthenware, pierced work on the upper
 edge; red clay, yellow slip, painted in brown and green,
 scratched drawing and legend
Height 32 cm., Diameter below, 30.5 cm., above, 18 cm.
Museum für Kunst und Gewerbe, Hamburg, Inventory
 No. 1902.121

As is usual with such covers, the utensil is made like a pot
on a potter's wheel and stands on its opening. The edge is
thickened by a sort of double flange and is strengthened
below to serve as a supporting ring. The upper part of this
edge is wavy and pinched in from the top. The base of the
pot forms the roof of the stove cover. Here also there is a
flanged edge, wavy and pinched in below. Above the
edge, a 5 cm. high crown has been fixed. This is pierced by
a triangle, three circular discs arranged as a triangle, a
three-leafed branch and a cross and, once again, by the
same branch, circular discs and triangle. A bare third of
the wall is vertically cut out, without, however, touching
the upper edge. Opposite this wall opening is the handle
with a band-like cross-section. The inside is unglazed as is
the edge of the wall opening. Cutting out was the last
operation before the final drying and firing.

The walls bear verses scratched on in gothic letters,
whereas under the handle the owner is named, *H. M.*

Schultz. On the left stands: *Is / und Trink mit / Maßigkeit,
Schlaf / und Wacht zu rechter Zeit* (Eat and drink in
moderation; go to sleep and wake up at the right time);
and right: *Tischler / und Maurer, / sind rechte laurer / sie
stechen und meßen / und wenn sie haben / gegeßen, so
haben / sie alles wieder / vergeßen* (Joiners and bricklayers
are weary Willies, they make holes and measure with
compass and dividers, and after they have eaten, have
forgotten everything again). This could easily be a
complaint of our own times. Apparently we still have
trouble with craftsmen who never work fast enough and
still take too many breaks.

For use see no. 87.

Literature: Jedding (1976), p. 39, fig. 20; pp. 94-95, no.
20.

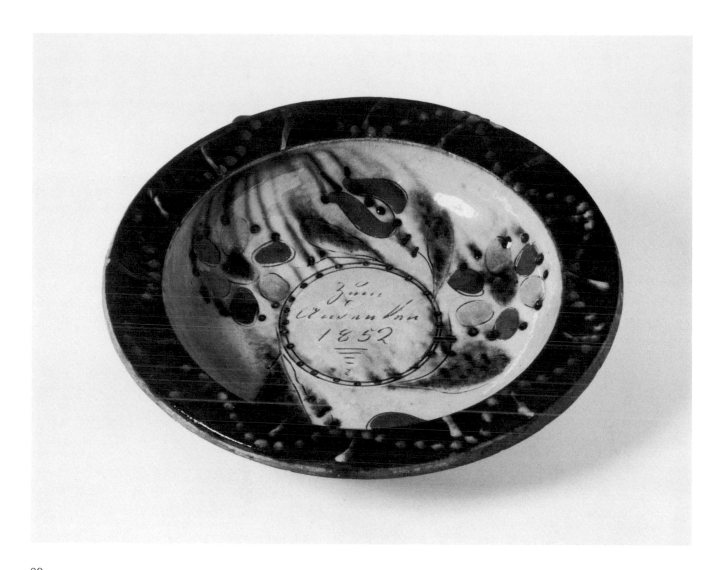

89.
Dish
Windbergen (in Süderdithmarschen, south of Meldorf)
 (?), dated 1852
Lead-glazed earthenware; greyish-yellow clay, light-
 yellow slip, painted in dark and light-brown, ochre and
 green, scratched legend and drawing
Diameter 22 cm., Height 4.5 cm.
Städtisches Museum Flensburg, Inventory No. 12699

The flat dish, which could also be taken for a deep plate,
has a flat base out of which the short concave wall rises. A
narrow sloping border is added with a marked bend. In
the center is a double circle loosely filled with dots. From
this circle emerge, onto the wall, four flowers on stalks,
two of them tulips. The inscription in gothic letters reads:
Zum / Andenken / 1852 (In Memory, 1852). The dark-
brown border is decorated with a dotted wavy line and
vertical strips pointing to the crests of the waves.

As the dish was acquired from a Flensburg trader, it is not
possible to draw any conclusions from the previous
owner about the place of origin. Form, decoration, color,
the use of gothic letters and comparison with Tellingstedt
wares all point to the probability of Windbergen. The
inscription indicates the decorative character of the plate,
which apparently came into the previous owner's house-
hold as a present.

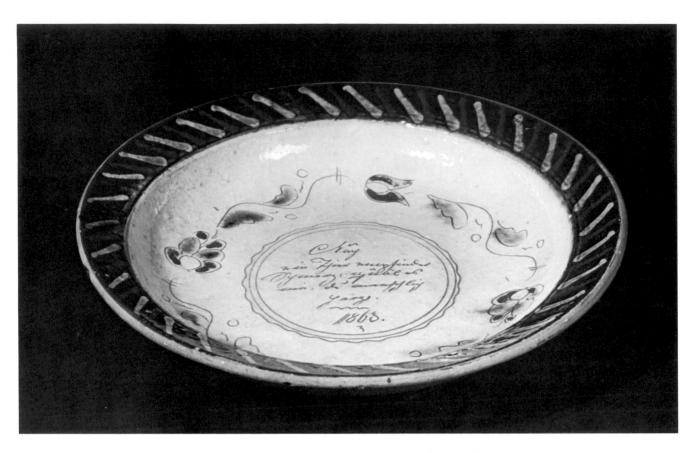

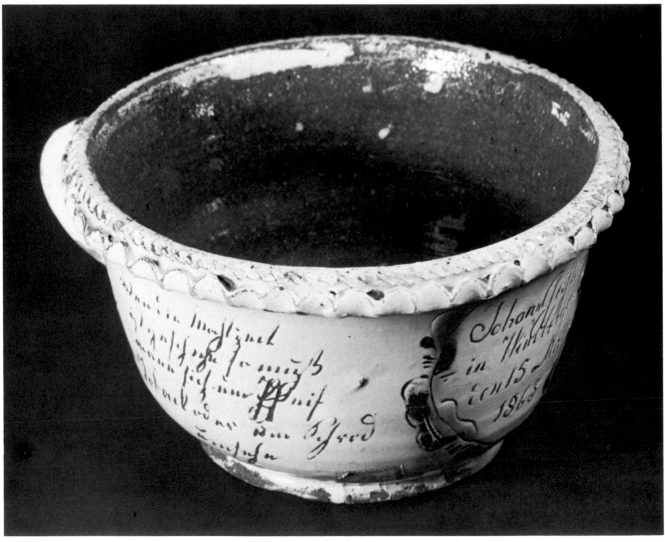

90.

Dish

Windbergen (in Süderdithmarschen, south of Meldorf),
 dated 1863

Lead-glazed earthenware; yellow clay, light-yellow slip,
 painted in dark-brown, light-brown and green,
 scratched legend and drawing

Diameter 31.5 cm., Height 5.5 cm.

Dithmarscher Landesmuseum, Meldorf, Inventory No.
 3616

The flat dish could also be taken for a deep plate. The
short, concave wall rises from the flat base. The sloping
border is added with a marked bend and keeps the same
thickness up to the light-brown edge and is accentuated
by the dark-brown coloring, decorated alternately with
light-brown and green stripes. In the center, surrounded
by two circles and a wavy band, is the inscription: *Auch |
ein Thier empfindet | Schmerz, quäl es | nie, du menschlich
| Herz | 1863* (An animal also feels pain, never maltreat it,

thou human Heart). The free space up to the border is
loosely decorated with a tendril of flowers.

The dish was acquired in the village of Krumstedt, a bare 8
km. southwest of Meldorf, in the immediate sales area of
the Windbergen potteries. Windbergen itself actually lies
only 5 km. to the southwest but cannot be reached
directly so that its goods were supplied through the
Meldorf market.

91.

Pot with Handle at the Side

Windbergen (in Süderdithmarschen, south of Meldorf),
 dated 1863

Lead-glazed earthenware; reddish-yellow clay, light-
 yellow slip outside only, painted in brown, scratched
 legend and drawing

Height 11 cm., Diameter above, 19 cm., below, 10.3 cm.,
 Width with handle 22 cm.

Dithmarscher Landesmuseum, Meldorf, Inventory No.
 1324

The pot, resembling a large cup, has a flat bottom with a
clearly set off base, a wall slightly curved below and a
notched edge to which is attached a wavy flange. A
vertical handle is fitted on one side. On the wall opposite
the handle is a heart-shaped leaf tendril with the owner's
name in Latin letters and the date: *Johann Geisler | in
Windbergen | den 15 Mai | 1863.* Scratched in on both
sides in gothic script are, left: *Wen die Mahlzeit | ist
geschehn so muß | mann sich um Pfeif | Toback oder um
Schrod | umsehn* (When the meal is over one must look for
a pipe or a pinch of tobacco); and right: *Arbeitsamkeit |
und ein gut Gewissen | das ist ein sanftes | Ruhekisen*
(Diligence and a good conscience make a soft cushion to
rest on).

On the outer, unglazed bottom is the potter's mark,
H.M., presumably from the Martens pottery, which for a

long time was the largest in Windbergen. (To date,
individual names of potters with their Christian names are
known only for the period around 1820, and not for the
period around 1860.)

The purpose of the vessel is not clear. As the pot has no
lip, it is unsuitable for pouring. One of the sayings
definitely points to a meal. But the pot was also not
suitable for cooking directly over an open fire or on the
iron stove-plate of the English kitchen range, which
became popular in the country only after the middle of
the 19th century. It could have been used for eating soup
or keeping it warm, or for the preparation and consump-
tion of the various cold soups of milk, gruel or fruit juice.
This form first appears as a rural kitchen utensil in
Schleswig-Holstein in the 19th century.

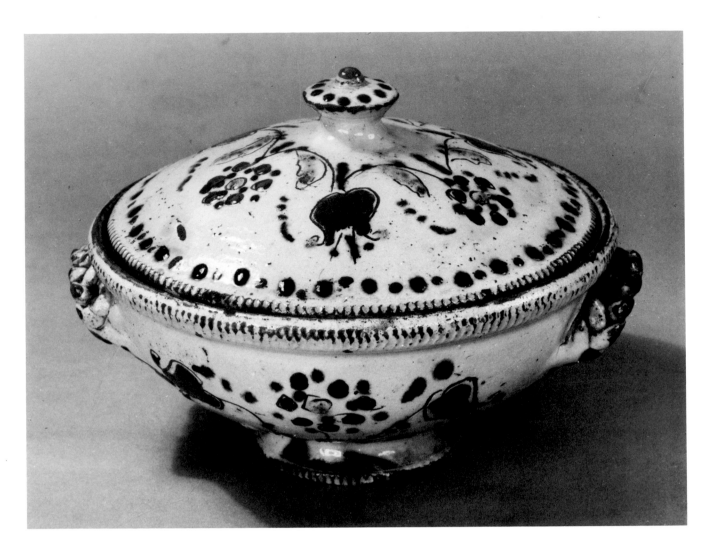

92.
Tureen with Lid
Hohenwestedt (in central Holstein, west of Neumünster), dated 1864
Earthenware lead-glazed, inside and out; light-brown clay, light-yellow slip, painted in light-brown and green, sgraffito
Height with lid, 14 cm., without, 9 cm., Diameter without handle 20.3 cm.
Schleswig-Holsteinisches Landesmuseum, Schleswig, Inventory No. 1937/34 a, b

The calotte-shaped dish rises outwards from a small, vertical circular base to a concave molding ending in a vertical ribbed edge with a flange on the outside. Below the edge are two handles in the shape of a *guilloche*. The flat, curved lid lies in a little groove on the edge of the dish and tapers off into a button-shaped handle. The edge of the lid is also grooved. The decoration on the wall and the lid consists of flowers on thin sweeping, almost leafless stalks. Here the tulips can be identified. The other types have round star-shaped petals painted around a circular center. The edge of the lid is further emphasized by a row of alternating large and small dots. Written in hearts under the handles of the tureen are: *H K* and *Hohnwe / stedt 1864* respectively. *H K* could be the name of the potter, for among the three potters active in Hohenwestedt around 1855 was one named Kühl. (A very similar tureen from Hohenwestedt, dated 1853, with the same dish and lid handles, is to be found in the local museum there.)

Hohenwestedt pottery betrays a certain likeness to that of Tellingstedt. However, on closer observation differences in the coarser decor can be detected.

Lidded tureens of this type which, like nos. 28, 108 and 114, are often taken for dishes for women in childbed, would probably, by the second half of the 19th century, no longer have been used exclusively for serving gruel to women in childbed. They were more likely to have served as soup tureens on feast days. On such occasions, particularly amongst the well-to-do, the company at table split up; the immediate family ate apart from the remainder of the household, which included maids and servants or laborers, and, in artisan families, apprentices and journeymen. Thus a tureen of this size would suffice for the intimate family circle, especially since this group often did not include the children of the family.

93.
Dish
Tellingstedt (in Norderdithmarschen east of Heide),
 dated 1859
Lead-glazed earthenware; greyish-yellow clay, light-
 yellow slip, painted in dark-brown and green,
 scratched drawing and legend
Diameter 21.8 cm., Height 4.5 cm.
Museum fur Kunst und Gewerbe, Hamburg, Inventory
 No. 1912.78

The little dish is formed out of a flat base, concave wall rising almost vertically, and border rising only slightly to the edge and maintaining the same thickness. On the center appears the dictum *Glück und/Glas wie bald/ bricht das* (Glass and luck brittle muck), and underneath the date *1859* and the place of production, *Tellingstedt*.

The dish was acquired in Flensburg, a sign of how far the sales area of Tellingstedt wares had extended by the middle of the 19th century. At that time there were up to sixteen workshops operating in this village, which was well known as a pottery center. Thus the craft of pottery reached a peak hitherto unattained, although, by modern standards, the creative genius did not equal that of the potters at the end of the 18th century, when there were only six or seven workshops. On the other hand, it must not be forgotten that the decors on other ceramic wares produced more for the haute bourgeoisie—for instance porcelain and stoneware—were, in the Biedermeier period and especially in its late phase, far more modest and quiet than the luxuriant, "fuller" decors at the end of the 18th century. This was not due to lack of decorative sense and creative genius, but to a change in the taste of the customers.

Literature: Jedding (1976), p. 95 at no. 20.

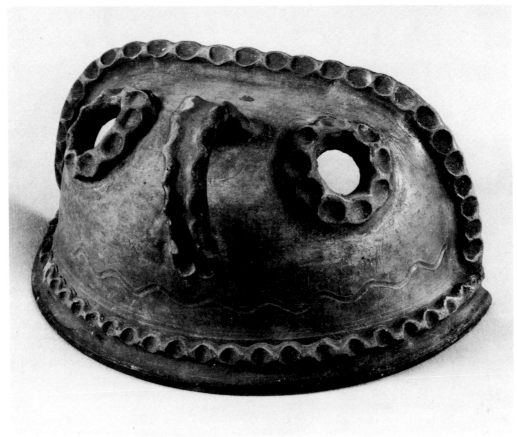

94.
Dish

Tellingstedt (in Norderdithmarschen, east of Heide), dated 1859
Lead-glazed earthenware; greyish-yellow clay, light-yellow slip, painted in dark-brown and green, legend and drawing scratched in
Diameter 31.8 cm., Height 4.5 cm.
Museum für Kunst und Gewerbe, Hamburg, Inventory No. 1912.79

The plate-like dish has a large base, curved slightly upwards, a concave, rising wall and a sharply set off border, which slants gently upwards and is of uniform thickness up to the edge. The center is fully taken up with the verse: *Bey | deiner Biebel | sitze gern, sie ist | der Weisheit Kern | und Stern, die schlage | auf die schlage du | erst mit des Sarges | Deckel zu. | 1859 | T* (Sit by thy Bible, it is the core and star of wisdom: open it and first shut it when thy coffin is shut). The verse is surrounded by thin branches, with leaves, flowers and different fruits, including four grapes. The border is decorated with dots and strokes and a thin wavy line. The plate, on which the *T* may stand for Tellingstedt, and which in decor exactly follows no. 93, was also acquired in Flensburg. A dish with the identical verse is to be found in the Museum für Dithmarscher Vorgeschichte und Heider Heimatmuseum in Heide.

In Schleswig-Holstein such dishes are also known as *Mehlbeutel* (flour bag) plates. The lack of any signs of hard ware indicates that they were seldom used for foods eaten with knives. It thus seems fairly certain that they were frequently used for the popular *Mehlbeutel*, bites of which were eaten with a fruit sauce or sometimes with pork crackling and potatoes. A *Mehlbeutel* was a flour pudding or large dumpling, basically consisting of flour, fat, milk, yeast and eggs to which could be added sugar, currants and raisins, lemon peel and cinnamon. It was cooked, not in a form, but in a thin linen cloth for three hours in water over a very small flame. In bourgeois cuisine the term is *Serviettenkloss* (napkin dumpling).

95.
Fire Cover

North Frisia, 18th century (?)
Unglazed earthenware without slip
Height 20 cm., Width 37.5 cm.
Altonaer Museum in Hamburg, Norddeutsches Landesmuseum, Inventory No. 1925/133

As the traces of turning show, this piece was first intended as a pot and then vertically cut in half. The lower edge is slightly pulled out; around the edge and across the top there is a pinched on flange. In the middle of the shoulder, a handle shaped like a broad band has been pressed on. On the two upper rims of the handle and at its lower edge, it has been sharply pinched in. On both sides of the handle are the two smoke outlets circled by strong, round flanges. The opening at the back has, here, also a narrow pinched in rim, projecting like a flange. The only other decoration is a wavy band scratched into the clay above the lower edge.

This piece of clay brick, rather welded together on one side by overfiring, is impressive because of its simple plastic decoration made by the pressure of fingertips alone. It comes from the North Frisian island of Pellworm. It cannot be ascertained whether it was also produced there. It is more probable that it came there like ordinary building bricks from the North Frisian mainland. The dating is also uncertain as such original pieces betray no elements which can fix a definite period. The preference in the 19th century, however, for quite different forms make the probable dating 18th century or even earlier.

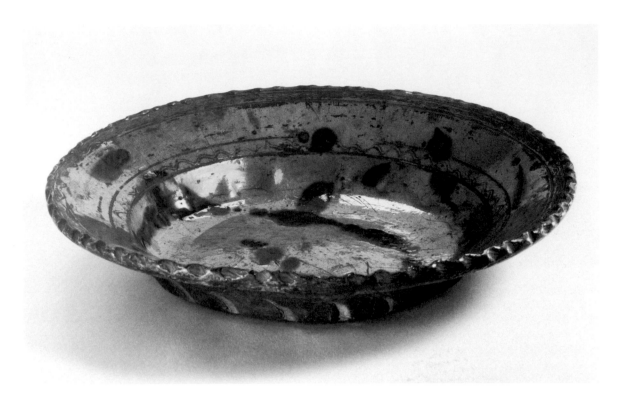

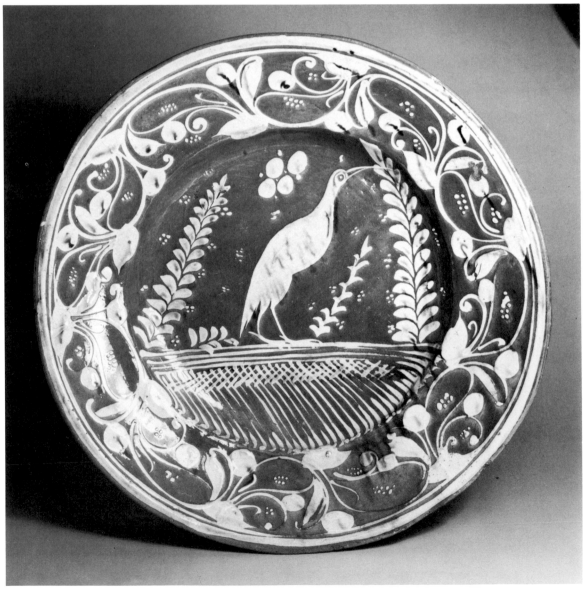

96.

Dish

Surroundings of Husum (North Frisia), 18th century,
 probably 2nd half

Lead-glazed earthenware; light-brown clay, without slip,
 appears ochre-yellow under the glaze, bespattered with
 blots and lines in manganese, sgraffito

Diameter 39 cm., Height 7.5 cm.

Altonaer Museum in Hamburg, Norddeutsches Landes-
museum, Inventory No. 1939/77

This dish, with the appearance of a plate, has a large flat
base, a short, relatively steep wall and a wide, slightly
sloping border; the edge is thickened below like a flange,
and pinched in above in small narrow waves. Conspicu-
ous are eighteen little bosses pressed into the wall from
below. The border is decorated below in sgraffito
technique and above with circling rings with intermediate
wavy lines; it is combed vertically between the bands. The
edge is also glazed, and a few unintentional blots of glaze

on the outside show that the blackening of the outside
resulted from use, for instance keeping food warm over
an open fire.

The heavy dish indicates that potters were capable, with
normal standard ware as well, of achieving by cheap and
simple means those decorative effects which, at any rate in
the 18th century, were rarely absent and which still
delight us today.

97.

Dish

North Germany, ca. 1800

Lead-glazed earthenware; red clay, reddish-brown slip,
 decorated in white and a little in partly blended green

Diameter 32.3 cm., Height 6.5 cm.

Museum für Kunst und Gewerbe, Hamburg, Inventory
 No. 1880.547

The flat base of the rather thin dish merges into a concave,
curved wall to which is added a sloping, slightly upturned
wide border with a uniformly thick edge. Center and wall
are painted with a heron striding towards the right on a
flat space, with hachures underneath. The heron is framed
left and right by stylized little trees and leafed plants.
Around the border runs a wavy tendril with leaves and
fruit. Two small holes above the heron served for hanging
the dish and indicate its decorative function.

According to the previous Hamburg owner, the dish
comes from "this area," in other words, surroundings of
Hamburg. There are few pieces directly comparable with
this very decoratively painted dish with its light colors on
a dark background, which is unusual for North Germany
(see no. 98). Its most probable place of origin could be
western Schleswig-Holstein.

The heron was at one time very common in North
Germany, especially in the coastal lowlands. However,

one must assume that a picture such as this was not
painted from nature but was transposed onto ceramics by
copying a graphic illustration. One of the most important
collections of bird pictures, repeatedly copied over a
period of 150 to 200 years, was the work of copperplate
engravings by the Dutchman, Adriaen Collaert (ca.
1560-1618), entitled *Avium vivae icones* and published in
two volumes in 1580 and 1598. The native potter would
almost certainly never have possessed such a work, but
any copy would have enabled him to grasp correctly
certain elements of the striding and the long dagger-like
beak, attributes which differentiate this bird from the
crane or the stork, both native to North Germany at that
time.

Literature: *Folklig Konst*, no. 48; Jedding (1976), p. 34,
fig. 15; pp. 92/93, no. 15.

98.
Dish

Husum or surroundings, dated 1805
Lead-glazed earthenware; greyish-yellow clay, light
 reddish-brown slip, painted in white and dark-brown,
 design scratched in, parts of the paint flaked off
Diameter 38 cm., Height 11 cm.
Altonaer Museum in Hamburg, Norddeutsches Landes-
 museum, Inventory No. 1939/75

The wide wall rises at a slant from a relatively small base,
the upper part extending rather more outwards. The base
inside is curved slightly upwards. A trough above the base
is separated from the rest of the wall by a bend. The edge
is hardly thickened but pinched in. The clay as a whole is
relatively thin and hence the dish is rather light for its size.

Base and wall are decorated with a bird, which is
conspicuous by its head plumage and long beak but is not
zoologically identifiable. In front of the bird there is a
tulip with its stalk between the bird's legs; above it is the
date, *1805*. The upper third of the wall is decorated with a
wide border consisting of two dark-brown lines which
run along a broad white stripe, and two white lines. The
broad white stripe is marked with diagonal dark-brown
lines which apparently, while still moist on the wheel,
were drawn out into a decor with an eight-toothed comb.

The dish was used in the neighborhood of the town of
Husum on the west coast of Schleswig-Holstein and was
probably also produced there. The most suitable com-
parison is no. 97.

Literature: *Folklig Konst,* no. 76.

99.
Dish
(Illustrated on cover)

North Germany, ca. 1800
Lead-glazed earthenware; whitish-grey clay, dark-
 brown slip, decorated in white, red, green, brown and
 a little ochre
Diameter 38.5 cm., Height 7.2 cm.
Museum für Kunst und Gewerbe, Hamburg, Inventory
 No. 1878.21

The flat base merges into a wide, curved, concave wall, to
which is added a rather narrower, almost horizontal
border; the edge is thickened with pinched in waves
below. The center is decorated by a whorl in white, red
and green of three fishes lying on top of one another (a
so-called fish *triquetrum*). The spaces in between are
filled with tulips which cover the wall as well. The
inscription on the edge reads: *in dieser Siesel sind trey fich
wan sie wern gebraten will ich alle laten* (?) (In this dish
are three fishes, after they are fried, I will eat them).

The dish was acquired in Hamburg but without a record
of its provenance. According to Meyer-Heisig, it can be
connected with the village of Hohenwestedt west of
Neumünster together with other works similarly painted.
But he is also surprised by its relationship with crockery
from Wetterau in South Hesse.

Examining the inscriptions for idiomatic expressions that
might indicate the provenance is very seldom of any help.
Apart from the fact that one did one's best everywhere to
compose such texts in High German, these texts travelled
long distances with the craftsmen. (In North Germany it
would have been more appropriate to use Low German
but this occurs only in exceptional cases.) Furthermore,
many craftsmen in the 18th century were still very
unpractised in reading and writing so that they were
forced to copy the texts—always in High German—from
hand written or printed originals. This general lack of
reading skill could lead to many a corruption of the text,
which today makes the reading of such inscriptions very
difficult. Also, the technique of painting with the quill
compelled the user to write quickly and thus increased the
likelihood of errors. Mistakes often went undetected and
in any event could not be corrected. The whorl of three
fishes is regarded as a symbol for the Holy Trinity and
occurs all over central and northern Europe, in both
Protestant and Catholic areas. It is found not only on
pewter and ceramic vessels or on baking forms, but also
on waffle irons and roasting grates. As it is obvious that in
Catholic areas one associated fish with food for days of
fasting, the knowledge of the real significance of the
symbol could have been lost and its place taken by a
realistic interpretation as here.

Literature: Meyer-Heisig, p. 31, colorplate III; Jedding
(1976), p. 35, fig. 16; p. 93, no. 16.

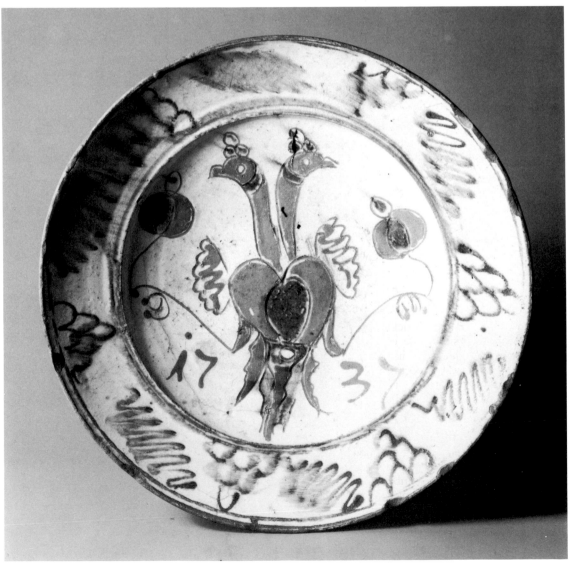

100.

Dish

Surroundings of Husum (west coast of Schleswig-
 Holstein), 2nd half of the 19th century
Lead-glazed earthenware; brownish-yellow clay, light-
 brown slip, painted in green and white
Diameter 23.5 cm., Height 8 cm.
Schleswig-Holsteinisches Landesmuseum, Schleswig,
 Inventory No. 1961/221

From a small base, which is shaped as a foot on the
outside, the wide wall slants upwards, merging above into
a rim with a slightly thickened edge on the inside and a
groove on the outside. The handle, shaped like a large
eyehook, is unglazed like the outside of the dish. It is
pressed onto the rim at an angle. The upper part of the
wall is decorated by two green rings encircling a white
wavy band.

This is a piece of normal standard ware frequently used in
the household. Dishes such as this one could be used for
communal eating, for preparing food, or for skimming
milk. Milk dishes were, of course, used only for this
purpose. The few surviving pieces that have been iden-
tified as milk dishes have occasionally, even today, a
slightly sour smell, and their glaze has been damaged by
lactic acid.

101.

Dish

Flensburg (?), dated 1737
Lead-glazed earthenware; brown clay, cream colored
 slip, decorated in reddish-brown, green and blue,
 sgraffito
Diameter 29.8 cm., Height 6 cm.
Museum für Kunst und Gewerbe, Hamburg, Inventory
 No. 1964.217 (formerly Dr. Konrad Strauss Collec-
 tion, Hamburg and Munich)

The trough-shaped dish, where center and wall merge,
has a wide sloping border and a thickened edge, almost
perpendicular on the outside. The center is decorated
with a double-headed eagle which in both sets of claws
carries a flower or probably a pomegranate. The date *1737*
can be seen on both sides of the tail. The border is
decorated by blue curlicues in the shape of spirals and
little bunches of scales (grapes?).

The dish was acquired on the Baltic island of Fehmarn.
Because of its type and the coloring of its decoration, it
has been ascribed to Flensburg. The double-headed eagle,
an old symbolic and heraldic emblem became very
popular in folk art, particularly through the influence of
textiles, which are still derived from Byzantine fabrics.
Furthermore, it was also the heraldic animal of the Holy
Roman Empire (until 1806). In the immediate vicinity of
Fehmarn, the Free Imperial City of Lübeck sported the
double-headed eagle in its coat-of-arms. However, this
need not indicate any direct reference to the imperial
coat-of-arms; it is possible that it is a reference to the
so-called *Schützenvogel* (target bird). Since the 14th
century, marksmen's associations (*Schützengesellschaf-
ten*) had been founded to practice shooting. At their
shooting festivals they first used a parrot *(Papagei)* on a
high pole as a target, and were thus often called
"*Papagoiengilde*" (Parrot Guild) after this exotic bird. In
the 18th century the two-headed imperial eagle was
always used as the "*Schützenvogel*", whose feathers,
crowns and jewels had to be shot off in turn, until, with
the champion's shot *(Königsschuss)*, the carcass was also
shot off the pole. Thus, in this case, the dish might be a
Schützenteller—a prize for a marksman or even for the
champion marksman.

Literature: Jedding (1976), p. 27, fig. 8; p. 90, no. 8.

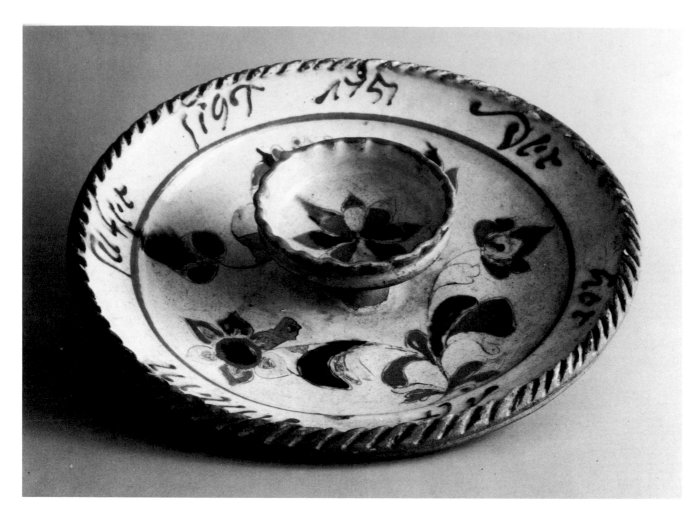

102.

Double Dish

Flensburg or surroundings (?), dated 1751

Lead-glazed earthenware; yellowish-brown clay, cream-colored slip, painted in reddish-brown, green, yellow and blue, sgraffito

Diameter 30 cm., Height 6.5 cm. (without inner dish, 6 cm.)

Museum für Kunst und Gewerbe, Hamburg, Inventory No. 1964.218 (formerly Dr. Konrad Strauss Collection, Hamburg and Munich)

The trough-shaped dish has a wide border rising in a slight curve and an edge thickened above and below; above also is a circular row of diagonal notches in a wickerwork pattern round a groove. In the center of the dish is a second smaller dish with an almost vertical wall and wavy rim, set on a round shaft, hollow at the bottom. Two plants with various flowers and leaves decorate the center of the large dish, and a star-shaped flowering rosette decorates the small dish. The inscription is spread loosely along the wall: *Der her ist mein guter hirt 1751* (The Lord is my shepherd 1751) (from Psalm 23, Verse 1).

The dish was acquired on the Baltic island of Fehmarn. This island belongs to Holstein but earlier belonged to the Duchy of Schleswig, with which it and the neighboring Danish islands had close commercial ties. It has been ascribed to Flensburg on the basis of comparison with other dishes and, in particular, because of the amount of blue in the decoration. Such provenance is not improbable because of the above mentioned commercial connections, which were mainly by sea.

The provenance of such double dishes ranges from Scandinavia to the Alpine regions. But they appear to have been more popular in the Danish Schleswig-Holstein area than, for example, in Lower Saxony, Westphalia or the Lower Rhine. They are closely associated with eating habits. The bowl in the middle contained the trimmings for the main dish. The type of food determined the size of the bowl. In Schleswig-Holstein the bowl was fairly small and contained mostly melted butter or bacon fat for dunking. For this reason these dishes were known in some places as bacon dishes. The principal food dunked in this bacon fat might be fish (hence this dish was generally known in Denmark as *Fiskefad*). Of course, in accordance with old customs, all present at the table ate out of the same dish.

Literature: Jedding (1976), p. 26, fig. 6; p. 89, no. 6.

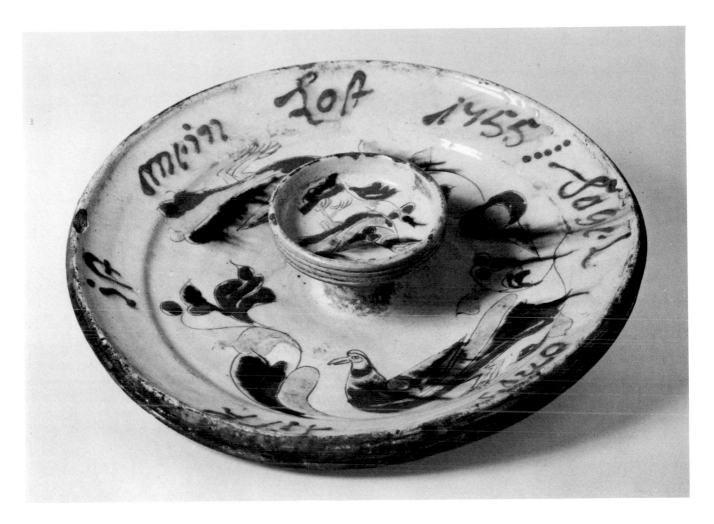

103.

Double Dish

Hadersleben or surroundings (north of the German-
 Danish border), dated 1755
Lead-glazed earthenware; greyish-yellow, light reddish
 clay, light-yellow slip, painted in dark-brown, yellow
 and blue, sgraffito
Diameter 33.5 cm., Height 7 cm. (without inner bowl 5.5
 cm.)
Städtisches Museum Flensburg, Inventory No. 3278

The trough-shaped dish has a slightly curved, wide border rising to an edge, thickened above and below. Set in its center on a shaft that is hollow below is a second, smaller dish with a flat base and a vertical wall, with three grooves on the outside. Two long branches of equal size, but with different leaves and flowers, fill the base of the bigger dish. A large bird sits on each branch. A corresponding, but smaller bird sitting on a branch fills up the base of the smaller dish. The border bears, in a loose row of words painted in blue, the text: *Fagel ondt fisk ist mein Lost 1755:* (Bird and fish is my delight 1755).

The dish was acquired in Hadersleben and is one of a group of similar double dishes which were all collected in the eastern part of North Schleswig (Sønderjülland) and in the district around Flensburg. They differ from Probstei double dishes not only in the form of the inner dish but also in the greater application of decor and color, especially in the additional use of blue for the painted (rather than incised) inscriptions (see no. 50).

The inscription indicates the use of the dish for eating fish (see no. 102) and, apparently, birds and poultry carved into small pieces. Incidentally, in North Germany the term "birds" is used to mean poultry, waterfowl and marsh birds, or game birds; never songbirds. As explained in no. 102, these dishes were also used for thick gruel or dumplings. The smaller dish in the middle always contained the sauce of melted bacon, butter or frying fat.

(Hadersleben, which lies on the Baltic Sea about 60 km. north of Flensburg, was, earlier, the most northerly town of the Schleswig part of Schleswig-Holstein. In this frontier area there has always been an intermingling of German and Danish cultural influences. The town has belonged to Denmark since the frontier was redrawn in 1920, after World War I.)

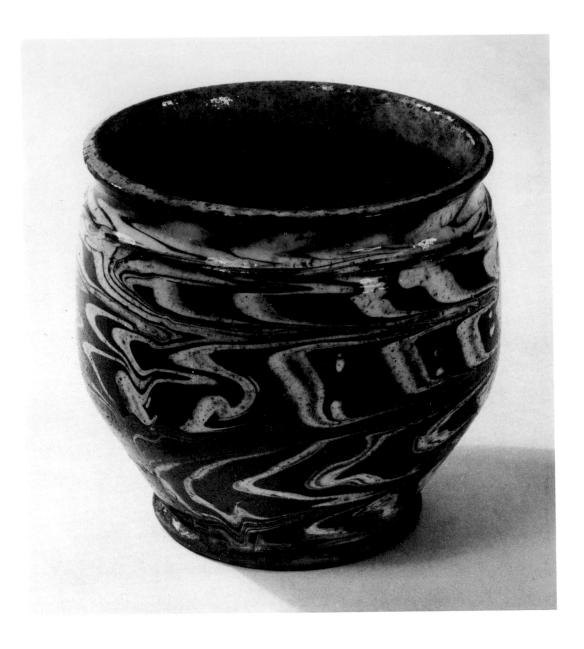

105.

Preserving Jar

Flensburg or surroundings, 1st half of the 19th century

Lead-glazed earthenware; brownish-yellow clay, inside
without, outside with reddish-brown slip, onto which,
while still wet and while the wheel is still rotating,
white marbling has been sprayed

Height 15.3 cm., Diameter 14.5 cm.

Schleswig-Holsteinisches Landesmuseum, Schleswig,
Inventory No. 1935/213

The wall rests on a small base above which is a narrow
groove. The wall, rather bulbous below, rises almost
vertically and is slightly pulled in at the top. The rim
forms a concave furrow onto which cloth or paper could
be tied to act as lid.

This relatively small pot is another example of normal
wares mass-produced for household use. Such wares
could be cheaply and simply beautified by marbling,
which was especially popular during the Biedermeier
period.

Preserving jars (or storage jars, as they were generally
called) of all sizes were required in large numbers in the
household. They were used for the more or less short
term storage of marinated meat, ragout, boiled liver
sausage, butter and lard; as well as for sugar, flour, groats,
dried peas and beans and the like. As there were no
kitchen cupboards in the modern sense, they stood on
open racks and shelves, or in old chests and little wall
cupboards that had been relegated to kitchen quarters.
Because of the poisons that could result when lead glaze
was exposed to acid, these pots were not suitable for
storing pickled foods such as salt beans, sauerkraut and
the like for long periods. For this purpose the larger
storage pots of salt-glazed stoneware were preferred.
These were imported en masse from the Rhineland,
Westerwald and southern Lower Saxony.

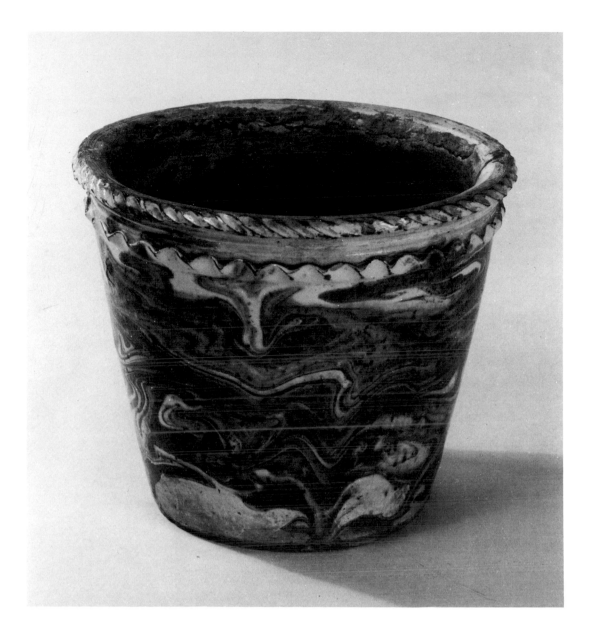

106.
Flowerpot
Northern part of Schleswig, probably Flensburg or
 surroundings, 1st half to middle of the 19th century
Lead-glazed earthenware; red clay, white slip, with
 marbled flat decor in blue, reddish-brown and a little
 yellow applied by the wheel
Height 12.9 cm., Upper diameter 14.7 cm.
Schleswig-Holsteinisches Landesmuseum, Schleswig,
 Inventory No. 1933/170

From a flat base, the wall widens towards its top like a
blunt cone; there is no pronounced edge. The pot ends in
a rim consisting of a flange pressed upwards and, after a
slight gap, the rim; this is thickened on the outside and
decorated by diagonal notches. The small hole in the base
and the unglazed interior clearly indicate that the piece is a
flowerpot.

The pot was acquired from the estate of a captain in the
village of Morsum on the island of Sylt. Morsum was
mainly populated by shipmasters and seamen. Whether
the pot was also produced there is questionable but
possible. As such standard ware was produced
everywhere in similar fashion, only finds from pottery
shard pits can give exact information. At any rate the use
of blue is conspicuous; this was also characteristic in the
18th century for earthenware from North Schleswig, and,
in particular, Flensburg and surroundings.

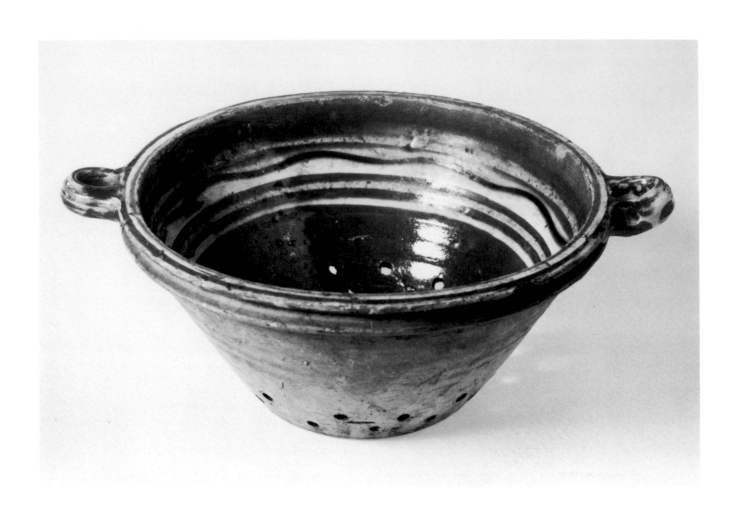

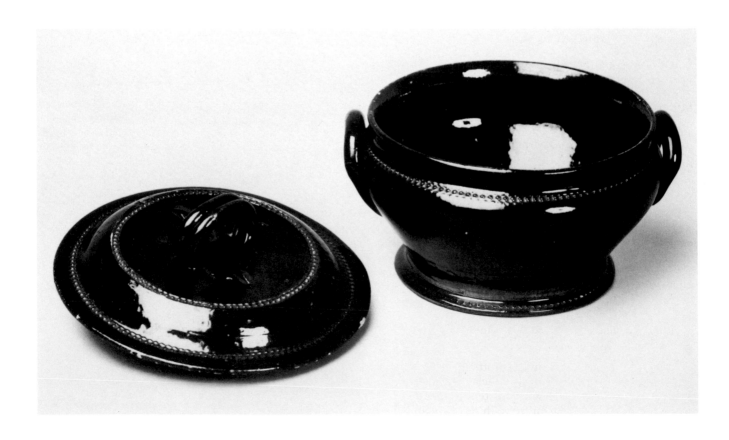

130

107.
Colander

Flensburg or surroundings, 19th century (probably middle)

Lead-glazed earthenware; light-yellow clay, reddish-brown slip, painted in light-yellow, light-green and dark-brown

Diameter 26 cm., Height 11 cm.

Städtisches Museum Flensburg, Inventory No. 15567

The form of this especially deep colander is that of a dish with a small base. It has a high, relatively steeply rising wall and, on the outside, a grooved edge like a rim. On the edge, opposite to one another, have been added two horizontal eyehole-shaped handles. Only the base and the lower part of the wall have been pierced, the latter with a double row of holes. Only the interior of the colander, including the edge and the handles, have been poured, painted and glazed. The decoration consists of circular, light-grey and green stripes of different thickness in the upper part of the wall, with a dark-brown wavy line in the widest of the light-yellow stripes.

Such colanders were part of the crockery in every kitchen. They came in many forms and were used for all sorts of purposes. This colander was probably used for washing and draining fresh vegetables and salad or, even more important, for draining cooked vegetables (peas, beans and roots) and potatoes. It could, if necessary, also be used for draining plain dumplings or semolina dumplings, which were served almost daily in one form or another; although for this purpose shallower colanders were usually used so that the dumplings would not be squashed together.

Note: Such utensils were never called sieves in Schleswig Holstein. Sieves were used for sifting flower, groats or even milk and were made of very thin wire or plaited hair.

108.
Tureen with Lid

Northern Schleswig, 1st half of the 19th century

Lead-glazed earthenware; light greyish-yellow clay, manganese black slip

Height with handle 19.5 cm., Diameter 20 cm., Width at the handles 23 cm.

Städtisches Museum Flensburg, Inventory No. 20350

A bulbous dish on a projecting circular foot with a high, initially sloping wall; the shoulder is drawn in and merges into a concave rim, curved slightly outwards. Under the shoulder are two vertical upright handles formed out of two round clay flanges. The lid has a flat edge, is slightly curved and flat on top. It has a handle made out of a long, round clay flange, shaped as a double ring with vertical notched ends. The lid lies on the tureen with a fold formed by the edge with rim beneath. The sole decoration consists of pearl strings pressed in around the foot, the shoulder of the tureen, the edge of the lid and the upper rim of the lid.

The tureen belongs to a group of pottery pieces whose exact provenance is unknown but which were apparently produced in northern Schleswig-Holstein, presumably at several places both north and south of the German-Danish border. Mainly soup tureens, coffee-pots and teapots have been preserved, but there are also examples of cream jugs, milk jugs and occasionally drinking vessels in mug or cup form, although the latter are very fragile. They were made from the end of the 18th up to the middle of the 19th century, and quite obviously imitated English stoneware in form and coloring. English stoneware, a cheap competitor of the native faience, was imported in large quantities at that time, except during the period of Napoleon's continental blockade.

Naturally the native potters, with their limited technical means, could not hope to compete with the popular, light English crockery with its printed decor. On the other hand, it was fascinating to imitate the black stoneware known as Egyptian Black or Basalt ware. This had been invented by Josiah Wedgwood and had been produced in many English manufactories since the 1780's. It was very popular in North Germany and for a time was regarded as fashionable and elegant; it was much more expensive than the common, light English stoneware. In general, it was only used on festive occasions. With the help of thick, highly manganous-oxidic slips, it was possible to obtain, even on earthenware, with light clay, a very dark to dark-brown coloring. Native potters could often produce these wares more cheaply than the English originators, and enough buyers could be found who were satisfied with these imitations particularly in rural areas, since farmers counted their pennies more closely than city dwellers. Since these pieces of crockery were openly displayed on shelves, and since at this time it was customary to think in terms of sets of crockery, in the country as well as in town, even cake and pudding molds were produced with this black "slip" and displayed alongside the other crockery.

Many potters all over North Germany tried their hand at producing these dark wares. One cannot explain why the production, especially in Schleswig, the northern part of Schleswig-Holstein, was so voluminous and why the surviving pieces are so typically characteristic, whereas in other places only individual pieces such as tobacco jars and writing utensils (see nos. 76-78) were produced in the fashionable color. That the Probstei potters were also capable of doing this is proved by the dark-brown, mottled handle pot (no. 68). Possibly in their sales area there was a lack of interested customers, or perhaps there was a more favorable selection of English stoneware to offer.

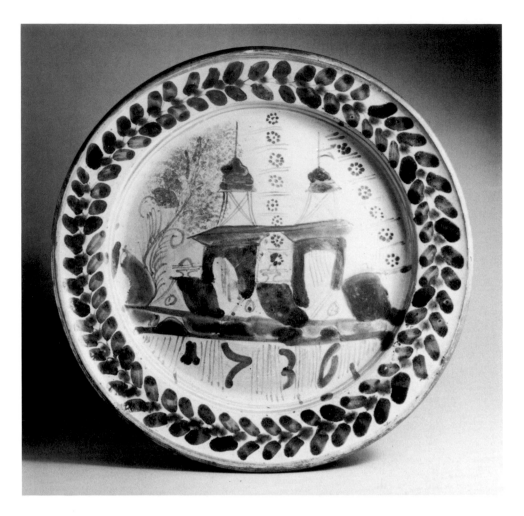

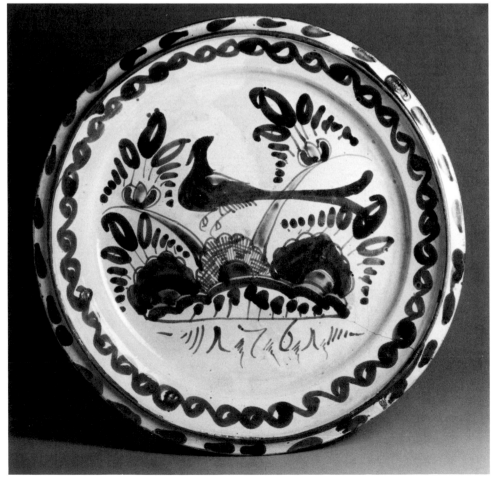

109.
Dish
So-called *Stettinergut* (Stettin ware), dated 1730
Tin-glazed earthenware; reddish-yellow clay, greyish-
 white tin glaze onto which colors have been painted in
 dark-blue, green, ochre-yellow and manganese black
Diameter 33.2 cm., Height 4.2 cm.
Museum für Kunst und Gewerbe, Hamburg, Inventory
 No. 1864.216 (formerly Dr. Konrad Strauss Collec-
 tion, Hamburg and Munich)

This plate-like dish has a flat, slightly curved base, a
short, almost vertical fluted wall and a wide sloping
border with a slightly thickened edge. The center shows,
above, the date, *1730*—the *0* could also be read as a
6—and above the crest of a wall, three house roofs which
are topped by a pair of considerably taller towers—either
a church or a castle. On the left is a tree with insubstantial
green leaves. The free spaces, right and center, are filled
with two vertical rows of point clusters, separated by
short double lines. The border is filled with a circular
wreath of stylized blue flowers on manganese colored
stalks with green fruit in between.

These dishes, which were clearly meant to imitate Nether-
landish and, in particular, Frisian faiences—and are
occasionally mistaken for the latter by experienced
collectors—were not produced in North Germany. They
were named *Stettinergut* after the export harbor, and
were very popular in Schleswig-Holstein, particularly on
the east coast and in Denmark, as inexpensive imported
goods. They were not made in Stettin itself, but this most
important Baltic port at the mouth of the Oder was, as far
as we can ascertain, between 1730 and 1856, the only port
for the export of these goods, whose provenance is still
not accurately known today. However, it seems that the
large area in question could probably cover the Baltic
coast, Silesia, Saxony and Bohemia. Here, the Oder, with
its tributaries, Neisse and Warthe, provided excellent
traffic communications.

Understandably enough, the name, *Stettinergut* appears
to have been commonly used only in Schleswig-Holstein
and Denmark, for these products reached West and East
Germany and Poland—where they were equally
prized—by other routes. Mass production must have
been used in their manufacture.

In their forms the dishes and plates, which account for the
bulk of these goods, and the handled dishes and handled
pots, which are not so common, copy the types that are
well known in North Germany. In their decoration, they
closely resemble simple Netherlandish ware, and one
cannot help thinking that the simplified and coarsened
village, town or castle views, flowers and flowerpots are
copied direct from Netherlandish tiles, which in their
turn were shipped from the Netherlands over the Baltic to
Saxony, Silesia and Poland and could thus also be well
known. There are, of course, town and castle views
bristling with towers on Lusatian and Bohemian earthen-
ware as well, but these have a completely different
appearance. Even the town and castle views on Lower
Rhenish earthenware, which have been influenced by
Netherlandish products do not resemble the prototypes
as closely as those on *Stettinergut*. But in contrast to the
Netherlandish faience ware, dishes and plates of *Stet-
tinergut* are never glazed on the back, and, as in the case of
normal earthenware, the article before firing was dipped
into a simple, unfritted, greyish-white tin glaze like a slip,
and painted, usually with a brush. Like earthenware, the
pieces were only fired once, not twice as was usual with
faience.

Literature: Jedding (1976), p. 32, fig. 13; p. 92, no. 13;
Nørregaard, pp. 5-39, particularly figs. 1-4.

110.
Dish
So-called *Stettinergut* (Stettin ware), dated 1761
Tin-glazed earthenware; reddish-yellow clay, greyish-
 white tin glaze, partly reddish in appearance, onto
 which dark-blue and green colors have been painted
Diameter 35.6 cm., Height 5.6 cm.
Museum für Kunst und Gewerbe, Hamburg, Inventory
 No. 1964.219 (formerly Dr. Konrad Strauss Collec-
 tion, Hamburg and Munich)

The dish has a similar form to that of the groats dish
(described in nos. 18, 19), with a slight curved base. To
this is joined a wall, steeply fluted, then, after a bend,
wider, and slightly curved; it ends in a vertical sloping rim
3 to 4 mm. high, thinner at the edge. The edge serves for
scraping the spoon over a narrow, horizontal border,
which is hardly above the level of the wall. The center
shows a curvaceous flower-bed with three flowering
plants. A bird with long tail feathers hovers between the
two tallest flowers; the date *1761* appears underneath.
The wall is decorated with a circular chain of interlocking
S-shaped hooks; the rim for scraping the spoon is colored
blue, and the border is dotted with long blue spots.

As with no. 109, there is an astonishingly close re-
semblance to Netherlandish prototypes. This applies
especially to those of the second half of the 17th century
which imitated Chinese decor. This decor occurs on
dishes, plates and on tiles, and in the 18th century in the
Netherlands, was increasingly simplified and altered
beyond all recognition. For provenance and distribution,
see no. 109.

Literature: Jedding (1976), p. 33, fig. 14; p. 92, no. 14.

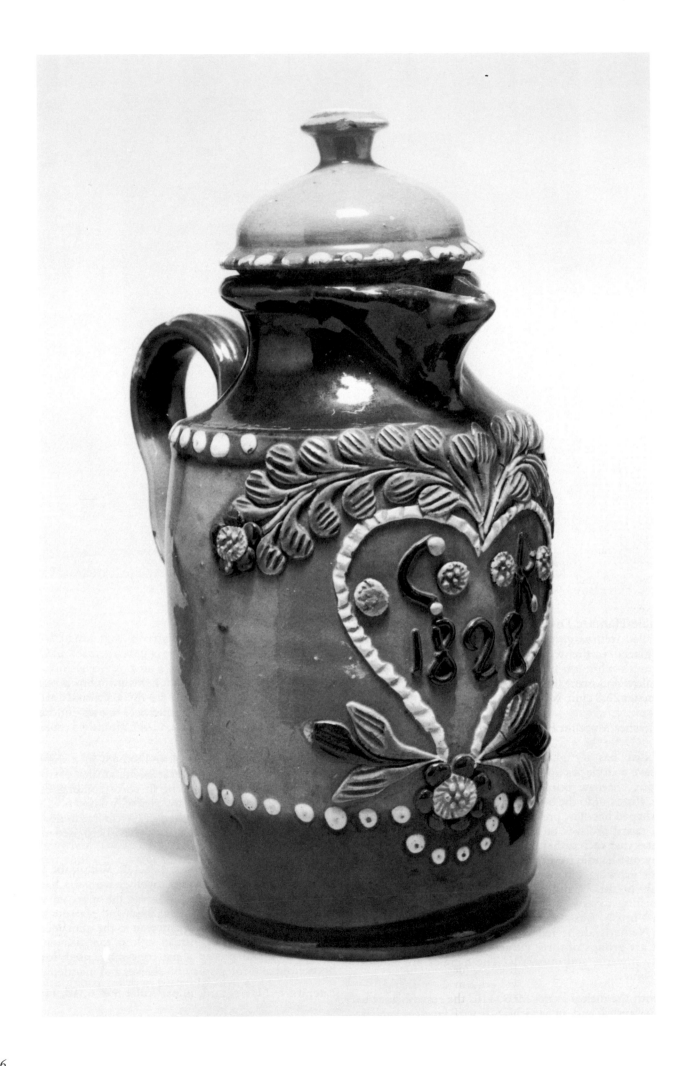

113.

Coffee Pot

Marburg, dated 1828

Lead-glazed earthenware, inside and out; whitish-grey clay, brownish-red and blackish-brown slip; the decor in relief is shaped out of the mass, colored dark-brown green, white and ochre

Height with lid, 21 cm., Diameter 9.5 cm.

Museum für Kunst und Gewerbe, Hamburg, Inventory No. 1909.270

A calotte-shaped lid, with a button-like, shanked knob, is placed on the cylindrical body, the lower part of which is darker and slightly tapered. It has a sharply bent shoulder, dark fluted neck, flanged rim, lip pulled out to a point and a flat curved handle. The decor of leaves and ribbons is concentrated at the front below the lip: a heart with the inscription, *C.R. / 1828*, out of which emerge above, two symmetrical leaf tendrils; below, two short branches with a flower in the middle. Circular rows of painted white spots on foot, shoulder and lid emphasize the change from the black to the red parts of the pot. There is no slip in the interior so that the lead glaze appears yellow on the clay. The inside of the lid is unglazed. The unglazed base is blackened by the dark slip of the bottom quarter of the pot.

Pottery in Marburg (Hesse) and the surrounding villages had experienced a steady upturn since the middle of the 18th century and a quite astonishing boom at the beginning of the 19th century. In 1840 it reached its peak, with thirty workshops and fifty journeymen in this town of 7,500 inhabitants. This was only made possible by an export volume extending far beyond the borders of Hesse to Denmark and the Netherlands. The exporting was done by horse and cart, mostly through the markets. When all the goods had been sold, horse and cart were sold as well so that the return journey of hundreds of kilometers on foot was kept as cheap as possible. The traders used to visit the same areas year after year so that they could accept orders for specially initialed coffee pots like this one.

Incidentally, coffee pots were vessels which were only reluctantly adopted by potters in the 19th century. In the 17th and 18th centuries they had been produced for well-to-do customers in metal, porcelain or very rarely in faience. It was only at the beginning of the 19th century that coffee drinking became common practice in the country and in the small towns, although only in exceptional cases was this beverage brewed from coffee beans. Mostly one made do with cheaper substitutes such as chicory, roast barley, rye or acorns. Hence the Marburg traders could fulfil a demand in North Germany with their coffee pots so that the market for both large and small pots was very considerably extended.

Literature: Jedding (1976), p. 60, fig. 41; p. 104, no. 41.

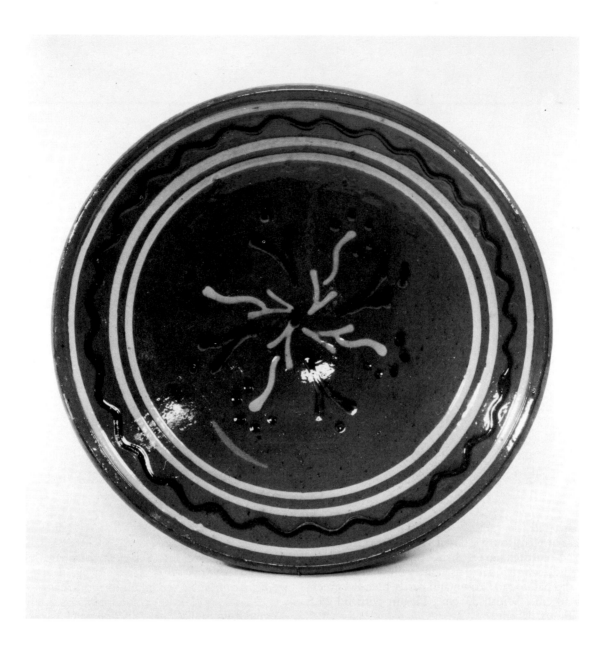

116.

Pancake Dish

Hehemann Workshop in Hagen-Gellenbeck, southwest
of Osnabrück, between 1945 and 1949
Lead-glazed earthenware; reddish-brown clay, painted in
whitish-yellow, dark-brown, green
Diameter 25.6 cm., Height 6.8 cm.
Kulturgeschichtliches Museum Osnabrück, Inventory
No. A 3175 K

The projecting base of 8.7 cm. is small for a vessel of this
size. From it rises a sloping wall ending in an edge,
thickened on the outside. The clay is rough and, on the
inside, apparently not poured. The decoration consists of
whitish-yellow circular lines on the upper third of the
wall which surround a dark-brown wavy line. In the
center and lower third of the wall, it consists of a bundle
of four whitish-yellow arrows, concentrated on the
center, with dark-brown points and four green angles
with a green point.

The dish, relatively small for this type, is an example of
the last production phase of a workshop in operation
since the 1820's. It sold its standard everyday ware far
beyond its immediate surroundings; southwards, 10 to 20
km. beyond the Teutoburg Forest; westwards to Ems-
land, distances of from 40 to 50 km. In contrast to many
other workshops, it kept the traditional forms and decor
of this region, without going over to the production of
decorative, artistic ceramics.

Pancake dishes are characterized by a small bottom and
base. The flat pancakes, made of raw potatoes and less
often of flour with fruit added, are fried in the pan and
served at table, piled high in layers. They are eaten in this
region at lunch by the Catholic population on fast days,
therefore also regularly every Friday. In the funnel-
shaped dish the surplus fat collects at the bottom.

Literature: Segschneider, in particular pp. 20-36, fig. 11.

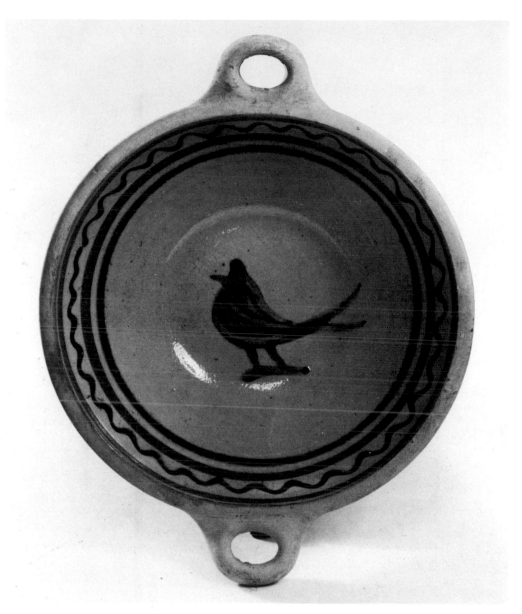

117.

Double-Handled Dish, or *Näpken* (small bowl)
Hehemann Workshop in Hagen-Gellenbeck, southwest
of Osnabrück, between 1945 and 1949
Lead-glazed earthenware; reddish-brown clay, painted in
brown, dark-brown and green
Diameter 23.3 cm., Height 7.7 cm.
Kulturgeschichtliches Museum Osnabrück, Inventory
No. A 411 b

The high wall rises from the base, more steeply than in the pancake dish (no. 116), to the edge, thickened on the outside. To the latter are attached two ear-shaped handles. The clay is rough and with apparently no slip inside. The decoration consists of rows of two brown lines (above) and two green lines (below), which enclose a dark-brown wavy line on the upper part of the wall. The center is decorated by a dark and light-brown bird with its tail stretching over part of the wall. On the crockery of the district it is known as the *Hagener Hahn* (Hagen Cock).

This dish, large for its type, is a further example of traditional forms and decors that have been preserved until very recently in many areas of Northern Germany. Until the middle of the 19th century they were in constant use everywhere as standard ware. This dish form was used morning and evening for eating milk soup and porridge, into which pieces of bread were broken. In the evenings the soup might also consist of buttermilk with cinnamon, sugar and raisins added. For this, each had his own dish. The smaller examples of this type can be compared with the warm beer dishes (nos. 55-61). These dishes were stored by hanging from a hook.

Literature: Segschneider, particularly pp. 20-35, fig. 2.

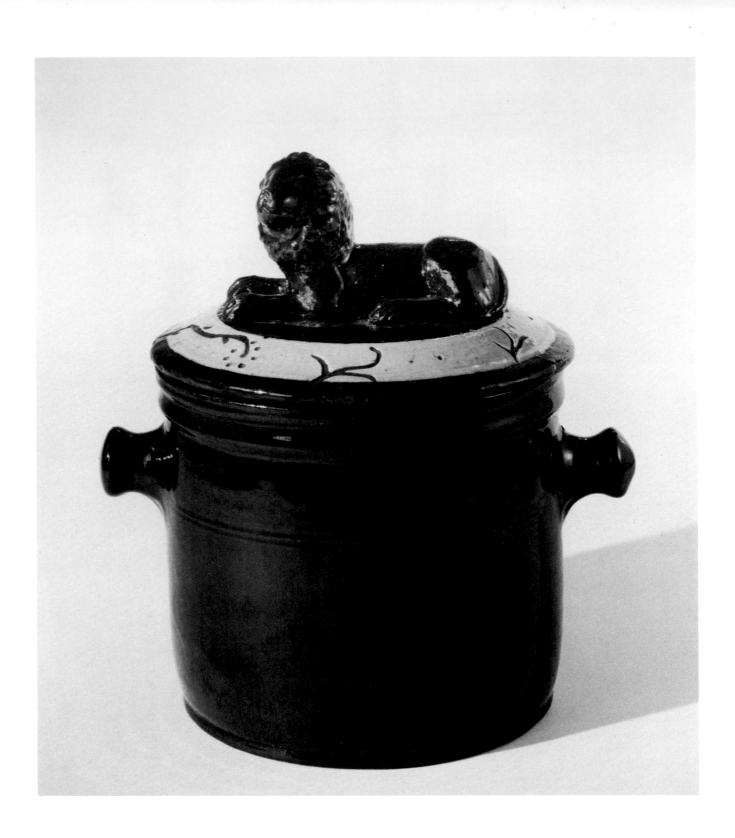

118.
Tobacco Jar
Hehemann Workshop in Hagen-Gellenbeck, southwest
 of Osnabrück, between 1945 and 1949
Lead-glazed earthenware, inside and outside, sculptural
 design; reddish-brown clay, dark-brown slip, painted
 in whitish-yellow on the lid
Height with lid 23.7 cm., without 15.2 cm., Diameter
 15.5 to 16.8 cm.
Kulturgeschichtliches Museum Osnabrück, Inventory
 No. A 414

The cylindrical pot, with slightly pulled in foot, has at the top a fluted rim, thickened on the outside, with two button-like grips beneath it on opposite sides of the cylinder. The gently curved lid is decorated with a circular, broad, whitish-yellow band with an incised decor of thin branches and flower dots. This decor encircles a modelled lion lying in the middle, which serves as a grip.

In the region of Osnabrück, as in Prostei, tobacco jars were among those pieces of everyday ware on which the potter could display his artistic talent. Either more or less heavily ornamented, they were produced from the 19th century onwards in many variations but always retaining the basic pot-like form. This recent example cannot conceal that the lion is patterned on prototypes in the English stoneware of the 19th century. A comparison with no. 78 shows that although the form of this piece is still basically the same as the one which was once thought to be so modern, based on the English prototype, in the course of time, it adapted itself to the changing taste of the customers, where classical severity and proportions, together with dark coloring, had given way to softer forms and less accentuated proportions. However, the Hehemann workshop has, in the 20th century, produced tobacco jars in lighter coloring as well. Although they have almost the same form as this jar, because of their yellow, green and brown slip decoration they lose that immediately recognizable visual affinity to the classical prototypes of the early 19th century and give, unintentionally, a rather "artsy craftsy" impression.

Literature: Segschneider, particularly p. 37 and cover illustration.

SELECTED BIBLIOGRAPHY

Bauerntöpferei vom Niederrhein 17. bis 20. Jahrhundert. Niederrheinisches Freilichtmuseum Dorenburg, Grefrath, 1978. (Exhibition catalogue)

Borchers, Walter. *Volkskunst in Westfalen.* Münster/Westfalen, 1975.

Brinckmann, Justus. *Führer durch das Hamburgische Museum für Kunst und Gewerbe,* Vol. 1, Hamburg, 1894.

Creutz, Max. *Die Rheinlande.* Deutsche Volkskunst, Vol. 1, Weimar, 1924.

Ehlers, Louis. *Dansk Lertøj.* Copenhagen, 1967.

Folklig konst i tyg och lera. Catalogue for an exhibition from Northwest Germany circulated in Sweden 1963/64; organized by Deutscher Kunstrat, Cologne.

Grohne, Ernst. *Tongefäße in Bremen seit dem Mittelalter.* Bremen, 1940.

Jedding, Hermann. *Alte deutsche Bauernschüsseln.* Museum für Kunst und Gewerbe, Hamburg, 1963.

Jedding, Hermann. *Volkstümliche Keramik aus deutschsprachigen Landern.* Museum für Kunst und Gewerbe, Hamburg, 1976.

Karlinger, Hans. *Deutsche Volkskunst.* Berlin, 1938.

Kaufmann, Gerhard. *Bemalte Wandfliesen. Kulturgeschichte, Technik und Dekoration der Fliesen in Mitteleuropa.* Munich, 1973.

Kroha, Tyll. *Sparbüchsen. Ein Brevier.* Braunschweig, 1959.

Lehnemann, Wingolf, ed. "Töpferei in Nordwestdeutschland." *Beiträge zur Volkskultur in Nordwestdeutschland,* No. 3, Münster/Westfalen, 1975.

Meyer-Heisig, Erich. *Deutsche Bauerntöpferei. Geschichte und landschaftliche Gliederung.* Munich, 1955.

Meinz, Manfred. "Ein Emder 'Brannwinskopje' im Altonaer Museum. Zu einem Gefäßtyp und den damit verbundenen Trinksitten im Nordseeküstengebiet." *Jahrbuch,* Vol. 1, Altonaer Museum in Hamburg, 1963.

Meinz, Manfred. *Die Silberkammer des Altonaer Museums.* Hamburg, 1967.

Mit Drehscheibe und Malhorn. Germanisches Nationalmuseum, Nuremberg, 1954.

Naumann, Joachim, ed. *Meisterwerke hessischer Töpferkunst. Wanfrieder Irdenware um 1600.* Staatliche Kunstsammlungen, Kassel, 1974.

Nørregaard, Anker. "Lertøj og pottemagere på Lolland-Falster." *Lolland-Falsters Stiftsmuseum, Arsskrift,* 1964.

Nørregaard, Anker. "Stettinergods." *Lolland-Falsters Stiftsmuseum,* Arsskrift, 1978.

Pessler, Wilhelm. *Niedersachsen.* Deutsche Volkskunst, Vol. 1, Weimar, 1923.

Redlefsen, Ellen. "Möschenpötte und Wöchnerinnenschalen." *Die Heimat,* Vol. 48, No. 11, 1938.

Schlee, Ernst. *Schleswig-Holstein.* Deutsche Volkskunst, new series. Weimar, 1939.

Schlee, Ernst. *Schleswig-Holsteinische Volkskunst.* Kunst in Schleswig-Holstein, Vol. 14, Flensburg, 1964.

Schlee, Ernst. *Die Volkskunst in Deutschland. Ausstrahlung, Vorlagen, Quellen.* Munich, 1978.

Scholten-Neess, Mechthild and Jüttner, Werner. *Niederrheinische Bauerntöpferei 17.-19. Jahrhundert.* Werken und Wohnen. Volkskundliche Untersuchungen im Rheinland, Vol. 7, Düsseldorf, 1971.

Schwindrazheim, Hildamarie. *Altes Spielzeug aus Schleswig-Holstein.* Heide/Holstein, 1957.

Segschneider, Ernst Helmut. *Irdenware des Osnabrücker Landes, 19. und 20. Jahrhundert.* Kulturgeschichtliches Museum, Osnabrück, 1973.

Spies, Gerd. "Gefäße in der Heilsgeschichte. Bild und Objekt als Quellen ikonographischler Betrachtung." *Kunst und Antiquitäten,* No. 6, 1978.

Stieber, Paul. "Deutsches Hafnergeschirr." *Keysers Kunst- und Antiquitätenbuch,* Vol. 3, Munich, 1967.

Strauss, Konrad. *Alte deutsche Kunsttöpfereien.* Berlin, 1923.

Stüben, Gertrude. "Alte Probsteier Töpfereien." Unpublished manuscript in Altonaer Museum in Hamburg and Schleswig-Holsteinisches Landesmuseum, Schleswig, 1952.

Volkskunst aus Deutschland, Österreich und der Schweiz. Kunstgewerbemuseum der Stadt, Cologne, 1968. (Exhibition catalogue)

Wagner, Hertha. "Töpferei in Tellingstedt." Unpublished manuscript in Altonaer Museum in Hamburg and Schleswig-Holsteinisches Landesmuseum, Schleswig, 1950.

PHOTO CREDITS

Beatrice Frehn, Hamburg: Cat. Nos. 18-21, 28, 31, 32, 37, 49, 56-61, 88, 93, 94, 97, 99, 101, 102, 109, 110, 113, 114; Bernd Kirtz, Duisburg: Cat. Nos. 1-10, 13, 14; Gerard P. Parkonson, Meldorf: Cat. Nos. 34, 86, 87, 90, 91; Fotostudio Gerd Remmer, Flensburg: Cat. Nos. 23, 48, 62, 63, 66, 85, 89, 103, 107, 108, 112; Photo-Atelier Rheinländer, Hamburg: Cat. Nos. 22, 24-27, 30, 35, 36, 38-40, 45, 51, 64, 96; Altonaer Museum in Hamburg, Norddeutsches Landesmuseum, Hamburg (Dieter Otte): Cat. Nos. 29, 41, 42-44, 46, 47, 50, 52-55, 65, 67-70, 72-84, 92, 95, 98, 100, 105, 106, 111, 115-118, Fig. Nos. 2, 4, 5; Museum für Hamburgische Geschichte, Hamburg (Hilmar Liptow): Fig. No. 3; Museum für Kunst und Gewerbe, Hamburg (H.-J. Heyden): Cat. Nos. 11, 12, 15-17, 33, 104; Schleswig-Holsteinisches Landesmuseum, Schleswig: Cat. No. 71, Fig. No. 7